PEOPLES OF THE PLATEAU

THE WESTERN LEGACIES SERIES

Published in Cooperation with the
National Cowboy & Western Heritage Museum

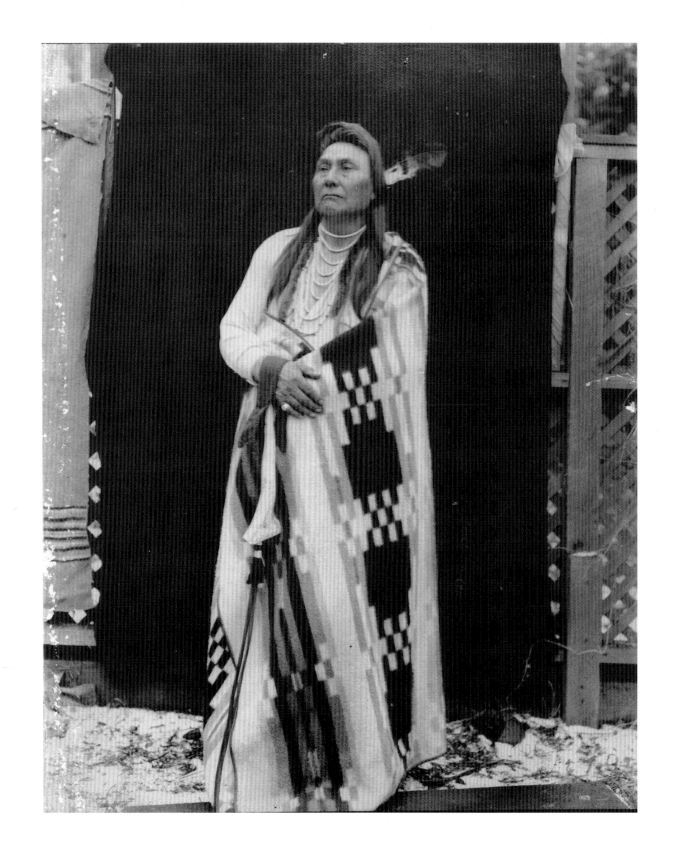

PEOPLES OF THE PLATEAU

THE INDIAN PHOTOGRAPHS OF LEE MOORHOUSE, 1898–1915

STEVEN L. GRAFE

FOREWORD BY PAULA RICHARDSON FLEMING

University of Oklahoma Press : Norman

Peoples of the Plateau: The Indian Photographs of Lee Moorhouse, 1898–1915
is Volume 2 in The Western Legacies Series.

Library of Congress Cataloging-in-Publication Data

Grafe, Steven L.
 Peoples of the Plateau: the Indian photographs of Lee Moorhouse, 1898–1915 / Steven L. Grafe;
foreword by Paula Richardson Fleming.
 p. cm. — (The western legacies series; v. 2)
"Published in cooperation with the National Cowboy & Western Heritage Museum."
Includes bibliographical references and index.
ISBN 0-8061-3727-4 (alk. paper) — ISBN 0-8061-3742-8 (pbk.: alk. paper)
 1. Indians of North America—Columbia Plateau—Portraits. 2. Indians of North America—Columbia
Plateau—Pictorial works. 3. Moorhouse, Lee—Photograph collections.
I. Moorhouse, Lee. II. National Cowboy and Western Heritage Museum. III. Title. IV. Series.

E78.C63G75 2005
979.7'01—dc22

2005041885

The paper in this book meets the guidelines for permanence and durability of the Committee on Production
Guidelines for Book Longevity of the Council on Library Resources.∞

Printed in China

1 2 3 4 5 6 7 8 9 10

CONTENTS

FOREWORD

PAULA RICHARDSON FLEMING

I first discovered Major Lee Moorhouse in the early 1970s while working with some of his original glass plate negatives in the National Anthropological Archives. Because of the technical quality of the images and because Moorhouse had used glass plate negatives at a relatively late date, I thought he must have been a professional photographer as well as a military man, as I inferred from his title. What a fascinating combination.

Then I discovered his small publication, *Souvenir Album of Noted Indian Photographs,* which included not only his photographs but also poetry. Admittedly, it was poetry with a nineteenth-century flavor, but it still added "appreciation of poetry" to the accomplishments of a man I thought was an ex-military officer turned professional photographer. I also learned that Moorhouse himself was included in a group portrait of Native American leaders from the Columbia Plateau who had come to Washington, D.C., in 1889 and that he had been their Indian agent. Obviously, there was more to Major Lee Moorhouse than met the eye.

As it turned out, he was not a professional photographer, but relegating him strictly to the rank of amateur may deny him the credit he deserves. He had an eye for composition and a drive to document life around him—not only that of Native Americans but also life in Oregon's Euroamerican community. He was an insatiable photographer, producing nearly nine thousand images on cumbersome glass plates. Whereas some turn-of-the-twentieth-century professional photographers, such as Edward S. Curtis and Frank Rinehart, became friends with their Native subjects, Moorhouse was clearly a part of their lives. His subjects have names and are not dehumanized or generalized as cultural "types." Although some of his work appears contrived, he worked within the stylistic trends of his time. He used props from his own collection

of objects, something considered inappropriate today, but at the time they were appropriate to his subjects, and they do not misinform the viewer. His enormous body of images documenting the people and life in his region is an invaluable historical resource; it cannot be dismissed as contrived or inaccurate.

Although Moorhouse and his work were locally well known during his lifetime, after his death his photos passed into obscurity until the glass plates were transferred to public repositories in 1949. Even then they remained unresearched for more than forty years. My own brief forays into the work of Lee Moorhouse made it clear that he was a complex subject whose career called for in-depth research if his images were to be fully understood. It was also obvious that the necessary primary resources would be scattered across the country and not concentrated in U.S. government repositories.

In the 1990s I had the pleasure of working with Steve Grafe on various research topics, not the least of which was his ongoing work on Moorhouse. He was indeed the scholar to do the in-depth research, given his knowledge of Plateau cultures, his ability to view Moorhouse with as unbiased an eye as possible, and his ability to place Moorhouse in the context of his times. As expected, the work required to come to grips with this important figure took many years. It is a pleasure that this invaluable information is now being published so that a wider audience can appreciate the tremendous visual record produced by Lee Moorhouse and gain access to its riches.

PREFACE

L ee Moorhouse and his Indian photographs first came to my attention in December 1990, when I was reviewing visual reference material for a research project related to Columbia River beadwork. I eventually discovered that a variety of Moorhouse photos had found their way into print, but I was surprised to see that the clothing and other items of material culture evident in many of the images appeared on multiple subjects. This challenged me to identify the set of objects the photographer had used as studio props. My goal was achieved several years later when I found photos of the Moorhouse curio collection in the University of Oregon's Knight Library.

During this initial quest I came to appreciate the vast unpublished body of Moorhouse's work. His views of rural and small-town life in the turn-of-the-twentieth-century Columbia River Basin are important. It has surprised me that much of this material, particularly the maritime, railroad, agricultural, and circus views, has received little attention from researchers with relevant expertise. Similarly, Moorhouse's nonstudio views of life on the Umatilla Indian Reservation are less well known than one would hope. The dawning of the digital age is helping to rectify this neglect, and the University of Oregon library and the Tamástslikt Cultural Institute in Pendleton, Oregon, are now working together on a Web-based project that is affording greater visibility to the Indian photographs.

My goal in producing this book is to introduce Lee Moorhouse to a wider audience than has previously appreciated his work. I provide general biographical information about the man but only a limited assessment of how and why he recorded the images he did. It has not been my task to critique him, his motivations, or his aesthetic sensibilities with twenty-first-century hindsight. Some of the photo captions I have selected interpret specific images

using period texts, so that readers may appreciate the fact that Lee Moorhouse made his expansive photo record at a time when the U.S. government was promoting the acculturation and assimilation of Indian peoples through heavy-handed and paternalistic policies. Other captions reproduce descriptions of people and events from Umatilla County newspapers and the prose of regional boosters. These represent the kind of civic thought that surrounded the photographer and offer a glimpse into a world and way of thinking in which he was actively involved. My intention in quoting these passages is to provide a context for considering the images and enhancing their emotional quality without detracting from them.

The Columbia River Plateau is less well known than some other regions of Native North America, and for this reason, in some of the captions I discuss aspects of Native material culture that may be relatively unfamiliar. My great desire for this book is that through the Moorhouse photos, the public's attention will be drawn to the rich equestrian lifestyle that flourished on the Plateau during the nineteenth century. Plateau peoples had a profound effect upon Plains Indian cultures. During the historic period, there were no "culture regions," and tribal affiliations were much more fluid than they are now. Some Plains Indian traits have been thought to be hallmarks of that region only because outsiders first observed them in the middle of the continent. The Plateau is generally less known and less celebrated, and for this reason its primacy as an equestrian center and exporter of culture has been ignored. The historic record and Plateau oral traditions both support a more exalted view of Plateau Indian influence, but a century of academic canons lies between the truth and public perception.

A brief supplemental list of academic works describing the peoples of the southern Plateau appears at the end of this volume. This bibliography is meant to be introductory in the same way my essay about Lee Moorhouse is meant to be introductory. The residents of the Umatilla Reservation have their own traditions about Lee Moorhouse, none of which is reported here. These people, of course, preserve a vast body of traditions about their own history. My final hope is that some readers will review my list of published works and then move on to consult with the staff at the Tamástslikt Cultural Institute. They are the true stewards of Umatilla, Walla Walla, and Cayuse history, and they care for it daily.

ACKNOWLEDGMENTS

During the last decade and a half, a great many people have taken an interest in this research and assisted me with it. In compiling the list, I am touched to realize that many of these people are now family friends. Initial credit is due my academic mentor, Joyce Szabo, of the Department of Art and Art History at the University of New Mexico. Duane Alderman, of Pendleton, Oregon, has answered many questions, supplied numerous leads, and challenged a lot of my thinking during the decade I have known him. Mary Dodds Schlick, of Mt. Hood, Oregon, has also been an enthusiastic supporter of my Plateau research. Her thoughts on Warm Springs, Wasco, and Yakama material have proved critical to the present work.

Larry Dodd, formerly of the Northwest and Whitman College Archives at Whitman College in Walla Walla, Washington, provided foundational help. As in the case of my dissertation, I can say that "the superlative assemblage of historical texts and manuscript materials in the collection of Penrose Library figured prominently in the creation of this text." Whitman's current archivist, Colleen McFarland, also provided efficient and cheerful assistance.

Lee and Lois Miner, of Yakima, Washington, helped me make the initial connection between Lee Moorhouse and his contemporary, the photographer Thomas Rutter. John Baule, of the Yakima Valley Museum, supplied further and important information about Rutter.

Among those who offered significant help and encouragement along the way were Bill Holm, of Shoreline, Washington, Bill Farr, of the O'Connor Center for the Rocky Mountain West at the University of Montana, and Marjorie Waheneka, of the Tamástslikt Cultural Institute, Pendleton.

Paula Richardson Fleming, formerly of the National Anthropological Archives, Smithsonian Institution, has also been enthusiastic and consistent in

her support for my work. I very much appreciate her willingness to supply the foreword for this volume.

I am indebted to Julie Reese, of the Umatilla County Historical Society in Pendleton, for her ongoing assistance. Charles McCullough, of Weston, Oregon, repeatedly helped me with my review of the Historical Society's Moorhouse holdings and also provided information about Umatilla County history. Wayne Low, of Pilot Rock, Oregon, has been unselfish with his knowledge of early Pendleton photography and ephemera.

James Fox, Lesli Larson, Normandy Helmer, and others are ably caring for the Moorhouse Collection in the University of Oregon's Knight Library Special Collections in Eugene. Their ongoing interest, enthusiasm, and vision for their work is heartening, and their patience when responding to my considerable demands has been much appreciated. Daisy Njoku and Becky Malinsky of the National Anthropological Archives have likewise been very indulgent in dealing with my requests.

My move to Oklahoma has allowed Lee Moorhouse to be introduced to the world. I am grateful to the National Cowboy & Western Heritage Museum for maintaining an interest in western history and for providing a creative environment in which to work. I applaud my colleagues here for their passion, expertise, and professionalism. I am especially indebted to Ed Muno, Richard Rattenbury, Don Reeves, Melissa Owens, Helen Stiefmiller, and Dustin S. Potter for their assistance. Chuck Rand, Jonathan Nelson, and Jerri Stone, of the museum's Donald C. and Elizabeth M. Dickinson Research Center, have provided prompt and cheerful research assistance. The museum's executive director, Chuck Schroeder, and its assistant director, Mike Leslie, have occupied themselves with the practical matters of running this institution while I occupied myself with this project. A friend of the museum who wishes to remain anonymous graciously supported the production of this publication.

The University of Oklahoma Press is dedicated to publishing the history that I love so much. I am particularly grateful for the interest and enthusiasm offered there by Chuck Rankin, Alessandra Jacobi, Alice Stanton, and Patsy Willcox.

The Moorhouse photographs record a wide scope of locations and subjects. Producing even the most minimal of photo captions for this diverse material proved challenging. Among those mentioned earlier, Duane Alderman, Bill

Farr, Lee and Lois Miner, Mary Schlick, and Marjorie Waheneka helped in that effort. I am also grateful for significant input from the following persons: Rebecca Andrews, Burke Museum of Natural History and Culture, University of Washington, Seattle; Phillip Cash Cash, University of Arizona, Tucson; Barry Friedman, Phoenix, Arizona; Jan Kristek, Brno, Czech Republic; Armand Minthorn, Confederated Tribes of the Umatilla Indian Reservation, Pendleton; J. Diane Pearson, University of California, Berkeley; Kevin Peters, Nez Perce National Historical Park, Spalding, Idaho; Josiah Pinkham, Cultural Resource Program, Nez Perce Tribe of Idaho, Lapwai; Eric Satrum, National Museum of the American Indian, Smithsonian Institution; Richard D. Scheuerman, Spokane, Washington; Clifford E. Trafzer, University of California, Riverside; Carmagene Hulse Uhalde, Columbia Gorge Discovery Center and Museum, The Dalles, Oregon; Dave Walter, Montana Historical Society, Helena; Nakia Williamson-Cloud, Cultural Resource Program, Nez Perce Tribe of Idaho, Lapwai; and Steve Wright of the Winthrop Group/Pendleton Woolen Mills archives.

Finally, my wife, Christina, and our son, Roy, have allowed Lee Moorhouse into our home for a good long time. Their patience and good humor have been laudable.

Should readers discover any errors in the text, they are solely my own.

PEOPLES OF THE PLATEAU

LEE MOORHOUSE

THE LIFE AND LEGACY OF AN AMATEUR PHOTOGRAPHER

In 1905, Lee Moorhouse, a Pendleton, Oregon, photographer of some local reputation, compiled a small body of his images into a book titled *Souvenir Album of Noted Indian Photographs.* For a full century this slender volume contained the largest collection of the photographer's work ever published. Promoted as containing the best of his Indian imagery, "to the number of about 50," it offered photos of Chief Joseph, the popular images Moorhouse called *The Cayuse Twins,* and "other unusual and picturesque views." Additional titles included *Sac-a-ja-wea, Princess We-a-lote, Cayuse Maiden,* and *Sins of the Redman*. These were accompanied by a variety of poems celebrating the romantic life and approaching demise of the Indian race. Taken as a whole, the work seems to have been dedicated to perpetuating various misconceptions and stereotypes about the Indian peoples of the interior Pacific Northwest.

During his lifetime, Lee Moorhouse's Indian images appeared frequently as postcards and prints, in select periodicals, as illustrations for regional histories, and on calendars. In recent years, a few Moorhouse photographs have been published as illustrative of some aspect or another of traditional Columbia River Plateau Indian life or dress. The sum of the published images supports a view of the photographer as one who produced a romanticized and pictorialist record of late-nineteenth- and early-twentieth-century American Indian life.

Despite their pictorial quality, many of the Moorhouse Indian photos are of limited value as visual history because of the photographer's use of studio props. Fortunately, his added adornments came from a fairly static and well-documented collection. Although the absence of fancy dress clothing in other of his studio images may lessen some viewers' interest in them, these photos provide a fairly accurate view of the everyday styles of dress of turn-of-the-

twentieth-century southern Plateau peoples.

What truly sets Lee Moorhouse apart from most of his contemporaries is that on many of his Indian photographs, he identified their subjects by name. Modern skeptics may be inclined to discard Moorhouse's description of himself as a long-standing friend and confidant of his Indian neighbors. His claims could be taken as hyperbole and a product of self-promotion, but there was a great deal of truth to them. In an era when others were titling Indian imagery with general or overly poetic appellations or seeing their subjects as types, Lee Moorhouse was aware that he was photographing people.

A BRIEF BIOGRAPHY

Thomas Leander "Lee" Moorhouse was born on February 28, 1850, in Marion County, Iowa. His father was a native of England, and his mother had come to the Midwest from Germany. In 1861 the Moorhouse family, with its ten children, moved to Oregon, traveling across the Great Plains in an ox-drawn wagon. After arriving in the interior Northwest, the family settled near Walla Walla, Washington. Young Lee spent the winter of 1861–62 living with the Henry Bowman family on Birch Creek, about five miles south of Pendleton, Oregon. Bowman was at that time the head miller for the Umatilla Reservation. The Bowmans had previously resided in Osceola, Iowa, and had become acquainted with the Moorhouses while living there.[1]

Lee Moorhouse rejoined his family the following spring and enrolled in Walla Walla's Whitman Seminary shortly thereafter. As a young adult he led a varied and interesting frontier life. While a teenager he went prospecting to the Boise mines before moving on to the mining country of southern British Columbia. Going broke in Kootenai, he traveled to Helena, Montana, where he found work keeping books for a livery stable. A stint breaking horses followed, after which he returned to Walla Walla. He then studied briefly at a Portland business college before joining an Oregon and California Railway survey crew that was working south from Roseburg, Oregon. After this, he signed on as a cowhand driving a herd of wild cattle from Walla Walla to Winnemucca, Nevada.

Around 1874 Moorhouse returned to Pendleton. There he found work as county surveyor before taking employment with local merchant Lot Livermore. Livermore's businesses included a general store, the post office, and a branch

of the Wells Fargo Express Company. On September 5, 1876, Moorhouse married Sarah Ella Willis at the bride's family farm near Milton, Oregon.[2] The following year the newlyweds left Pendleton for Umatilla Landing, on the south shore of the Columbia River near its junction with the Umatilla River. There Lee began work as a clerk for John R. Foster and Company.

At the time, Umatilla was a terminus of Columbia River navigation and a thriving village of nearly fifteen hundred residents. When the final skirmishes of the Bannock-Paiute War erupted nearby in 1878, Moorhouse served as field secretary to Oregon's governor, Stephen F. Chadwick. The governor had come up the Columbia River to observe the movement of troops and the distribution of weapons. Umatilla Landing was generally removed from the front line of battle, but the population was nonetheless agitated. In describing the scene, Moorhouse later recalled: "John R. Foster's big stone warehouse and J. H. Koontz's warehouse were both filled with refugees. The steamboats were patrolling the upper river looking for Indians. They had bales of wool piled around their decks for protection. Whenever they saw a canoe load of Indians they would fire at it and sink the boat and kill the Indians, if possible."[3]

The following year Moorhouse was appointed assistant adjutant general of the Third (Eastern Oregon) Brigade, Oregon State Militia, by Governor William Wallace Thayer. He kept the commission and the resultant rank of major for four years, although the title remained with him for the remainder of his life.

In the fall of 1879 a group of Portland capitalists invested in a four-thousand-acre project called Prospect Farm, about five miles northeast of present-day Stanfield, Oregon. Lee Moorhouse was a stockholder in Prospect Farm and was chosen as its first superintendent. The project's land and equipment cost $100,000 and included a two-story dwelling for the superintendent, a boarding house for nearly forty male employees, a blacksmith shop, granaries, and machine sheds. A post office, named "Morehouse" before being changed to "Moorhouse," operated at the site between January 1880 and June 1883. Lee Moorhouse served as its postmaster. During his four-year tenure overseeing the fortunes of Prospect Farm, the property produced 250,000 bushels of wheat.

Returning to Pendleton, Moorhouse became a partner in the general store of Marston and Moorhouse. Several years later he joined his former employer, Lot Livermore, in the Lee Moorhouse and Company General Store. An 1888

advertisement noted that a variety of "new and choice" novelties were to be had at the Moorhouse establishment, as well as "Stylish Clothing, Stylish Neckwear, Stylish Hats, and Stylish Underwear." In 1885 Moorhouse was mayor of Pendleton. He was the city's treasurer and surveyor in 1888.

In 1889 his political activity gained him an appointment as agent of the Umatilla Indian Reservation. During his term there, the Umatilla Reservation was surveyed prior to the assigning of allotments to individual tribal members. When the survey was complete, a series of auctions was held, and the Indian land deemed surplus was sold to local farmers, ranchers, and land speculators. Moorhouse left the Indian Service shortly after the surplus land auctions were completed in 1891.

Returning to business in Pendleton, he entered the wheat firm of Hamilton and Rourke. He later joined one of these partners, Charles V. Hamilton, in selling fire insurance. The partnership existed until 1908. After that date, he established an independent insurance business. It was during this period of his life, from his late forties to his mid-sixties, that he enthusiastically turned his energy to the avocation of photography.

Lee Moorhouse was admitted to the Oregon Bar in 1900 but never actively practiced law. In 1901 he began twenty-five years of service as clerk of the Oregon Supreme Court, Eastern District. Early in the twentieth century he sat on the Oregon Geographic Names Board. He discharged numerous other civic duties during his lifetime, was an active member of two fraternal organizations, and served for several years as president of the Pendleton Camera Club.

Thomas Leander Moorhouse died at his home on June 1, 1926, after an illness of four weeks' duration. His obituary was front-page news in the following day's *Pendleton East Oregonian,* where he was heralded as one of the "best known and beloved pioneers" of Umatilla County and one of the "outstanding citizens" of the region.

THE COLUMBIA BASIN, UMATILLA COUNTY, AND THE UMATILLA INDIAN RESERVATION

Lee Moorhouse was interested in history, and the south-central Columbia River Basin—an area incorporating the Umatilla and Walla Walla River valleys and the confluence of the Snake and Columbia Rivers—was uniquely

situated in that regard. The region's oldest traditions were intertwined with the lives of the Cayuse, Walla Walla, and Umatilla Indians. The land reserved for these peoples jointly under the 1855 Walla Walla Treaty was located in the eastern expanse of Umatilla County.

In the early nineteenth century, Walla Walla, Umatilla, and Cayuse territory extended well beyond the boundaries of their current reservation (MAP 1). The Walla Wallas inhabited the lower Walla Walla River drainage and the region around the juncture of the Columbia and Snake Rivers. The Umatillas lived in a large area to the south and west of the Walla Wallas, with their largest village at the mouth of the Umatilla River. Cayuse territory extended south from Walla Walla land as far as the headwaters of the Malheur River, abutting Nez Perce territory in the Blue Mountains on the east and Umatilla land on the west. Early estimates suggest that the Walla Walla and Umatilla populations totaled fifteen hundred to twenty-five hundred persons each, with the Cayuse community comprising a lesser number.

The Walla Wallas and Umatillas spoke dialects of a language that had affinities with that used by the Nez Perce. The Cayuse spoke a unique language that was little used after 1800. All the people of the southern Columbia River Plateau were related culturally and linguistically, and intermarriage between members of different groups was not uncommon. During the nineteenth century, Cayuse–Nez Perce intermarriage was particularly noted, and the Lower Nez Perce dialect was observed to be in frequent use in Cayuse households. Many Walla Wallas and Umatillas were likewise aligned with the Nez Perce. As early as the 1820s, Nez Perce was in general use as a trade language by all residents of the region.

Columbia River peoples acquired horses in the early 1700s. Local rangeland provided a superb environment for the expansion of herds, and the historic record contains a litany of comments praising the sizes and quality of regional herds. During the spring of 1806, Meriwether Lewis noted that the herds he saw in Umatilla territory were "as fat as seals." The Corps of Discovery's Patrick Gass observed: "Between the great falls of the Columbia and [the Clearwater River], we saw more horses, than I ever before saw in the same space of country."[4] Oregon Trail emigrants descending the western flank of the Blue Mountains four decades later noted that the large herds of Indian ponies they encountered there were among the finest they had ever seen.

Describing the participants in the 1855 Walla Walla Treaty Council, Lawrence Kip stated: "Each of the tribes now here possesses large numbers of horses, so that wherever they are, the prairies are covered with these animals, roaming at large till they are wanted by their masters."[5]

Horses and horse culture significantly altered the previously existing regional lifestyle. Increased mobility gave Native people easier access to a wider range of food resources. Increased quantities of material goods and provisions could also be easily transported. Buffalo hunting, previously accomplished on foot, was now undertaken from horseback. The Nez Perce are often referred to as the most frequent southern Plateau visitors to the plains, but their downriver associates—particularly the Cayuse—often joined them.[6] In general terms, the Walla Wallas and Umatillas pursued riverine economies while the Cayuse adhered to an equestrian lifestyle. The southern Columbia River Plateau was a center of aboriginal North American horse culture, and its peoples left their marks on eighteenth- and nineteenth-century Plains Indian social and material life. The renown of the Cayuse for their equestrian lifestyle ultimately resulted in the use of their tribal name as a vernacular designation for Indian ponies.

During 1805 and 1806, Lewis and Clark and their Corps of Discovery became the first white men to travel down the Snake and Columbia Rivers. In 1811 the North West Company's David Thompson descended the Columbia River, only to find representatives of John Jacob Astor's Pacific Fur Company in residence at its mouth. During this trip Thompson stopped at the junction of the Columbia and Snake Rivers, conferred with local leaders, and "claimed" the territory for Great Britain. In 1818 the North West Company founded Fort Nez Perces at the confluence of the Walla Walla and Columbia Rivers, and for more than forty years the facility served as the main regional outlet for Euroamerican goods. Throughout much of the 1820s and 1830s, fur traders remained the only whites to reside in and travel through the region.

In 1823 the North West and Hudson's Bay Companies became a single entity. The movement of Hudson's Bay Company traders back and forth to the Rocky Mountains helped establish a route that had been blazed by Astor's Overland Astorians. Though it eventually became known as the Oregon Trail, the route had no official name when Protestant missionaries followed it during the 1830s. In 1836 Dr. Marcus Whitman and his wife, Narcissa, established a mission station on Cayuse land at Waiilatpu, about twenty-five miles east of

Fort Nez Perces. Their colleagues, the Reverend Henry Harmon Spalding and his wife, Eliza, settled one hundred miles farther east, among the Nez Perce on Lapwai Creek.

This trickle of interlopers turned into a flood in 1843. That year marked the beginning of serious overland emigration as nearly nine hundred white settlers crossed the Grande Ronde Valley and the Blue Mountains and continued west through the Umatilla River valley. A spur route—generally taken by those in need of provisions—eventually bypassed Waiilatpu and Fort Nez Perces.

By the 1840s, not only were the Cayuse rich in ponies, but as a result of missionary training they also had become skilled gardeners. With the Wallowa Band of Nez Perce, the Cayuse greeted emigrant trains in the Grande Ronde Valley with fresh stock, fresh vegetables, roots, and fish. They constructed a toll road along the western egress of the Grande Ronde Valley. Emigrant diaries report that weary travelers traded a variety of items for foodstuffs and horses. To the west, the Umatillas also traded produce, and Umatilla men were frequently employed ferrying emigrants across the rivers that flowed northward into the Columbia.

More than ten thousand people traversed the Oregon Trail route between 1843 and 1847. The Walla Walla, Umatilla, and Cayuse people grew alarmed by the increasing numbers of emigrants passing through their lands. An 1847 measles outbreak killed many Cayuse and resulted in the murders of Marcus and Narcissa Whitman and others affiliated with their mission station. A volunteer militia was raised to punish the Cayuse. Cayuse horses and livestock were eventually appropriated, volunteers were granted the privilege of claiming Cayuse land, and the Cayuse economic base was essentially destroyed.

In June 1855, Washington territorial governor and superintendent of Indian affairs Isaac Ingalls Stevens, with Joel Palmer, Indian superintendent for Oregon, convened a treaty council at present-day Walla Walla, Washington. Two reservations—one for the Yakama and another for the Nez Perce—were initially proposed, but a third was eventually negotiated for the Walla Walla, Umatilla, and Cayuse together. Located on the west flank of the Blue Mountains and in the upper Umatilla River valley, the reservation encompassed less than 10 percent of the original land base of its new inhabitants (SEE MAP 1).

In 1877 the U.S. Army sought to move the Wallowa Band and other nontreaty Nez Perce onto Idaho's Nez Perce Reservation. With a band of

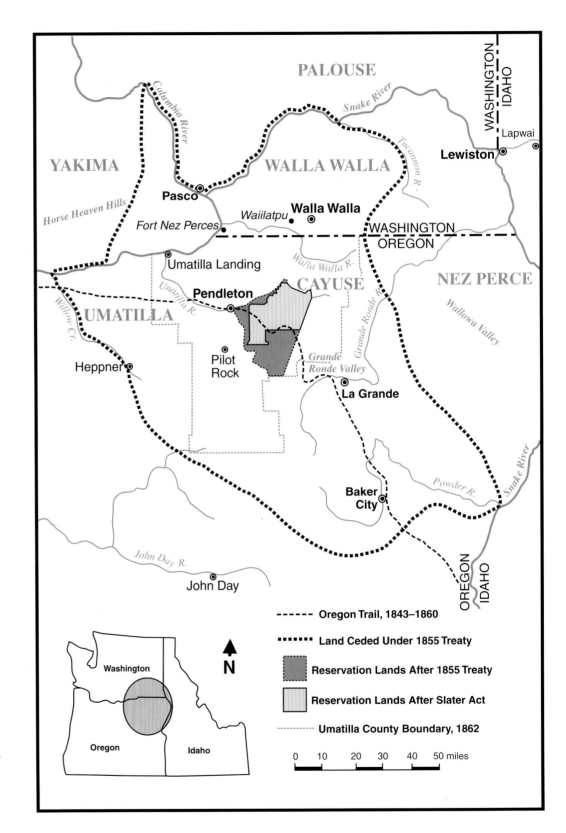

Palouse and several Cayuse, many of the nontreaty people sought to escape to Canada. After a series of battles, most of the survivors were sent into exile in Indian Territory (Oklahoma). Some who did escape to Canada were unable to return to Nez Perce territory and instead quietly moved to the Umatilla Reservation to live near relatives. A few exiles who returned after 1885 did the same. Throughout the twentieth century, links between the Umatilla and Nez Perce reservations remained strong.

Not only do Umatilla County and its environs boast a rich Indian history, but the list of historic European and American personalities who traveled through the region reads like a *Who's Who* of the American West. In addition to Lewis and Clark and a variety of early fur trappers, Sir George Simpson, Peter Skene Ogden, and Charles Bonneville all traversed the region. Jason Lee, Samuel Parker, and Pierre Jean de Smet were among the missionary visitors. Early explorers and adventurers included Wilson Price Hunt, David Douglas, John C. Fremont, and William Drummond Stuart. Too, nearly every early Euroamerican resident of the Pacific Northwest who traveled the Oregon Trail caught his or her first glimpse of the Columbia River valley from the heights of the Blue Mountains.

The historic past was made available to Lee Moorhouse through geography and regional anecdotes but also through personal contacts with historic personages. During his two years as Indian agent on the Umatilla Reservation, the agency physician was William Cameron McKay. McKay had been born at Fort George (Astoria, Oregon) in 1824, the son of Thomas McKay and a woman named Timmee, whose father, the one-eyed Chinook chief Concomly, had entertained Lewis and Clark. His paternal grandfather was Alexander McKay, who died in an Indian attack on the Pacific Fur Company ship *Tonquin* in Clayoquot Sound. His paternal grandmother was Marguerite Wadin, who eventually became Mrs. John McLoughlin. Marcus Whitman influenced Thomas McKay to send young William to New York for medical training, and William studied there and in Ohio. Returning to Oregon, he was invited by Indian leaders to establish a trading post near present-day Pendleton in 1851. He operated the business for five years and was present at the 1855 Walla Walla Treaty Council. In 1861 he was appointed government physician for the Warm Springs Reservation. McKay was later transferred to the Umatilla Reservation, where he remained until his death in 1893 (FIG. 1).

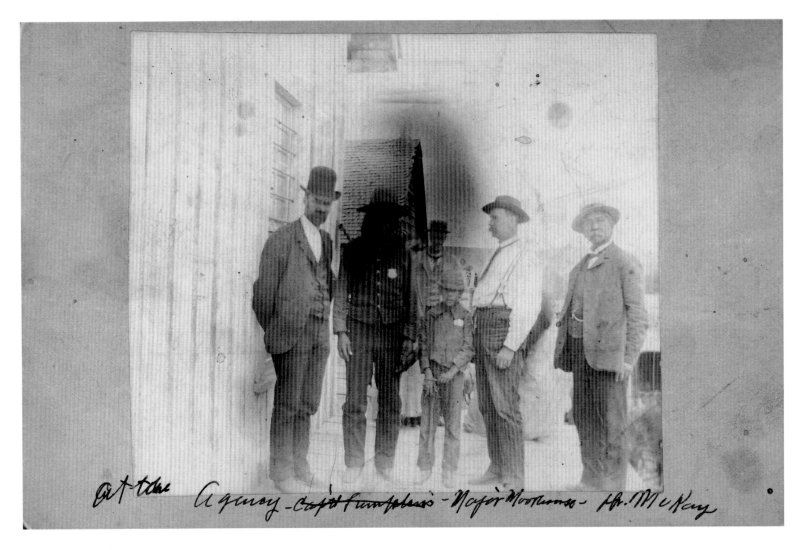

At the Agency – Capt ??? – Major Moorhouse – H. McKay

FIGURE 1

Photographer unknown, *At the Agency,*
c. 1890. Left to right: unidentified man, Capt.
Somkin, unidentified man, Mark Moorhouse,
Lee Moorhouse, William Cameron McKay. Print
Collection, PH035-1100, Special Collections
and University Archives, University of Oregon,
Eugene.

Moorhouse was also well acquainted with William Cameron McKay's half-brother, Donald. Donald was a son of Thomas McKay by his second wife, a Cayuse woman. He served as a U.S. government interpreter and scout for many years and gained renown for his service during the 1873 Modoc War, when he played a principal role in the capture of the Modoc leader Captain Jack. Donald later traveled to the eastern United States, Europe, and the 1876 Centennial Exposition with a troupe of Warm Springs Indian scouts. He remained in show business for nearly a decade and eventually settled near the Umatilla Agency. He died there in 1902.

While Moorhouse served as agent, his interpreter was John McBean. McBean's father, William, was chief clerk at the Hudson's Bay Company's Fort Nez Perces between 1846 and 1851. John subsequently served as interpreter for his father's successors, Andrew

Pambrun and James Sinclair. The younger McBean was for a time married to Jane, daughter of the Nez Perce leader Timothy (Tamootsin), who, with Joseph (father of the better-known "Chief" Joseph), was one of Henry Spalding's first two Nez Perce converts.

Moorhouse was acquainted with an array of other western personalities. Joaquin Miller, Ezra Meeker, and "Buffalo Bill" Cody all posed for him. Colonel Edward S. Godfrey did, too, while commanding Fort Walla Walla in 1903. As a lieutenant, Godfrey had been part of the Seventh Cavalry and was one of the first soldiers to view the aftermath of the Little Bighorn battle and the destruction of George Armstrong Custer's command. In subsequent years, Godfrey had been wounded at Bear Paw, Montana, during the concluding skirmish of the 1877 Nez Perce War. He was additionally present at the 1890 Wounded Knee Massacre.

At the turn of the twentieth century, Umatilla County was still very much aware of its past. Lee Moorhouse had himself crossed the continent on the Oregon Trail and had observed or participated in events that helped form the storied and romantic history of the American West. Like his neighbors, he was at once proud of and enamored with that past. A prevailing local attitude was vocalized by an *East Oregonian* writer who considered a 1902 performance of Buffalo Bill's Wild West Show in light of his daily surroundings:

> The Wild West show which appeared in Pendleton Wednesday afternoon and evening was not as interesting to the people of this city as to those living further east; as here it was a reproduction of the scenes which are actually witnessed by our people in every day life. . . .
>
> In the audiences . . . were . . . Umatilla Indians now civilized, but only a few years ago fierce and unrelenting foe of the whites, many of the redskins in the audience having notable records as fighters . . . old plains scouts and Indian fighters, rough riders from the ranges of Grant and Morrow counties who make no more of mounting a bucking bronco which has never before felt the weight of rider any more than the ordinary mortal would of putting on a clean collar before going out into society. . . .
>
> As the crowd left the show grounds and wended its way back to town the stage from Ukiah came dashing up Main street, its four well matched horses dusty and sweat covered from their long trip, while close behind rode a bunch of Umatilla braves bedecked with

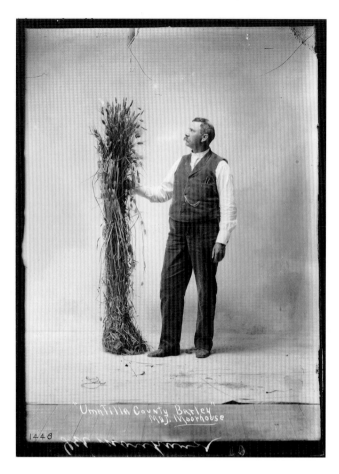

mirrors, feathers, and clothed in gaudy blankets, making an almost
perfect reproduction of the Indian attack on the Western mail coach
as represented in the mimic production of the afternoon. . . .

Lined up along the streets were numerous pack horses which
had been brought in by sheep herders from the back ranges, who
came in to see the show, and at the same time lay in a new supply
of "grub," while after the performance Sioux from the show grounds
were to be seen hob-nobbing with bucks and Indian maidens from
the reservation . . . and it took but little observation to discover that
the town itself was every bit as "wild westy" as the show, with the
very great difference that when such things as were produced in the
Wild West performances are done by the people of this section there
is no "acting" about it. Every bit of wild west life in this country is the
genuine 18-carat real thing.[7]

The wealth of Umatilla County's historic and frontier subject matter was
surpassed only by the diversity of its developing economy. As Pendleton
mayor, merchant, and agricultural and insurance broker, and as a booster
of Pendleton's annual rodeo, the Round-Up, Lee Moorhouse had long been
a promoter of regional development. The prevailing rhetoric was similar to
that voiced by one turn-of-the-century observer who noted that the county
was "unlucky in one respect only. Its railroad approaches give an entirely false
impression to the passing traveler."[8] As was true in the days of the overland
wagons, the travel route through the Umatilla River valley disguised the
proximity of productive fields and soil that one early publication proclaimed to
be "a wonder to all strangers."[9]

Local residents were proud of the county's agricultural productivity. In 1890
Umatilla County was Oregon's largest producer of wheat, accounting for nearly
one-third of the state's total of 15 million bushels. Thirty years later the region
was producing 7 million bushels yearly, almost 1 percent of the national total.
Barley and other grains were grown with some success, the orchard industry
was flourishing, and horse, cattle, and sheep ranching were also prevalent
(FIG. 2). Irrigation projects were helping to make new agricultural land available,
and new technologies were increasing the yield of existing land.

At the beginning of the twentieth century the local towns were all
experiencing unprecedented growth. Pendleton grew from a population of
twenty-three hundred in 1885 to more than seven thousand by 1920. It was
on the main stem of the Union Pacific Railroad and was the hub for connecting

lines linking local settlements. After the arrival of automobiles, it also found itself situated at the junction of the Columbia River and Oregon-Washington Highways. The town was home to a fair number of civic institutions, businesses, and industries—several flour mills and the Pendleton Woolen Mills among them. The twin villages of Milton and Freewater were the center of much of Umatilla County's fruit industry. Weston, Athena, Adams, and Helix were supply points for the wheat country situated between Pendleton and Walla Walla. Pilot Rock was the county's southern railroad terminus. It served as a shipping point for ranches situated farther south and was itself the heart of local barley production. In the western portion of the region, Hermiston and Stanfield had been founded to function as trading centers for large, adjacent irrigation projects. Nearby Echo largely served the needs of the wool industry. During Lee Moorhouse's adult life, each settlement was promoting its own peculiar advantages and amenities; all were building churches and schools and sponsoring various organizations and special events.

LEE MOORHOUSE, INDIAN AGENT

Local histories claim that Lee Moorhouse became an Indian agent through the successful petition of local Indian leaders, but what truly facilitated his appointment were relationships developed during his activities on behalf of the Republican political party. He was active in Umatilla County Republican politics for nearly fifty years and frequently served as chairman or secretary of the county party's Central Committee. This activity helped him gain the agency post in 1889.

In April 1888 Moorhouse attended the Umatilla County Republican Convention, where he was chosen to be a delegate to the Republican State Convention in Portland. Later that year, Benjamin Harrison received the nomination of the Republican Party for United States president. He was ultimately elected to the presidency on the strength of electoral balloting, having lost the popular vote to the incumbent, Grover Cleveland.

In February 1889 Moorhouse forwarded a petition to Oregon's Senator Joseph Norton Dolph advocating his own appointment to the agency post. Another petition had been endorsed by a group of prominent state Republicans on the preceding January 16. The group noted that Moorhouse had "performed untiring and effective service in our last State and National campaigns as a

member of the Republican State Central Committee and Chairman of his County Committee."[10]

The following month Moorhouse attended the inauguration of Harrison and Vice President Levi P. Morton as the guest of Oregon's Senator John F. Mitchell. On March 5, the day following the inaugural, Senators Dolph and Mitchell, along with Congressman Binger Hermann, forwarded these petitions and other letters of support to President Harrison with a cover letter recommending Moorhouse as their candidate to fill the existing vacancy at the Umatilla Agency. On March 8, Dolph notified the secretary of the interior that Moorhouse had the favorable recommendation of the Oregon delegation, although the nomination did not arrive at the Department of Interior until more than two weeks later. Lee Moorhouse was commissioned as agent of the Umatilla Indian Reservation on March 29 and assumed charge of the agency the following May 9.

Moorhouse's initial review of the Umatilla Agency, penned after two months on the job, reads like a promotional brochure for the reservation. Beginning with a long paragraph describing the physical features of the locale, he wrote that his twenty-eight years of residence in the region gave him "thorough knowledge" of the Umatilla Reservation and its inhabitants. He continued:

> I am convinced that this reservation possesses more natural advantages than any other in the United States. We have the finest of agricultural land, abundance of water, the best of timber, fine pasture lands, excellent climate, railroads for exporting our grain and importing our supplies, and being surrounded on three sides by a thrifty, energetic white population, these Indians, thus so favorably situated, will in a few years be eminently fitted to take their place by the side of their white brothers, and with measured tread march on in the great hosts of advancing civilization.[11]

In December 1889 Moorhouse traveled to Washington, D.C., with a delegation that included Chiefs Peo (Umatilla), Homli (Walla Walla), Young Chief (Cayuse), Showaway (Cayuse), and Wolf Necklace (Palouse). The group was accompanied by the agency interpreter, John McBean. During their visit to the nation's capital, the party had an interview with Thomas J. Morgan, commissioner of Indian affairs. The meeting included a discussion of upcoming allotments and other concerns, among them a grievance presented

by Wolf Necklace. Wolf Necklace was not a resident of the Umatilla Reservation but was allowed to join the party after agreeing to pay the expenses of the interpreter, McBean. At the time, the Palouse leader owned more than two thousand horses, and the county tax assessor was determined to tax him, despite the fact that he was not a U.S. citizen. Both Wolf Necklace and Agent Moorhouse considered this a violation of treaty provisions.

During the visit, Moorhouse received the promise of a new building to be built as part of the Umatilla Agency's Indian boarding school. The delegation had some time for sightseeing and visited the Bureau of Printing and Engraving to see how money was made. They met with a group of about thirty Sioux and also had their pictures taken at the Bureau of American Ethnology (FIG. 3). As Moorhouse recalled, "The chiefs disproved the idea generally entertained that the Indian loves to be conspicuous by their disinclination to don their war-suits which they carried with them. I finally prevailed upon them to do so, however, and we visited the Bureau of Ethnology, where the photographs of the chiefs in battle array were taken by the government photographer."[12]

Senators Dolph and Mitchell and Congressman Hermann visited with the party, and the Indians inquired about reparations remaining due them as the result of property loss suffered during the 1878 Bannock-Paiute War. No provisions for damages to Indian property had previously been considered, and Senator Mitchell promised to introduce legislation providing for the losses.

The trip to Washington was not mentioned in Moorhouse's published 1890 review of the Umatilla Reservation. That report was brief, and the hyperbole present in the previous year's accounting was less evident. A report filed at virtually the same time by the U.S. Indian inspector, Benjamin H. Miller, does provide some insight into the agent's character: "He seems to be a gentle man of good character & fair education. As far as my observation extended his habits are good, except that he is an intimate chum of tobacco. His qualifications for the position good, a lack of firmness & decision, possibly lacking."[13]

Miller also reported disturbing behavior among the Indians. Next to a note—"Agent's attention called to this"—the inspector wrote: "From all could hear and see, imagine that these Indians spend a good deal of their time in horse racing, with a good deal of gambling and betting in connection with it and there seems to be no special effort made to discourage it, by the Agent or other employes."[14] He continued with a report that the main features of

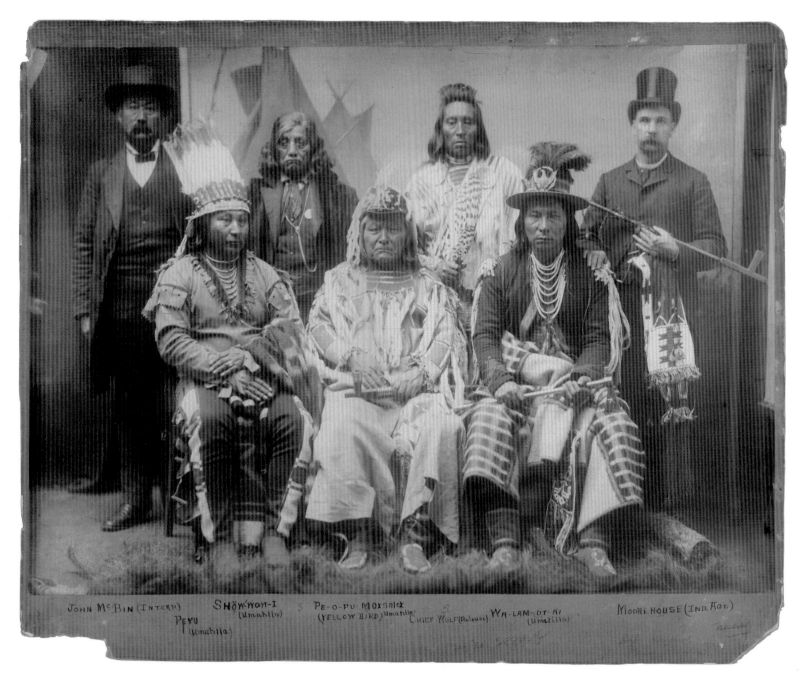

FIGURE 3
Charles Milton Bell, *Umatilla Delegation, Washington, D.C.,* December 1889. Front row, left to right: Peo (Umatilla), Homli (Walla Walla), Young Chief (Cayuse); back row, left to right: John McBean, Showaway (Cayuse), Wolf Necklace (Palouse), Lee Moorhouse. National Anthropological Archives, Smithsonian Institution, 01607700.

Pendleton's Fourth of July celebration were a parade including several hundred Indians all dressed "in good old Indian style" and an accompanying war dance. Inspector Miller urged that the event be discontinued, because he believed that the Indian young people in attendance would emulate these "barbarous practices."[15]

Several years before Lee Moorhouse's appointment to the Umatilla Agency, the Slater Act had become law. Written specifically for the Umatilla Reservation, the Slater Act provided that 160 acres of land be allotted to each Indian head of household, with smaller amounts provided for single persons and orphans. After continuous occupancy of twenty-five years, the allottee was to be awarded a land title in fee simple. The Confederated Tribes of the Umatilla Reservation accepted the provisions of the Slater Act in October 1886, after a series of councils on the subject.

Prior to the assigning of allotments, reservation land deemed to be surplus was to be sold. Funds from the auction of this acreage were to be held in trust for the Indian population. Preparatory to the land sales, the Umatilla Reservation was diminished in size from 245,699 acres to 157,982 acres. This took place in December 1888, under order of the secretary of the interior. Surveying errors delayed the commencement of land sales and allotments for three more years.

The Umatilla Reservation surplus land auctions began on April 1, 1891. On the opening morning of the sale an excursion train carried eighty-two prospective buyers to the agency. Although the sale was a much-anticipated event, local interest in it quickly slackened. Attendance was generally low, and on some days no land was sold. On occasions when prime farmland was on the block, however, the activity became spirited. When property near McKay Creek was being offered, one E. J. Horton hired a man to bid for him while he and a compatriot distracted the crowd with a mock gunfight. At an opportune moment, Horton diverted the crowd's attention, leaving his deputy to buy the desired land at a price only slightly above its appraised value.[16] A would-be Walla Walla purchaser returning from the same week of sales told his local newspaper that he had "never experienced in his long career a more rascally, open and shut game than is carried on by the Pendleton land agent sharks."[17]

When the land auctions ended on April 30, 1891, about 25,000 acres had been sold. This acreage brought a sum of approximately $210,000. In his annual report, Moorhouse estimated that 70,000 acres of land remained unsold, although the actual amount was closer to 62,000 acres. Much of the unsold acreage was in timber or rangeland.

Two weeks after the land sale concluded, two special allotting agents held a council with the Indian population. This meeting was called to settle the

question of which allotment legislation would be applied to the parceling of the reservation. The General Allotment Act of February 8, 1887 (also known as the Dawes Act), had become federal law before allotments had commenced under the provisions of the Slater Act. Although similar to the Slater Act, the Dawes Act included a stipulation that Indians become United States citizens. Moorhouse reported that this provision complicated the allotment process. The chiefs, he wrote "have been resorting to every device they can conceive to delay the work, but the reason for this is found in the fact that as soon as the Indians are allotted they become citizens, their tribal customs and usages will become a memory of the past, and the authority of the chief, who now attempts to dictate to and direct his people without consulting their wishes, will be broken"[18]

The reservation populace chose to accept allotments under the Slater Act. Allotments began in the summer of 1891 and were completed in late 1892. They were approved by the secretary of the interior the following spring.

Another item of concern during Moorhouse's tenure as agent was the matter of Indian education. As agent, he had the ultimate authority in school matters, although he was not to direct school employees except through the superintendent. Among the agent's assigned duties was the responsibility for keeping the school filled with students.

During fiscal year 1889, the agency school saw an average attendance of fifty pupils, who attended class in a structure that was notably inadequate. In November 1889 the building was abandoned and the school moved to Pendleton. The contract for the facilities promised to Moorhouse during his December 1889 visit to Washington (one brick and one frame structure) was let in May 1890, and the buildings were occupied the following November. The two new buildings were expected to accommodate 150 students, although the number was later revised to 75. One structure initially housed the boys' dormitory and classrooms, and the other was given over to kitchen, dining room, laundry, girls' dormitory, and staff quarters. Looking ahead to the completion of the new school, Moorhouse stated his intention to make education compulsory and fill the school to its capacity.[19] Despite his goals, enrollment remained at an annual average of about fifty students throughout his tenure as agent.

These were the first buildings built at a new school location, one mile east

of the existing agency. In the spring of 1891 a garden was planted there, as was an orchard containing 185 pear, apple, peach, and plum trees. An additional 40 ornamental trees were planted on the developing school grounds, the majority of which soon died. These were planted as part of an Arbor Day celebration that had been mandated by Commissioner Morgan.

The following year the school farm was composed of a 10-acre cultivated garden, 40 acres of wheat sown for hay, and 640 rented acres. The garden included potatoes, corn, pumpkins, squashes, and assorted vegetables. As part of their industrial training, older male students were charged with maintaining all of these agricultural enterprises. Their feminine counterparts learned to sew, cook, and clean clothing, dishes, and living quarters. According to national guidelines, one-half of each student's time was to be devoted to these pursuits.

In addition to overseeing the construction and development of the school's physical plant, Agent Moorhouse was present during proceedings that culminated in the firing of two of the school's staff. Industrial teacher Benjamin T. Davis was terminated for a variety of causes, among them the use of profane language, intoxication, general neglect of duty, and disobedience toward his superiors. Shortly thereafter, school superintendent J. R. Geddes was fired after it was determined that he had been physically brutalizing students. Geddes was replaced by George L. Deffenbaugh, who arrived on the grounds the day classes commenced in the new school buildings. Prior to his appointment as superintendent of the Umatilla boarding school, Deffenbaugh had served as treasurer of the Presbyterian Nez Perce mission.

After these concerns, much of the agent's remaining time was spent protecting Indian property. On numerous occasions he requested compensation from the Oregon Railway and Navigation Company for livestock killed by trains or property destroyed by fires caused by sparks from train stacks. Local non-Indian stockmen were repeatedly warned to remove their animals from the reservation, and entrepreneurs were likewise cautioned to keep their enterprises off Indian land. On occasion, permission was given to ranchers allowing them to drive livestock across the reservation. Permission was also granted to individuals to trade for Indian horses.

In November 1890 the Reverend Daniel Dorchester, U.S. superintendent of Indian schools, visited the Umatilla Reservation. Shortly thereafter he directed

a letter to John W. Noble, secretary of the interior, that contained the following comments:

> Inasmuch as you have requested me to report to you any matters pertaining to the morals of the Indian reservations, and inasmuch as Indian Agents are appointed by your Office, I beg leave to submit to your attention the following statement relating to Major Lee Morehouse, Indian Agent at the Umatilla Agency, Oregon. . . .
>
> Agent Morehouse had been much addicted to the use of liquors before he was appointed Agent. When he took this office, he was surrounded by persons of like habits who brought liquors to the Agency with his knowledge, and he participated in their use. It is understood that he has used liquor so freely that a powerful appetite has been developed. This has become a matter of common knowledge with the people of Pendleton, who freely speak of the matter. . . . Suffice it to say that when friends induced him to break off from the use of whiskey, he suffered so greatly as to resort to chloroform using it in great quantities. He has been found in his bed, where he has lain all day, stupefied, with a bottle of chloroform by his side.[20]

Having made these allegations, Dorchester recommended that Moorhouse be replaced by either Special Agent Litchfield, then resident at Spokane Falls, or by John W. Strange, who was serving as clerk at the Umatilla Agency.[21]

Dorchester's letter was forwarded to Senator Dolph in early December. Dolph, Senator Mitchell, and Binger Hermann responded to the secretary by telegram, saying, "In view of the fact that we have known Mr. Morehouse Agent Umatilla personally many years and never known or heard of him being in any respect addicted to drink and are therefore amazed at the charges made. Will you not give us time to investigate and also to advise Morehouse and obtain his response. It can all be done inside a month."[22]

Moorhouse's reply to the allegations, dated December 17, 1890, and sent to Congressman Hermann, expressed his great surprise and suggested that while in Pendleton, Dorchester might have had contact with C. O. French, the city marshal. French had recently been overwhelmingly defeated in a reelection bid and had vowed eternal vengeance when he did not gain Moorhouse's endorsement for the post. The embattled agent denied ever having been drunk in his life and claimed that the use of chloroform had been prescribed by his physician.[23]

This response was accompanied by statements from a number of

THE LIFE AND LEGACY

prominent Umatilla County business leaders and civic officials, as well as letters from Moorhouse's family physician and the agency physician, William Cameron McKay. The family physician noted that he had previously warned Moorhouse about the injurious effects of chloroform and claimed that his patient had not used the drug since receiving the information.[24] McKay stated that he had known Moorhouse for many years, that he had seen him nearly every day since his appointment, and that he had never known him to be under the influence of liquor. Regarding the use of chloroform, McKay recounted that he had prescribed the drug for Moorhouse as an anesthetic for neuralgia.[25]

Testimonials were additionally offered by those involved in the agency allotments. Among these was a letter from two of the allotting agents noting that in their experience the agent had appeared temperate. They offered that "Mr. Moorhouse attends personally to the business of the Agency, [and] is in favor with the Indians, who are the parties most immediately interested."[26]

As the parties most interested, the Indians, too, offered a supporting petition. Under cover letters attesting that the document had been produced of the Indians' own volition and that the signatories fully understood its contents, the reservation leaders protested Moorhouse's possible removal and praised his performance, saying, in part:

> We all like Maj. Moorhouse and do not want him to go. We all have great confidence in him and like him because he treats us kindly and fairly. He does not try to lead us into ways we do not wish to go and does not try to compell our young men to go to this or that church but leaves us all to do as we please in this matter and to go to whatever church we want to, only he insists that we must always do what is right and be honest and to try to learn to do as do the white people and by doing so will please the Great Father
>
> When our helpless old squaws and old men were in want and suffering for clothing and food last winter he helped them by giving them food and clothing and had to do so at his own expense as we have been fully advised. When we have our little troubles and go to him to settle them he always treats us kindly and acts fairly and honestly with us. When we go to the Agency to see him and find he is at work he will always stop and listen to us and his door is open to us and we can go in and warm ourselves and so can our squaws and children and he does not act as though he did not like for us to be there or was tired of us.

We often find it is hard for us to control our young men as they like to drink the white man's fire-water, and to play cards, and to gamble, and to bet on horse-races, and to do many things that we know do not please the Great Father. They all like our Agent and are willing to do as he asks and to follow in his lead, and we fear that his removal will result in a feeling of insubordination. We find that we can get along with our young men and with the government better and have less trouble if we have a man for our Agent who is liked by our people.[27]

The petition also recounted that some months earlier, three Sioux men had come to the Umatilla Reservation with news of a coming messiah, telling a wonderful story and asking for young men to join them "in their weird dances." The reservation leaders reported that Moorhouse had counseled them to advise their people to refrain from participating in the "superstitious craze," as it would only bring them trouble. "So great was the confidence reposed in him that all went to the Sioux braves and asked them to leave for their distant home. They had not money to pay their fare home so we and the Agent made up the amount and soon we had them on their way, and were thus rid of what we deemed a very dangerous element. By this action our young men again showed their good feeling towards our Agent."[28]

Showaway, chief of the Cayuses, Homli, chief of the Walla Wallas, and Peo, chief of the Umatillas, all affixed marks to the paper, as did Young Chief, Paul Showaway, and five others.

Another who countered Dorchester's allegations was J. W. Strange, the man recommended as the agent's replacement. On December 17, Strange addressed a letter to the Oregon delegation. While noting that Moorhouse had been ill and had used chloroform on the advice of his physician, Strange affirmed that he had never observed the agent under the influence of drink or inattentive to the responsibilities of his office. He concluded his comments with a wish that he not be considered as a candidate to succeed Moorhouse.[29]

That same day, Strange wrote to Dorchester, stating his belief that Moorhouse was not a "common drunkard" and adding that Moorhouse's use of chloroform was as prescribed by the agency physician. The clerk then begged that, as a personal favor, the superintendent intercede with the secretary of interior for the withdrawal of the recommendation that the agent be removed.[30]

Senators Dolph and Mitchell forwarded the documents written in Moorhouse's defense to the secretary of interior on December 29, 1890, two and one-half weeks after requesting a month's time to investigate the situation. The legislators noted their belief that the papers appeared to fully and completely vindicate the agent, stating that "we cannot help but think Dr. Dorchester has been fearfully imposed upon."[31]

Citing "self-respect and the good of the service," Dorchester soon replied to the commissioner of Indian affairs. Casting aside the testimonies of the Pendleton citizens and noting that agency employees seldom wrote letters adverse to their agents, Dorchester offered a summary of his thoughts about the intemperate climate on the reservation and the corrupting influence of Pendleton. He ended with a dismissal of the comments of Moorhouse's Indian advocates: "I recognize the names of some of these liquor drinking Indians, in the papers sent in vindication of Major Morehouse."[32]

Dorchester denied that the spurned city marshal, C. O. French, had provided him much information about Moorhouse's behavior. Rather, the superintendent reported that Clerk Strange had been his main informant and that Strange had not only reviewed and approved a draft document describing Moorhouse's alleged offenses but had also sent Dorchester a note after that worthy had left the reservation. This message had arrived in Spokane Falls on November 28, 1890. It claimed that Moorhouse had gotten quite drunk on the day before Thanksgiving, topping off with twelve ounces of chloroform during the night. According to Dorchester, Strange had written: "*Something must be done at once. I cannot stay there with the present condition of affairs. I have done all I could. . . . Matters are worse than ever. I report you this condition, but you must not use my name in the matter. This must be strictly confidential.*"[33]

Dorchester claimed he had no reason to doubt that matters had become this severe, because he soon received two additional letters from Strange, both stating that the agent and conditions at the agency were much improved. Dorchester was now revealing to the commissioner of Indian affairs Strange's role in the matter because the superintendent felt the clerk had impugned his action and assisted with Moorhouse's rebuttal of the charges. Dorchester nonetheless claimed that other agency and school staff and various Pendletonians had helped him document Moorhouse's errant behavior. The only named individual among these witnesses was J. R. Geddes, the recently

fired superintendent of the Umatilla Indian school. The letter concluded: "With the foregoing statements, I am content to rest the case, respectfully submitting to the judgement of the Department, and close with the wish that the Umatilla Reservation may be placed in the hands of an Agent who will protect the Indians against the whiskey fiend."[34]

A month expired before Dorchester's response was forwarded to Senators Mitchell and Dolph. Dolph replied to the secretary of the interior with a note stating that Strange had apparently played a duplicitous role in the whole affair. He further speculated that Strange had perhaps misrepresented the conditions at the agency in order to gain a personal benefit.[35]

On March 24, 1891, the entire episode was reported in the *Portland Telegram* under the byline of a Pendleton correspondent. Three days later, the *East Oregonian* summarized the events and commented: "Agent Lee Moorhouse is not a drunkard. He doubtless takes a drink occasionally, but is not guilty of 'gross intoxication,' and is always able to attend to business." The writer also suggested that John Strange, who professed to be a friend of the agent's and who owed his appointment as clerk to the agent's recommendation, "has either mounted the high plane of morality occupied by those who lift their hands in holy terror when a fellow creature 'takes suthin' for the stomach's sake, or expects to reap some personal advantage."[36]

By that time, Strange had been discharged according to instructions received from the commissioner of Indian affairs. Colonel Robert S. Gardner had also arrived at the agency. Gardner was a U.S. Indian inspector, and although his presence was ostensibly part of a regular inspection tour, he admitted to a local reporter that he was also taking the opportunity to review the charges against Agent Moorhouse.[37]

Moorhouse reported the activity relevant to Strange and Gardner in a March 29 letter to Senator Mitchell.[38] To Dolph, writing on the same day, the agent mentioned that Gardner's departing interview led him to believe that an unfavorable report would not be filed. He further stated that he was ready and willing to resign, should the finding be adverse to his retention. Regarding Strange, Moorhouse recalled that the clerk had written an unsolicited letter countering the drunkenness charge and expressed surprise and grief at discovering that he "had been harboring a Judas in camp."[39]

Dolph forwarded Moorhouse's correspondence to the secretary of the

interior with his own cover letter on April 10. Noting that he had called several days previously at the Indian Department and found that Gardner's report had not yet arrived, Dolph related that Congressman Hermann had learned that the charges of drunkenness had been found to be untrue but that a change of administration at the Umatilla Agency had nonetheless been recommended.[40] This was indeed the case, as the secretary's office had the previous day sent a request asking the agent to resign.

Moorhouse offered his resignation on April 15, to take effect the following May 31. The Indian commissioner accepted it but eventually requested that Moorhouse be permitted to stay until his replacement could arrive at the agency. John W. Crawford, a former mayor of Salem, Oregon, who had served as clerk at the Grand Ronde Agency during the late 1860s, was appointed to the post on June 30, 1891. He assumed responsibility for the agency about six weeks later.

Despite having been unjustly victimized, Lee Moorhouse overcame the unflattering public scrutiny of his personal life and remained a visible, vital, and respected member of Pendleton society.

LEE MOORHOUSE, AMATEUR PHOTOGRAPHER

Lee Moorhouse began taking photographs in 1897 or 1898, when he was forty-seven or forty-eight and a businessman in Pendleton, his agency days behind him.[41] A decade earlier George Eastman had begun commercial production of the flexible film camera, and photography had become a popular American hobby. Serious amateurs opted not to use the flexible film but to continue working with dry gelatin plates, large cameras, and tripods. Moorhouse was an adherent of this technique, and photography allowed him to meld his multiple interests. He had long held an affection for the picturesque, and he lived in a richly historical landscape that was then being settled and becoming home to a diverse and burgeoning economy. Umatilla County and its environs provided the photographer with an inexhaustible supply of visual subjects. During a photographic career that lasted until about 1915, he produced almost nine thousand glass plate negatives.

The majority of Moorhouse's photographs record views of eastern Oregon ranch life and regional small-town scenes. Prominent among the agricultural

subjects are photos of horse-drawn and steam-powered farm machinery and regional irrigation projects.[42] Other commercial enterprises pictured include logging operations, the Columbia River salmon fishery, and a variety of small-town businesses. An extensive photographic record of railroad activity in the Columbia Basin is present, as are images showing diverse marine traffic, such as Snake and Columbia River steamboats, and views of the Portland and Astoria waterfronts.

Small-town activities appear in numerous photographs of city and county fairs, all manner of parades, and civic events and organizations. Images of ten different circuses are evident, including the 1899 Ringling Brothers Circus and the 1902 Buffalo Bill's Wild West Show. Moorhouse took pride in having photographed all of the military blockhouses in the Northwest, as well as military installations at The Dalles, Fort Walla Walla, Fort Spokane, Fort Vancouver, and elsewhere. His documentation of historic sites extended to the Little Bighorn battlefield, Whitman Mission at Waiilatpu, Memaloose Island in the Columbia River, the McLoughlin House in Oregon City, and various locations relevant to the Oregon Trail and the Northwest Indian wars.

Nearly seven hundred Moorhouse photos capture scenes of the Pendleton Round-Up.[43] The images record many of the star performers of the event's first decade. Male and female champions and also-rans are caught in action, as are nearly all of the noted saddle broncs of the period. Of particular interest are views of the Cowgirl's Bucking Contest, an event that was discontinued after 1929. Parade scenes and the Round-Up's Grand Review were also captured by Moorhouse's lens. These photographs were made using a five-by-seven-inch format camera. Many were reproduced as postcards and sold commercially.

The Moorhouse family's contribution to the Pendleton Round-Up was not limited to preserving an early pictorial record. Founded in 1910, the event has grown to become one of the nation's premier rodeos. Lee Moorhouse's son Mark, a Pendleton realtor and insurance salesman, was a Round-Up founder and its first exhibition manager. Prior to his untimely death in 1914, Mark Moorhouse also served as director of the Round-Up's competitive events.

THE INDIAN PHOTOGRAPHS
OF LEE MOORHOUSE

During much of his life, Lee Moorhouse defined himself as an authority on local Indian culture. His interactions with Indian people had begun early. An essay in the January 1916 issue of *Sunset* magazine reported that Moorhouse, as a young man, had been kidnapped by a "warrior chieftain" and held until rescued. The truth was less romantic. In the 1850s, Clarke County, Iowa, was still home to groups of Pawnee, Shawnee, Sioux, and Fox Indians. One day while his parents were otherwise occupied, young Moorhouse went wandering. A neighbor eventually came by the family home and reported that Lee had been seen a mile or so away, in the arms of a large Indian. A hastily formed search party found the boy ensconced in a nearby Indian village, unharmed and enjoying his surroundings.

Moorhouse's tenure as an Indian agent furthered people's acceptance of his persona as an Indian authority, and many published accounts recall that he served "many years" as agent. His first official review of the Umatilla Agency referred to his "thorough knowledge" of the residents of the Umatilla Reservation "and the lands they occupy."

Statements published later in his life suggest that Moorhouse's success in photographing Indians stemmed from his many years of good relations with them. In "Securing Indian Photographs," an essay in his *Souvenir Album of Noted Indian Photographs*, Moorhouse claimed: "Years of close friendship, association, and confidence are necessary to secure photographs from the Western Indian tribes. They are extremely superstitious and strangers may spend weeks before getting a picture worth developing. . . . It is well nigh impossible to secure consent to photograph an Indian unless the artist is vouched for by some one in the confidence of the Indian."[44]

Moorhouse also promoted the idea that his Indian subjects were often suspicious of cameras but that some were more amenable to having their images captured by a large-format camera than by a smaller film camera. "If an artist wants to find serious trouble, all he need do is to take a small kodak and go among the Indians in their camp, snapping promiscuously at tepees and Indians without permission. . . . They can grasp the possibility of something wonderful being confined in a large 'box,' but that an equally wonderful thing

could be inclosed in a pocket kodak is beyond their comprehension."[45]

Although none of his published comments reveals it, neither the "years of close friendship" nor the use of a large camera was a failsafe method. In a 1912 letter, Ezra Meeker asked Moorhouse for copies of several of his photos, including one "taken on the reservation showing the teepee—you may remember the squaw scolded you for taking it."[46]

On another occasion the photographer reported going to the camp of a Umatilla family with whom he was well acquainted. "I was very coldly received. On inquiry as to the unusual manner of receiving me, I was informed by the . . . mother that I had taken a picture of her little daughter some time before and that she had since died, and that my picture machine was 'Bad Medicine' and I could use it no more in her camp. Explanations and protestations of friendship were unavailing."[47]

Modern skeptics may be inclined to discard the photographer's descriptions of himself as a long-standing friend and confidant of his Indian neighbors. The claims might seem to be hyperbole in the service of self-promotion, but there was truth to them. Tribal members frequently entrusted him with gifts, money, and correspondence for delivery to others. Moorhouse, along with Roy Bishop of the Pendleton Woolen Mills, is credited with having initially enlisted the local Indian population's participation in the Pendleton Round-Up (FIG. 4). Too, Moorhouse made many of his Indian portraits at his own home, and he nearly always identified their subjects by name. The frequency with which Moorhouse photographed specific individuals and events suggests that he enjoyed a level of familiarity with his Indian neighbors.

Lee Moorhouse's Indian photos are his best-known images. Like many of his contemporaries, he accepted the stereotype of American Indians as an ancient race, noble and picturesque. In 1904 he wrote, "It is yet possible to secure the most perfect interpretation of the aboriginal Indian in his native environment in the far Northwest. . . . they use yet the most gaudy blankets, together with buckskin wearing apparel and ornaments elaborately beaded; live in the original tepee hidden away in the deep recesses of the forest on the bank of the stream . . . [and] pursue the migratory habits of yore."[48]

This romantic view of Indian life was complemented at the time by the belief that the Indian population was doomed to either extinction or assimilation. Moorhouse accepted both views. He considered himself an artist,

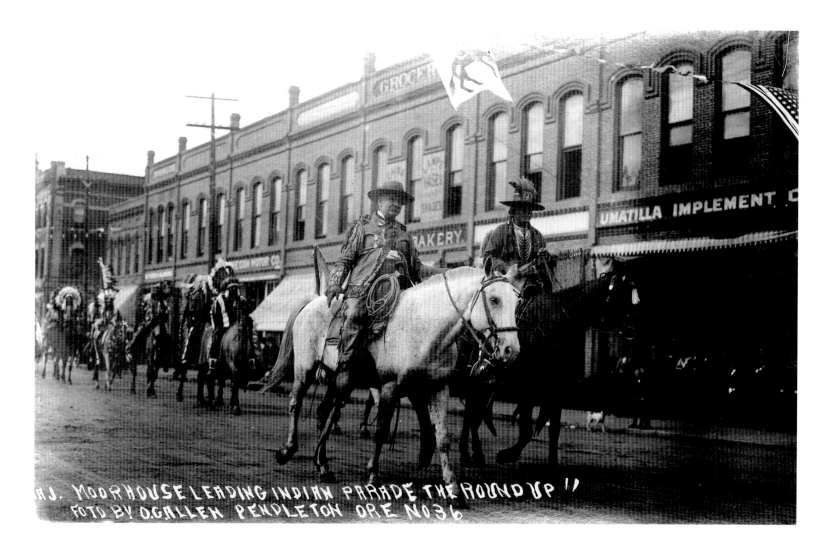

In the image (caption text): HJ. MOORHOUSE LEADING INDIAN PARADE THE ROUND UP "
FOTO BY O.GALLEN PENDLETON ORE NO 36

FIGURE 4

O. G. Allen, *Major Moorhouse Leading Indian Parade, the Round Up,* c. 1912. Charles W. Furlong Collection, PH244-0142, Special Collections and University Archives, University of Oregon, Eugene.

and his appreciation of art motivated him to compose picturesque subjects. His fondness for history prompted him to preserve a visual record of what he held to be a dying race. A contemporary critic noted: "The service which Major Moorhouse has rendered the historian is to preserve in pictorial faithfulness the wild and majestic attitudes of the best of the Pacific Indians as they lived and flourished in the halcyon days gone by."[49]

Moorhouse's photographic career got an early boost from two 1898 images entitled *The Cayuse Twins.* They became something of a signature work for him, and he reportedly sold 150,000 copies of them. The photographer reported that he had gained permission from the infants' mother to photograph them, but after he took the agreed-upon image, the girls commenced to cry. He then

FIGURE 5
Lee Moorhouse, *Cayuse Twins, Al-om-pum and Tox-e-lox, with Mother,* 1898. Lee Moorhouse Photograph Collection, PH036-5070, Special Collections and University Archives, University of Oregon, Eugene.

hurriedly placed a second plate in the camera and exposed it without the mother's knowledge. In truth, he may have made more than two images of these subjects on the same day, including one of the children with their mother (FIG. 5).[50]

The photos also circulated with a story that twins were believed to be a bad omen and that the images showed the first set of twins the Cayuse had ever allowed to live.[51] However, the missionary Narcissa Whitman had recorded visiting another pair of twins sixty years earlier. On March 14, 1838, she wrote to her parents from Waiilatpu that "husband, self and baby walked about a mile to see a pair of twins born in the night of the 10th. They were both boys and appeared very well. . . . Both . . . were laced to a board, as small as they were."[52]

Lee Moorhouse engaged in the noble savage theme in two publications that appeared during the first decade of the twentieth century. In 1901 he initiated a poetry contest for the residents of Umatilla County. He offered a photograph of an Indian tepee in the Umatilla River valley as the contest's literary subject matter, and a framed print of the image as a prize. Entries were to be published in the *Pendleton Tribune.* After six weeks, sixteen entries had been received, most of them recalling a romantic past or a dead or dying race.

Charles J. Ferguson, of Pendleton, was declared the winner in what was reportedly a close contest. Ferguson's entry was judged the best based on "mechanical construction, description and thoughts suggested by the subject. Several poems that might otherwise have been successful contained faulty meter and others wandered too far from the subject."[53] The winning poem read, in part:

> How lonely and forlorn it looks,
> Here on the darkened plain.
> Vacant; —aye, and cast aside—
> T'will ne'er be used again.
> Time was when hills and valleys
> Were dotted with its kind,
> But that is, —oh, so long ago—
> By few recalled to mind.
>
> T'is but the story of the race;
> Vanquished by too great odds.
> Its members now sleep soundly
> In the shadow land of God. . .[54]

FIGURE 6

Cover of *Souvenir Album of Noted Indian Photographs*, by Major Lee Moorhouse, 2nd ed.

When the winning poem appeared, the *Tribune* announced that it had received thirty-seven orders for a booklet containing all of the contest entries plus several of Moorhouse's Indian photographs. The small volume contained sixteen poems and four images, among them *A Lone Tepee* (the image that had inspired the poetry contest) and *The Cayuse Twins.* It was published on May 1, 1901, with the title *An Indian Tepee.*

Four years later, the photographer's *Souvenir Album of Noted Indian Photographs* appeared (FIG. 6), utilizing the same format as that of the earlier poetry booklet. The new work featured poetry by Bert Huffman and essays by Fred Lockley and was illustrated with photo portraits of a variety of Indians, some of them representing fictional personages, such as *Princess We-a-lote, Cayuse Maiden,* for whom the model was Anna Kash Kash.[55] The book was

produced in two editions, in 1905 and 1906. The contents of the two editions were generally the same, but the photos and poems were placed in a different order in each. The first edition was published in a fairly small press run, but copies of the second were still available for purchase from the Moorhouse family as late as the 1930s.

In the 1906 edition of the publication, a new image of a lone tepee, entitled *The Lonely Outpost of a Dying Race,* was the initial illustration. Preceding it was an untitled poem that began:

> An Indian tepee in the wilderness,
> The lonely outpost of a dying race
> That once were strong and conquerors of men;
> Perhaps some sachem, faring westward ever,
> His tribe dispersed, his gaudy braves all gone,
> Hath reared his nomad home in this far place.
> Remote from striving men and the fierce world
> Here museth he upon the days that were
> Before an alien people drove him forth
> And all his tribe to wander and to die;
> Here museth he upon the days that were
> That moveth ever toward the western sea
> Like his own driven people—there to cease. . .[56]

Again, the poetry that graced the pages of the book celebrated the romantic life and approaching demise of the Indian race. "Wal-lu-lah" tells of a "dusky Indian princess" who laments an absent lover. In "The Indian's Reverie," the only son of a "war chieftain's daughter" dreams of the glory of his tribesmen but awakens to find them all vanished. The second stanza of "Lament of the Umatilla" proceeds:

> By the silvery river
> All your race has died
> Sleep and dream my baby,
> By its lisping tide!
> Comes no more the huntsman
> From the glorious chase—
> O'er yon templed mountains
> Swarms the paler face![57]

The *Souvenir Album* contains the largest collection of Lee Moorhouse images published during the twentieth century. It does not, however, contain the best of Moorhouse's Indian photos, as claimed in the advertising copy. Instead, it is

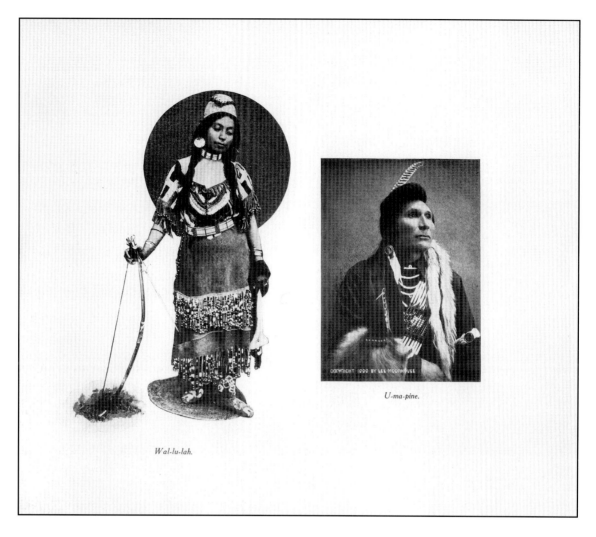

Wal-lu-lah.

U-ma-pine.

FIGURE 7
Lee Moorhouse, *Wal-lu-lah* and *U-ma-pine*, from his *Souvenir Album of Noted Indian Photographs*.

filled with the images that the photographer believed to be his most artistically successful, his most historically important, and his most marketable. In several interviews, Moorhouse referred to himself as an artist, and the photo selection for the *Souvenir Album* confirms that he thought of himself this way. A number of images now in the collection of the Umatilla County Historical Society demonstrate that he was exploring the artistic concerns being discussed in the popular photographic periodicals of the day. The compositional exercises and devices being tried by serious amateur photographers elsewhere in the United States informed many of his Indian portraits. This is evident not only in Moorhouse's use of light and shadow but also in his attempts to portray genre scenes and create tableaux inspired by the theater, poetry, and other literary sources. This last interest is evident in the overall construction of the *Souvenir*

Album and overtly realized in *The Indian's Reverie, Wal-lu-lah, The Song of the Bow,* and other images that expressly illustrate their preceding texts (FIG. 7).

For historical and commercial appeal, one *Souvenir Album* photograph showed an aged Cayuse woman who recalled having seen Lewis and Clark. This was complemented by a Bert Huffman poem entitled "Sacajawea" and Moorhouse's corresponding photographic rendition of *Sac-a-ja-wea, Lewis and Clark's Shoshone Indian Guide.* People who had figured prominently in the Indian wars of previous decades were featured as well. Chief Joseph had been a celebrity since the 1877 Nez Perce retreat. Umapine was a celebrated figure of the 1878 Bannock-Paiute War. Dr. Whirlwind was a hero of the 1879 Sheepeater campaign. Also included were photographs of the Umatilla chief, Peo, and images of three Cayuse leaders: their hereditary chief, headman, and head war chief. With these photos Moorhouse recalled one hundred years of Indian-white relations and offered proof to his readers that those who had invoked terror and dread in the not-too-distant past were no longer a cause for concern. "Where Peo ruled the council of his braves the school house of the paleface stands. Where the beaver built his dam now gleams the pumpkin among the shocked corn. . . . The red apples are gleaming redly from their carpet of orchard grass. . . . Plenty and prosperity reign in old Umatilla."[58]

Many of the *Souvenir Album* images were created in Moorhouse's backyard studio. The sitters were stiffly posed and often adorned with supplied clothing and accessories. The photographer frequently used these compositional formulas, but they could also provide sensitive and very human likenesses. Away from home, he created an expansive and important record of the residents of the Umatilla Reservation during a time of dramatic cultural change. His repeated visits to reservation families and camps and his annual attendance at Fourth of July celebrations and the Pendleton Round-Up produced an important and relatively unadulterated period record of the people of the Umatilla Reservation and their still-vital horse culture.

Moorhouse's one hundred photographs of the Umatilla Indian boarding school record a significant facet of reservation life that other photographers frequently overlooked. He also recorded scenes at Indian schools on Oregon's Warm Springs Reservation, on Washington's Colville Reservation, and elsewhere. He additionally visited and briefly photographed on the Nez Perce, Flathead, and Crow Reservations.

Most of the photos of Yakama Indians that bear the Moorhouse signature were actually the work of Thomas H. Rutter. Rutter began his photographic career around 1867 and operated photo studios in Butte, Montana, and adjacent towns during the 1870s and 1880s. He was active in Tacoma, Washington, during the 1890s and then moved to North Yakima (present-day Yakima), Washington, where he worked until retiring around 1906. Moorhouse secured a portion of Rutter's negatives after that time and, in the absence of copyright laws and in keeping with period practices, sold them as his own.[59]

The Rutter photographs provide a context for analyzing Moorhouse's own work. Rutter, Pendleton's Walter Scot Bowman, and numerous other regional photographic professionals are now generally known through finished "cabinet cards"—photographic prints and identifying studio imprints affixed to a cardboard rectangle. They operated studios in which they created portraits of diverse paying customers. They employed painted backdrops and a limited number of props, and they generally had excellent technical skills. Their studios were stationary, but most also recorded public events that could provide them with saleable images.

The sale of postcards and prints netted Lee Moorhouse a fair amount of income. If the sales figure for his *Cayuse Twins* images is correct as stated—150,000 copies—the photographer began receiving modest compensation for his work shortly after beginning his camera work. By 1900, Pendleton Woolen Mills were using Moorhouse images to promote their Indian blankets. A 1902 brochure refers to the company as "The Indian Robe and Picture Company." It includes reproductions of eight Moorhouse photos and offers for sale platinum prints from a list of fifty-four of his Indian images. Moorhouse imagery was prominently featured in Pendleton Woolen Mills' advertising through at least 1914, and it is still in use today. The photographer's work also promoted early editions of the Pendleton Round Up, and he profited from the sale of many photo postcards showing the rodeo's events.

Despite these commercial successes, however, Moorhouse was essentially an amateur. Throughout his career, his studio was in his home, he made use of numerous props, and, unfortunately, his technical ability was often less than expert. He held a day job and took photographs during his leisure time. He did not receive paying clients, but instead made images based upon his own ideas of what might be aesthetically challenging, historical valuable, and potentially

marketable. The control he maintained over his subject matter gave him the freedom to record many scenes that were not duplicated by professional photographers and this is what makes much of his work so important today.

Moorhouse's manner of working also differed from that of his professional contemporary Edward S. Curtis. Both men sought to compose artistic images, though Curtis's level of sophistication and technique was arguably superior. Both men had a romantic vision that led them frequently to manipulate the appearance of their subjects. Curtis, however, did not restrict his lens to recording the American Indian peoples of a specific region. He sought instead to create a pictorial and ethnographic record of individuals and groups from throughout the North American continent. His was a grand project that involved a huge cast of players, was sold incrementally by subscription, and was largely underwritten by wealthy benefactors.

THE MOORHOUSE CURIO COLLECTION

Some years before he took up his photographic hobby, Lee Moorhouse began collecting Indian artifacts. Although his primary interest was in material from the Columbia River region, he also collected items from the Great Plains, the Northwest Coast, and California. Representatives of prominent eastern institutions such as the University of Pennsylvania Museum of Anthropology and the Field Museum of Natural History purchased items from him while engaged in regional collecting expeditions. Moorhouse also had commercial dealings with important curio dealers such as Pasadena's Grace Nicholson.

The Moorhouse Indian curio collection was something of an institution in northeastern Oregon, and Moorhouse devoted three pages in the second edition of the *Souvenir Album* to a description of it. Written and visual records show that the collection contained several men's shirts, at least three dresses, some headdresses, "grass caps and baskets and an especially fine collection of baby boards." Its miscellaneous accessories included a cavalry sword from the Custer battlefield, obtained from E. S. Godfrey. The pictorial record suggests that the scope of the collection remained relatively static during the first decade of the twentieth century. Photos also reveal that for unknown reasons, Moorhouse preferred to use some curios as photographic props while he excluded others from such use.

The photographer's favorite studio space was in the east side yard of his

home at 400 Water Street in Pendleton. There he often erected a fabric-covered frame backdrop opposite the back door of the house. This arrangement provided adequate lighting, an easy camera setup, and quick access to his curio collection and darkroom. Moorhouse made numerous Indian portraits and compositional studies in this location. When he worked away from home, he seldom used the backdrop assembly and items of costume that are so prevalent in photographs taken in his side yard.

A Nez Perce man's shirt is prominent among the larger collection items that appear on photo subjects. It was eventually acquired from Moorhouse by Frank M. Covert, who sold it to the collector George Heye in 1907. It found a home at Heye's Museum of the American Indian in New York City and is now part of the collection of the National Museum of the American Indian.[60]

Three dresses from the curio collection appeared frequently on Moorhouse's Indian subjects. One was described in the *Souvenir Album* as a "wedding robe of black velvet, trimmed with pink satin and beautifully beaded in fantastic figures and designs." Moorhouse noted that "while the colors and figures are striking, it would scarcely be selected by a modern bride as part of her trousseau."

A second dress was a favored studio prop. It can be seen in numerous photographs and on a variety of models. The photographer gave it some prominence in his published description of his curios: "Another article of peculiar interest is the dress of an old Indian woman, a most elaborate garment, ornamented with beads sold by the Hudson Bay trappers on the Pacific Coast 75 years ago. . . . It required months to make this buckskin suit, because of its tedious bead work and intricate parts, and since it represents the better workmanship of the Indians of the Umatilla reservation almost a century ago, it has intrinsic value."[61]

Lee Moorhouse's Indian collection also figured in his dealings with his more famous contemporary, Edward S. Curtis. The men met for the first time in June 1905, when Moorhouse attended the dedication of a memorial to Young Chief Joseph in Nespelem, Washington, nearly a year after the Nez Perce leader's death. The Washington University State Historical Society, under the leadership of University of Washington history professor Edmond S. Meany, directed the arrangements for both the monument and its unveiling ceremony. Moorhouse and Meany had corresponded previously regarding illustrations

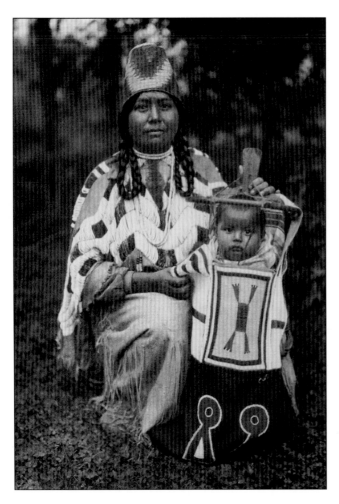

for a historical text Meany was writing, and Meany had adapted a Moorhouse image into a bas-relief portrait on the memorial marker. Moorhouse and Joseph had first met in 1890. The stone likeness came from an original photograph Moorhouse made about a decade later, when Joseph made an extended visit to the Umatilla Reservation.

The unveiling was also attended by the photographers Edward H. Latham and Edward S. Curtis. The pictorial record reveals that Moorhouse stood opposite the speaker's platform, with Latham working on his right and Curtis on his left. Several Moorhouse photographs of the event capture Edward S. Curtis in the midst of reloading his camera.

The 1905 meeting of E. S. Curtis and Lee Moorhouse preceded by several years Curtis's visit to the Umatilla, Walla Walla, and Cayuse tribes for the purpose of fieldwork and photography related to his *The North American Indian* volumes. Much has been written about Curtis's photographic methods and the fact that he directed his subject's poses and placed them in romanticized vignettes. Curtis apparently called on Lee Moorhouse during his visit to the Umatilla Reservation, and Moorhouse's storehouse of studio props provided Curtis with at least one clothing accessory for his photographic endeavor. Moorhouse's Umatilla dress of "intrinsic value" adorned the woman pictured in *Cayuse Mother and Child,* seen in volume 8 of Curtis's *The North American Indian* (FIG. 8).

After Moorhouse's death in 1926, the disposition of his curio collection became a subject of local discussion. A January 1927 article in the *East Oregonian* announced that Pendleton resident John Vert had secured an option to purchase the curios.[62] Vert planned to combine the Moorhouse collection with other local collections and offered the city of Pendleton a minimum of $5,000 toward the construction of an appropriate building to house the material. He eventually purchased about seventy-five ethnographic objects and other items from the Moorhouse family, which represented the bulk of the curio collection still in their possession. A civic center with an auditorium, meeting rooms, and a museum display area was eventually built adjacent to a local school. In recent years, the City of Pendleton has entered into stewardship agreements with local cultural institutions to ensure that the objects receive proper care.

THE MOORHOUSE PHOTOGRAPH COLLECTION

Lee Moorhouse's photograph collection languished for nearly two decades after his death. For much of that time it was stored in the basement of the Pendleton home of his daughter, Lessie Moorhouse Cornelison. Lessie fell heir to the images after being appointed trustee of her father's estate. In 1935 she sold three hundred negatives showing Indian subjects to the Bureau of American Ethnology (BAE); they are now in the collection of the National Anthropological Archives of the Smithsonian Institution. Work Projects Administration (WPA) employees selected the BAE images. In 1939, members of another WPA project catalogued historic records in private and public collections. They reported that Moorhouse's photos filled forty-five linear feet of shelving in Mrs. Cornelison's home and that the margins of some of the negatives had been ruined by rain leaking into a previous storage location.[63]

In 1948, the bulk of the photographs were given to the University of Oregon library. The January 2, 1949, edition of the *Portland Sunday Oregonian* reported: "The negatives were deeded to the university by the heirs to Major Moorhouse's collection, which is considered . . . to be the largest private collection in the state and one of the three largest assortments of Indian photographs in the nation."[64]

In addition to the more than 6,800 negatives deeded to the University of Oregon, the Moorhouse family gave approximately 1,450 negatives to the Umatilla County Library after 1950. These were transferred to the Umatilla County Historical Society in 1987, when Umatilla County turned management of the Pendleton library over to the city. These images represent the photographer's compositional studies and include a number of untitled portraits, many of which show models in theatrical or frontier clothing. When initially presented to the Umatilla County Library, this group of photos was purported to represent Pendleton's local population. Unfortunately, few of the images are labeled or dated. A January 1966 fire in what was the Moorhouse family home apparently destroyed much of the surviving manuscript material that related to the photographer's career.

The scope of the Moorhouse photo collection is remarkable, especially considering that the images were the work of an amateur photographer.

Although his photographic technique included the exclusive use of glass plate negatives rather than the more easily manipulated and stored film negatives, he produced what amounted to more than an image a day for almost twenty years. The diversity of his subject matter provides a rich historic record that can be appreciated by even the most casual observer.

The Moorhouse photographs are, at the time I write, being used in a variety of ongoing oral history projects on the Umatilla Reservation. The ventures are being pursued under the auspices of the Tamástslikt Cultural Institute and various other tribal entities. While the Moorhouse photos are valuable in providing mainstream historians and the general public with a far-reaching visual history of the southern Columbia Basin, their greatest worth is realized on a more personal level, in providing images of individuals. In recent years, many residents of the Umatilla Reservation have discovered that Lee Moorhouse captured the likenesses of their ancestors and that the photographer's care in noting whom he photographed preserved for them irreplaceable images of their families and forebears.

In a 1913 interview, Lee Moorhouse said, "I have certainly taken great pleasure and some profit out of my photography and I believe the work of preserving in photographic form the historic sites and the well known Indians will be valuable to future generations."[65] It can only be hoped that this historic record will receive the recognition it deserves and that its value will be more fully appreciated through increased study and use.

PLATES

Unless indicated otherwise, the following photographs are by Lee Moorhouse and are from one of two collections: the Lee Moorhouse Photograph Collection, Special Collections and University Archives, University of Oregon, Eugene (abbreviated UO), and the National Anthropological Archives, Smithsonian Institution, Washington, D.C. (abbreviated NAA).

Lee Moorhouse Collection of Indian Costumes and Artifacts, c. 1900. UO PH036-6218

PLATE 1

Lee Moorhouse Collection of Indian Costumes and Artifacts, c. 1900.
UO PH036-6230.

In addition to his photographic activities, Lee Moorhouse collected and traded American Indian artifacts. He most actively bought and sold items during the years around 1900. These photographs show portions of his collection as it appeared at that time. At least four of the baskets visible on his back porch (opposite page) are now in the collection of the Burke Museum of Natural History and Culture at the University of Washington in Seattle. In the second view, additional baskets are on display in an interior room of his home.

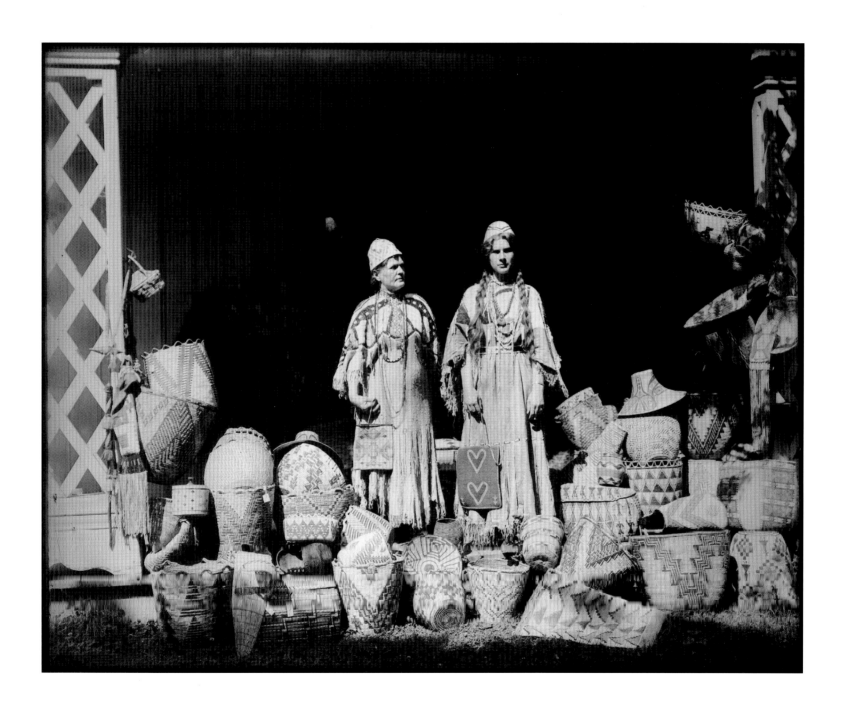

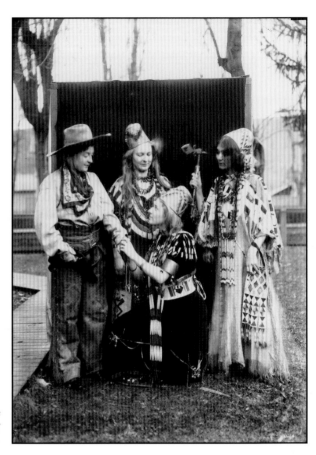

Untitled, c. 1898. Lee Moorhouse
Collection, M40, Umatilla County
Historical Society, Pendleton, Oregon.

PLATE 2

Lee Moorhouse Collection of Indian Costumes and Artifacts, c. 1905.
UO PH036-6225.

Moorhouse occasionally assembled his curio collection as a commercial display. He presented portions of it in diverse venues, winning awards at the Oregon State Fair, the Tri-State Fair in Spokane, and the Walla Walla Valley Fruit Fair. A twenty-five-cent admission fee was charged for entry to "Major Moorhouse's World Famous Indian Exhibit" at the 1913 Umatilla County Fair.

The photograph of the four women shows them all dressed in items from Moorhouse's assortment of studio props. The beaded dresses seen at center rear and on the right often appeared on his Indian subjects.

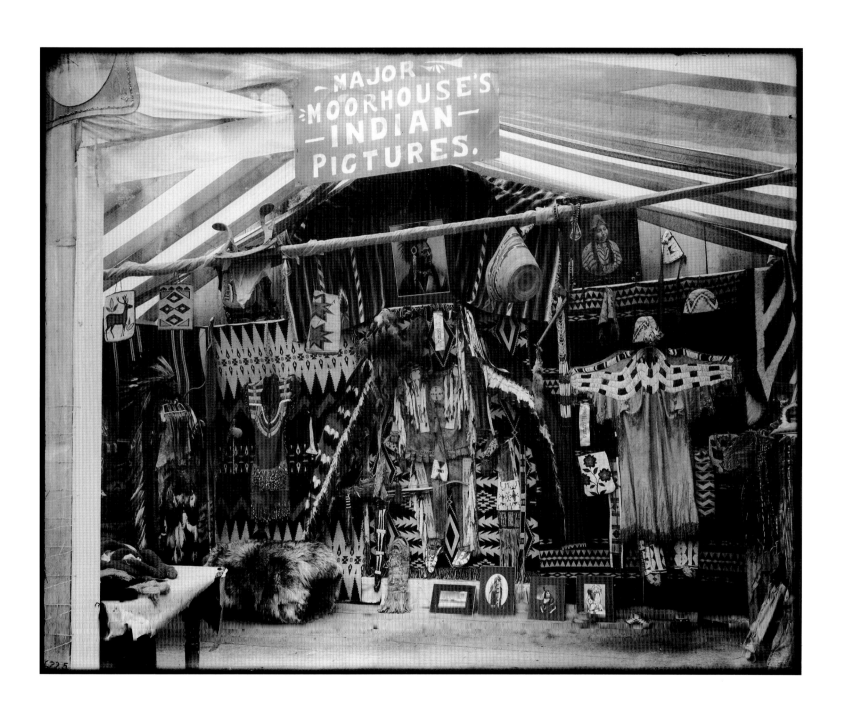

PLATE 3

Major Moorhouse's Indian Curios, Pendleton, Oregon, c. 1915
UO PH036-1439.

The photographer here poses with a late incarnation of his ethnographic and memorabilia collection. Moorhouse often wore the fringed jacket with military insignia in period portraits. It testified to his public persona of pioneer, Indian agent, and friend of the Indians. When he was mentioned in contemporary news accounts, these aspects of his personal history were frequently recalled in tandem with statements about the size and importance of his photograph and curio collections.

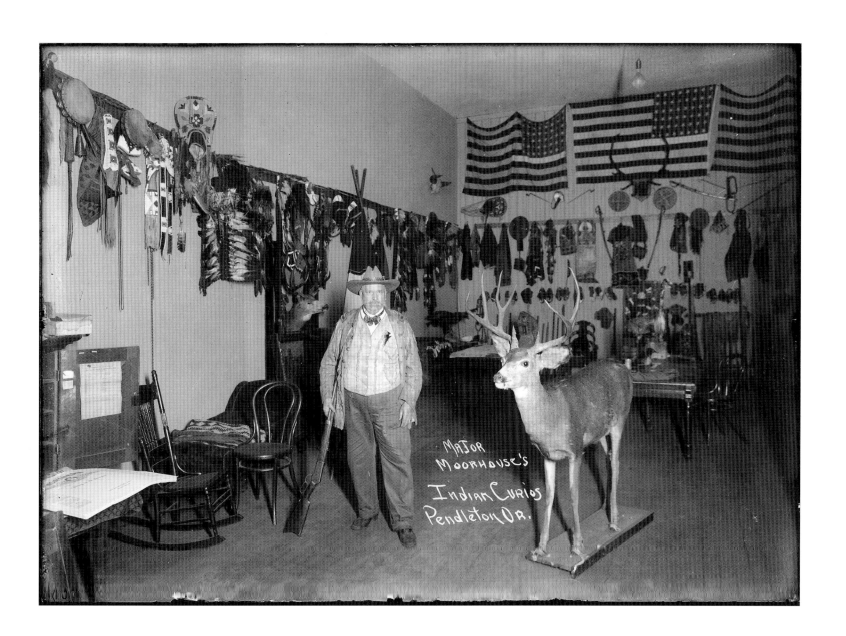

Major
Moorhouse's

Indian Curios
Pendleton Or.

PLATE 4

Dr. Whirlwind, Cayuse Tribe, c. 1905. UO PH036-4097.

Dr. Whirlwind was a favorite Moorhouse model. As a young man he had carried dispatches for Colonels Wright and Steptoe during the Indian uprisings of 1855–56. He also served as a scout during the Sheepeater campaign of 1879.

This image illustrates the standard format found in many of Moorhouse's studio portraits. The boardwalk at left passed along the east side of the Moorhouse home. Pendleton's Water Street is visible in the background. Whirlwind is wrapped in one of the photographer's blankets and wears a shirt from the Moorhouse curio collection. George Heye acquired the shirt in 1907, and it now belongs to the National Museum of the American Indian, Smithsonian Institution. The gun is in the collection of the Umatilla County Historical Society in Pendleton.

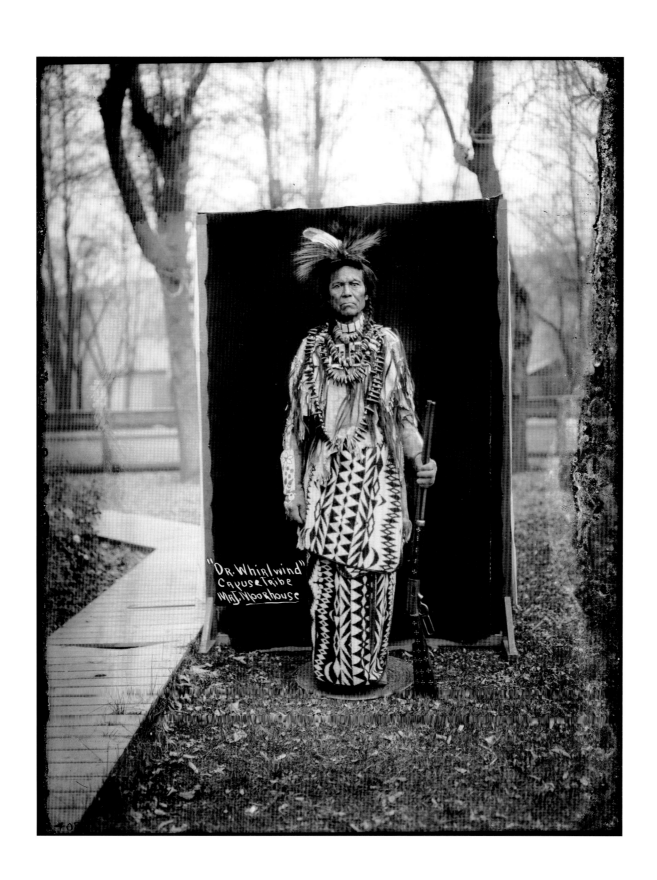

"Dr. Whirlwind"
Cayuse Tribe
Maj. Moorhouse

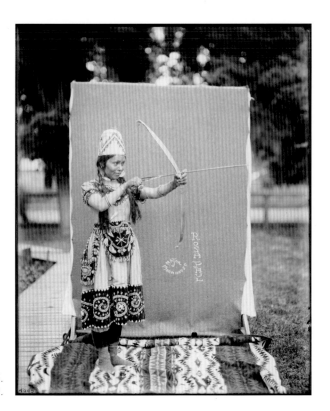

Rosa Paul, c. 1905.
UO PH036-4049.

PLATE 5

Ruth Coyote, Cayuse Tribe, c. 1905. UO PH036-4390.

Ruth Coyote is here posed in a beaded dress from around 1860–80 that the *Souvenir Album* claimed represented "the better workmanship of the Indians of the Umatilla reservation almost a century ago." Edward S. Curtis borrowed this dress when he was photographing on the Umatilla Reservation for *The North American Indian.*

Rosa Paul, of Walla Walla ancestry, was a frequent photo subject for Moorhouse. Her dress, from the Moorhouse curio collection, is described in the *Souvenir Album* as a "wedding robe of black velvet, trimmed with pink satin and beautifully beaded in fantastic figures and designs."

The woven hat worn by both women was a Moorhouse studio prop. It is among the Moorhouse collection items now owned by Pendleton's Vert Museum.

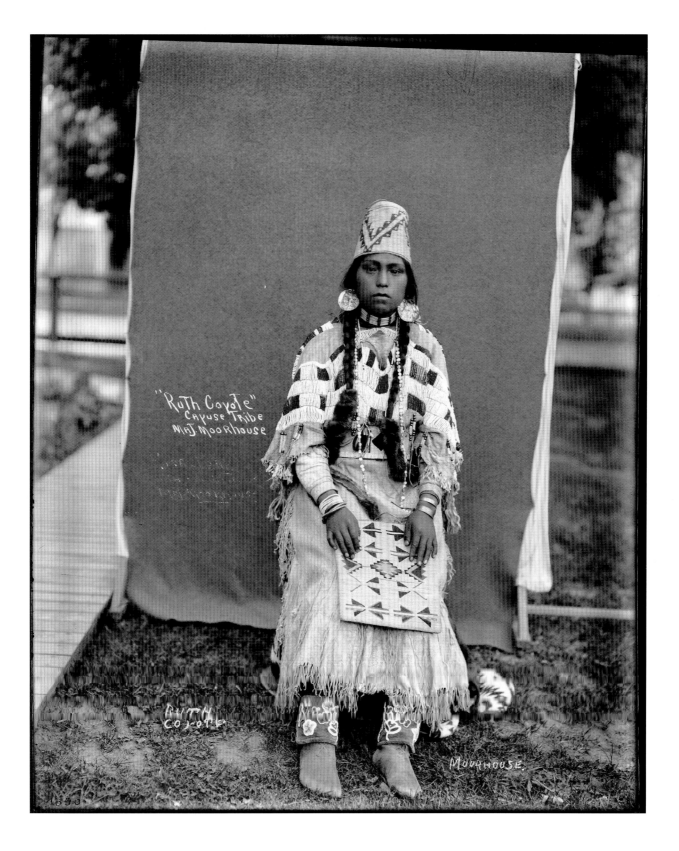

54

Plate 6

Holding Tomahawk that Dr. Whitman Was Murdered With,
c. 1898. UO PH036-6517.

This pipe tomahawk and the accompanying Wasco-style beaded bag purportedly belonged to Tomahas, one of five Cayuse men executed for their supposed role in the 1847 killings at the Waiilatpu mission station. In May 1850 Tomahas admitted that he had shot Marcus Whitman but claimed that his colleague Teloukaikt had been the one to strike the missionary with a hatchet.

An early photograph shows Tomahas with what appears to be this pipe tomahawk, but the beaded bag is not in evidence. An August 1864 newspaper article from The Dalles claimed that the tomahawk passed from Tomahas to his brother, who then gave it to one Stock Whitley. Whitley carried it "through the Indian war of 1855 and '56, and had it with him at the time he was killed by the Snake Indians" in May 1864. Whitley's family presented it to Donald McKay, who then gave it to a William Logan, who presented it to the Oregon Sanitary Fair. Sanitary fairs were held throughout the Union states to benefit military hospitals during the Civil War; they often included displays of Indian curiosities and exhibitions with live Indian performers.

The tomahawk then passed through unknown hands and was apparently acquired by Lee Moorhouse. The Oregon Pioneer Association later took possession of both it and the Wasco-style beaded bag and in 1899 donated them to the Oregon Historical Society. Both items were linked to "Tam-a-has, the Indian who killed Dr. Marcus Whitman in the Massacre of 1847" in Samuel C. Lancaster's 1915 *The Columbia: America's Great Highway through the Cascade Mountains to the Sea.*

This type of nineteenth-century Wasco-style bag has been attributed to Ellen Underwood and other members of the family of Welawa, a Cascade leader from the Hood River, Oregon, area. Underwood's nephew, Chewapanni Tomahus (Joe Thomas), could conceivably have owned the bag, and the tomahawk is decorated in a related design. Confusion produced by similarities between the Cayuse and Wasco names may have led to one or even both items having been assigned an incorrect provenance.

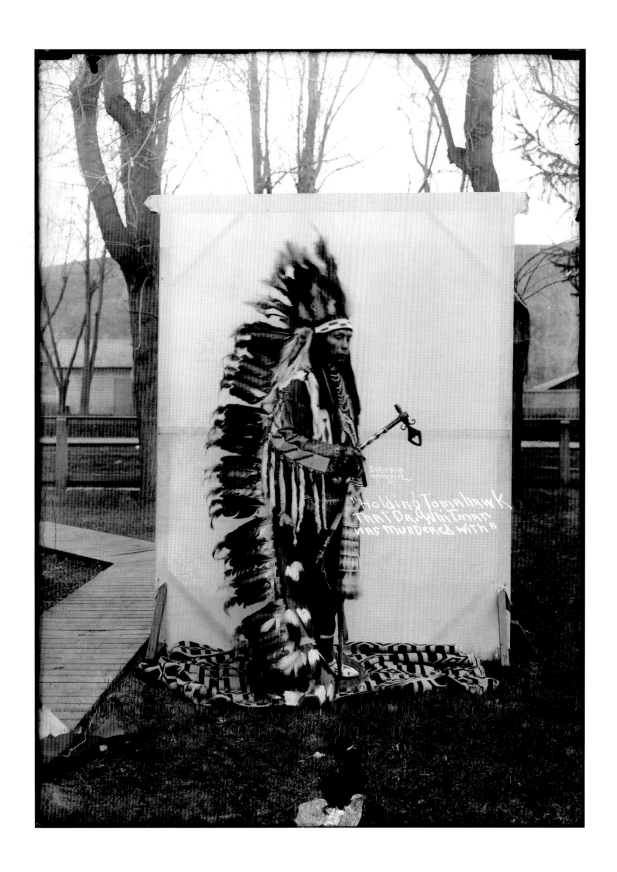

SHE-HAHA
MOONPUSE

"Holding Tomahawk
This Dr. Whitman
was murdered with"

PLATE 7

Anna Kash Kash, Cayuse Tribe, c. 1900. NAA 03073-B-18.

Anna Kash Kash often posed for Lee Moorhouse and was his model for the *Princess We-a-lote, Cayuse Maiden* and *Wal-lu-lah* compositions that appear in the *Souvenir Album.* She appears in this same dentalium-adorned dress in an 1899 portrait by Edward S. Curtis. Writing about her in *The Coast* magazine in 1908, Moorhouse reported, "This girl is well educated, a graduate from the Carlisle Indian school. She has taught in Carlisle and Oklahoma. She is now living with her parents on the Umatilla reservation."

Anna
Kash Kash —
Cayuse
Tribe

Major
Moorhouse

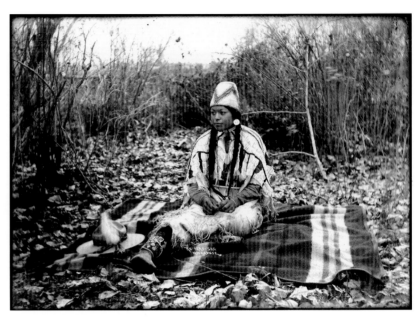

Ku-massag, Cayuse,
c. 1900. UO PH036-4250.

PLATE 8

Ku-massag, Cayuse, c. 1900. UO PH036-4247.

Ku-massag was also known as Agnes Davis. She was the subject of several Lee Moorhouse photographs and here appears in both studio and outdoor views. In a third photograph (UO PH036-4249) she is posed with her husband. The twined cap, beaded dress, leggings, and moccasins that she wears in the outdoor view are the same attire she wore when photographed contemporaneously by Moorhouse's friend and neighbor Walter Scot Bowman.

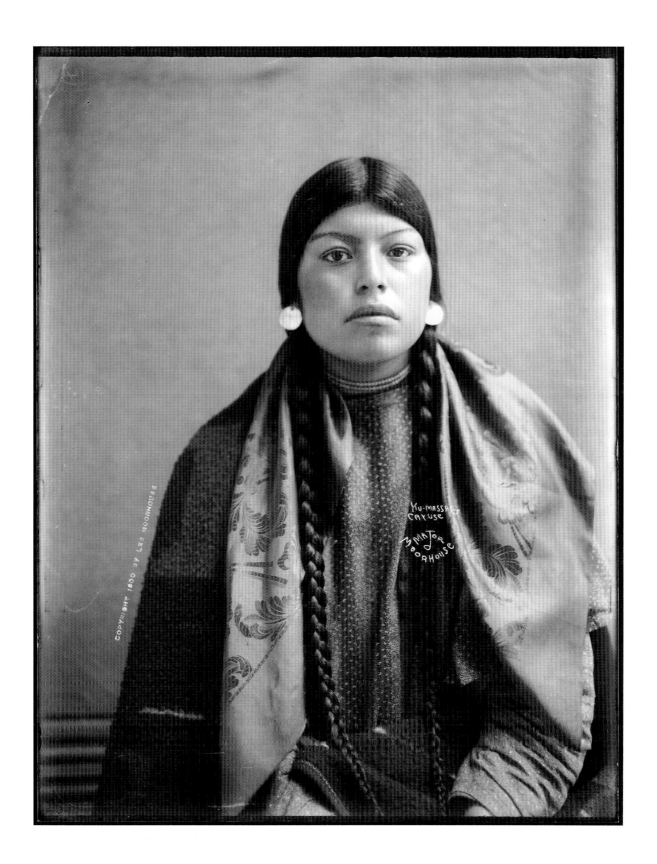

PLATE 9

Mrs. Ume Somkin, Cayuse Tribe, c. 1900. UO PH036-4595.

This and other photographs demonstrate that Moorhouse was able to take sensitive and eloquent portraits, particularly in the absence of his curio collection.

Cradles of the type held by Mrs. Ume Somkin generally displayed a solid field of beadwork in the broad upper section. By the beginning of the twentieth century, this beadwork was most often worked in floral designs or in the geometric Transmontane style. The decoration on this cradle was crafted from three pieces of a Transmontane-style beaded blanket strip. Blanket strips were originally used to cover the seam created when two halves of a tanned buffalo hide were joined to each other. In the Moorhouse photographs they may also be seen on smaller and lighter hides and on wool blankets. Although strips were frequently moved to new blankets, the recycling evident here is unusual.

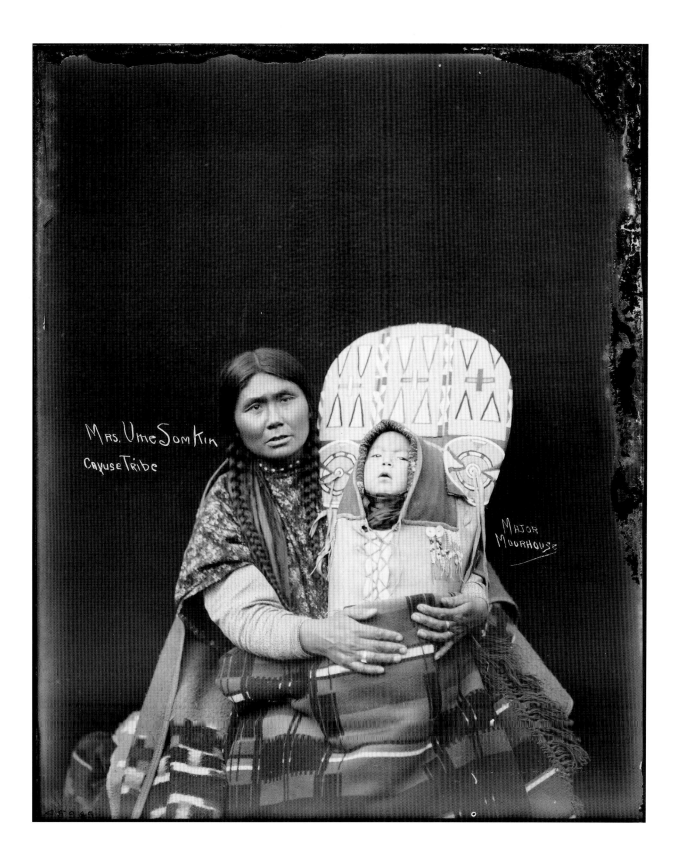

Mrs. UmeSomKin
Cayuse Tribe

Major
Moorhouse

Plate 10

Jennie Peo and Children, c. 1900. UO PH036-4081.

In his 1902 history of Umatilla County, William Parsons mentioned this woman:

> Another interesting personage is Jennie Peo, daughter of the Umatilla chief. Ten years ago she returned from the Indian training school at Chemawa [Salem, Oregon], as graceful and stylish a young lady as you would hope to meet anywhere. We saw her fresh from school, ride up to the agency, mounted on a magnificent horse, dressed in a tailor-made riding habit, with a tall silk hat, and dismount from an elegant modern side-saddle—a dream of grace and loveliness to-day she may be seen shopping in the "stores" of Pendleton, arrayed in regulation aboriginal dress, moccasins, blanket, and leggings, but her face still retains its spirituelle expression, and her demeanor is that of a refined and educated lady. She is the best interpreter on the reservation . . . and speaks [English] with a purity and softness which very few of her white sisters can equal.

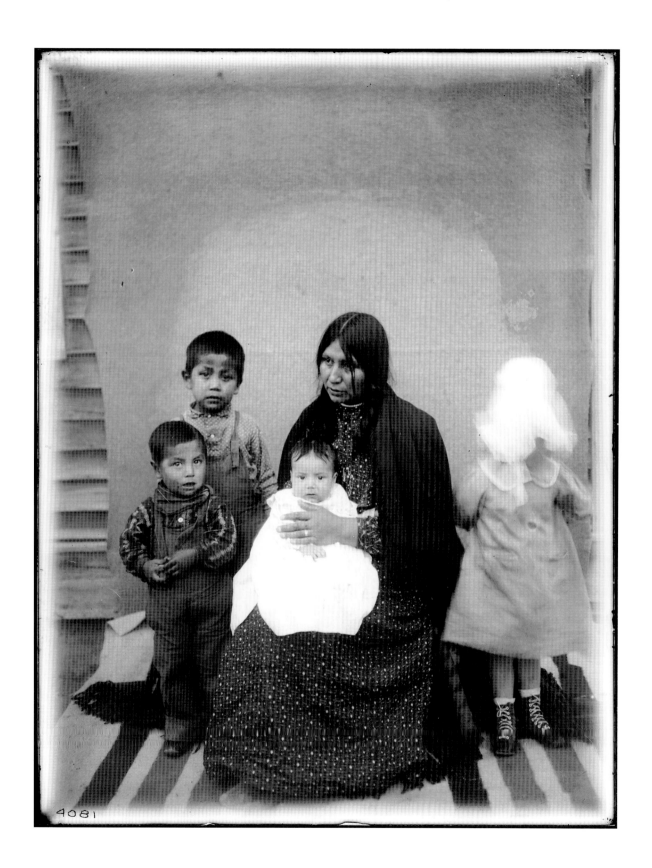

4081

PLATE 11

Red Elk, Walla Walla Tribe, c. 1905. UO PH036-4552.

After wool trade cloth and wool blankets were made available to the residents of the interior Pacific Northwest, they quickly became desired parts of the local wardrobe. Blanket coats became such common regional attire that the figure illustrating "Male Costume" in Charles Wilkes's published narrative of the U.S. Exploring Expedition's 1841 visit to the Columbia and Snake River regions shows a man dressed in one. The coat Red Elk wears here displays a striped pattern similar to the design that appeared on early Hudson's Bay Company trade blankets. The pinking and decoratively cut pattern visible on the cuffs of his sleeves is consistent with nineteenth-century fashion. Bandoliers and sashes made from otter and other fur were also common. As in this example, they were frequently adorned with mirrors.

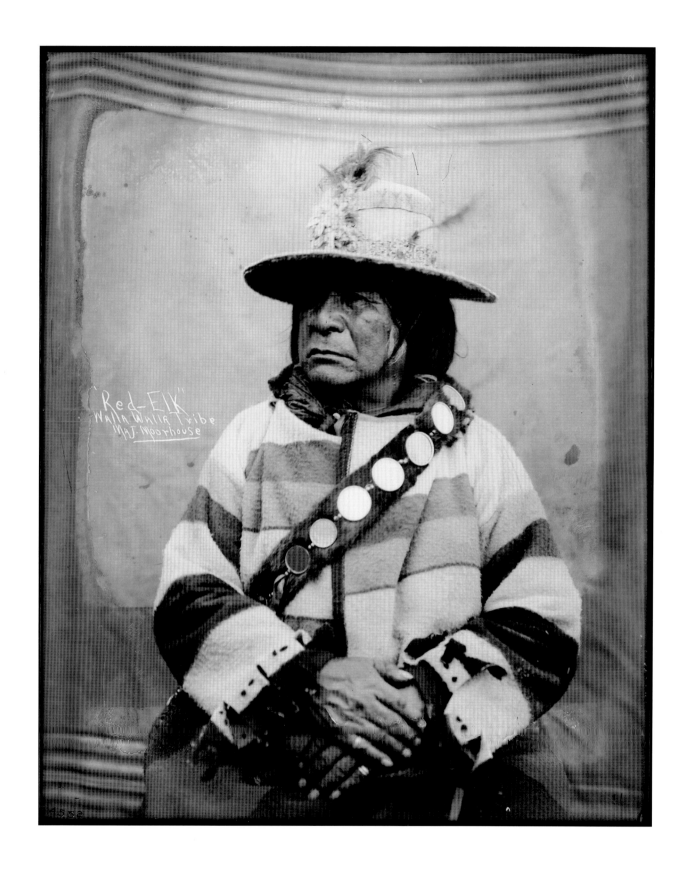

"Red-Elk"
Walla Walla Tribe
Maj. Moorhouse

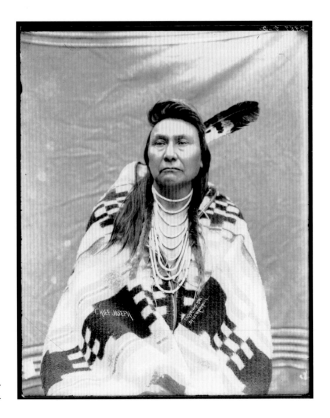

Chief Joseph, c. 1900.
NAA 02987-B-02.

PLATE 12
Chief Joseph, c. 1900. University of Washington Libraries,
Special Collections, NA605.

Lee Moorhouse first became acquainted with the younger Chief Joseph in 1890, when Joseph visited the Umatilla Reservation. Moorhouse photographed him on at least two occasions; these photos were taken at the Moorhouse home in Pendleton. Unlike the other images appearing in this text, the full-length portrait reproduces an original Lee Moorhouse print. A colorized version of the image appeared on the front cover of Pendleton Woolen Mills' 1902 brochure, *The Story of the Wild Indian's Overcoat.* It was also used on the back cover of the company's 1914 color catalog.

In 1905, the half-length portrait that is reproduced above was adapted to become the bas-relief portrait adorning Chief Joseph's memorial marker in Nespelem, Washington.

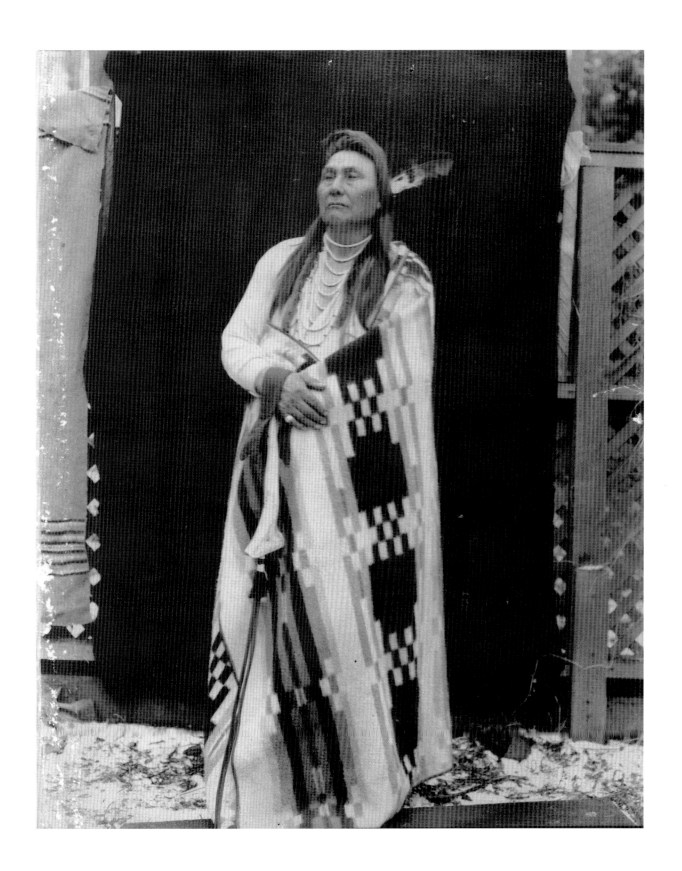

PLATE 13

Carl S. Wheeler, *Paul Showaway and White Bull,* c. 1900. NAA 03073-B-44.

The backdrop and carpet visible in this photo suggest that Lee Moorhouse did not make the image. It is instead from the Pendleton studio of Carl S. Wheeler. Moorhouse signed his name to this and other works that he acquired from regional photographers.

In his 1902 commentary on Umatilla County, William Parsons painted this picture of Paul Showaway:

> Paul Showeway, the Cayuse chief . . . [is] good-natured and bright; he cares nothing about Indian customs and dress; he wears what seems comfortable, regardless of the past. We saw him to-day, on the streets of Pendleton, wearing a cowboy hat, a buffalo coat, trimmed with beaver fur, modern pants, high-topped boots, and kid gloves, perhaps the most warmly dressed and comfortable looking man in Pendleton. He is an educated man, writes and speaks English well, and is one of the best citizens in Umatilla county. He has been east as a delegate of his people to Washington several times, and always was received with great respect.

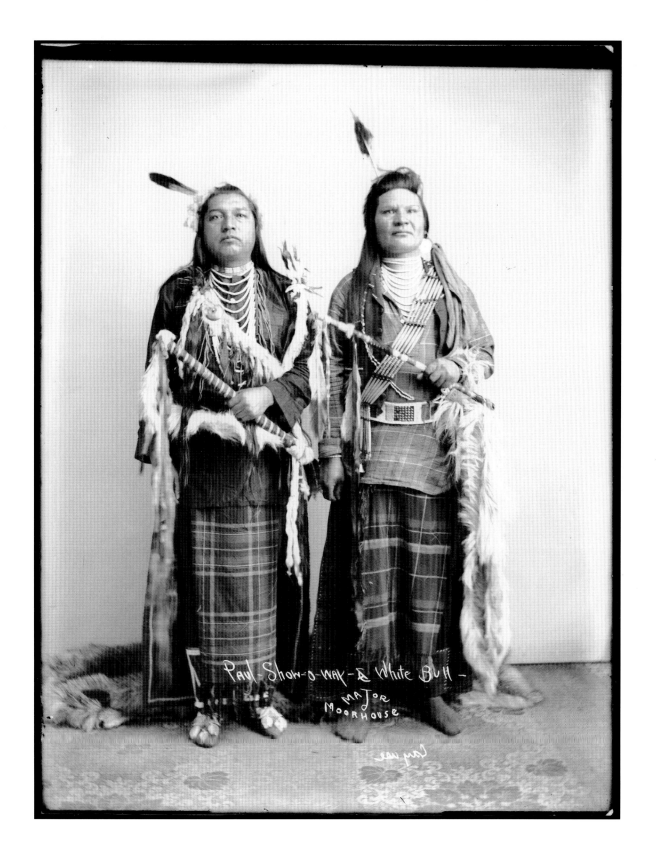

Paul-Show-o-way-& White Bull-
Major
Moorhouse

PLATE 14

Small Hawk and Wife, c. 1900. UO PH036-5114.

In addition to holding a tomahawk and a gun case with a Transmontane-style beaded design, Small Hawk here wears a horned bonnet, an otter skin sash, and a shirt with strips made of plaited quills. Mrs. Small Hawk is wrapped in a Navajo chief-style blanket, and the yoke of her wing dress is adorned with dentalium.

As in the case of Transmontane beadwork, some twentieth-century observers have claimed that Plateau peoples produced few items with quilled decoration and instead acquired these from Plains groups. This view contrasts with both local tradition and the material record. The Cayuse and their neighbors made and traded quill-wrapped horsehair items throughout the nineteenth century, and extant Nez Perce examples date to the 1840s. A plaited-quill-adorned shirt similar to this one was prominent among the props in which Lee Moorhouse dressed his photo subjects.

This photograph was used to market Pendleton Woolen Mills products before 1905. For several years it was reproduced on cardboard advertising labels. Woolen Mills advertising copy of the period claimed that the Umatilla Reservation was "recognized not only as a social center, but as the emporium of Indian fashion." Mrs. Small Hawk was additionally said to be "a lady of judgment, she is willing to pay a good price for a Pendleton robe, knowing that it will be bright and serviceable long after the cheaper grades have been thrown aside for saddle blankets."

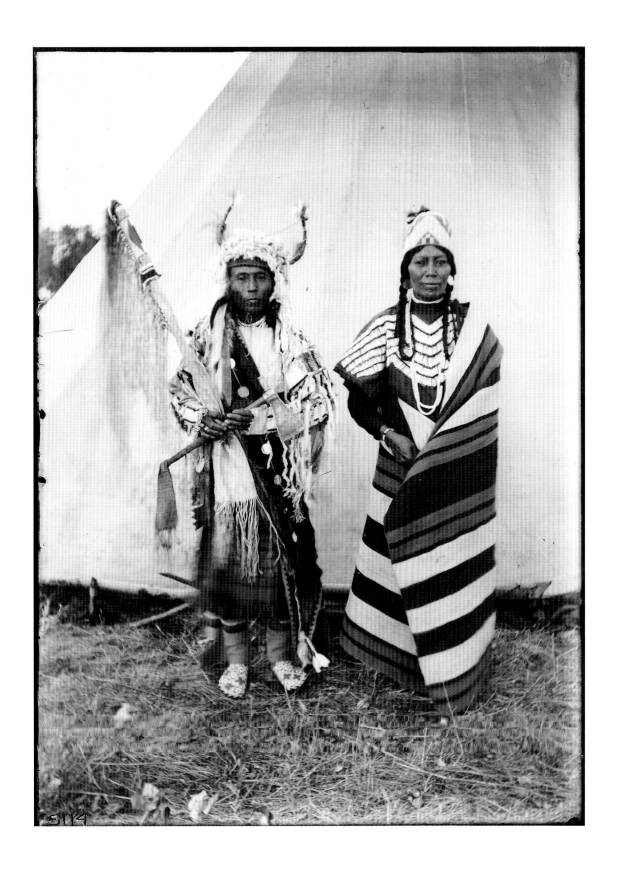

PLATE 15

Sheoships and His Wives, Cayuse, c. 1900. UO PH036-5106.

Straight-up feather bonnets and headdresses with long feather trailers were still in use on the southern Plateau at the beginning of the twentieth century. They appear in many of Lee Moorhouse's photographs. Charles Wellington Furlong, the celebrated easterner who wrote about the early years of the Pendleton Round-Up, observed of the type of headdress worn here by Sheoships that "some of the native American costumes are far more valuable than those made by many a king's tailor. The eagle feathers of a fine war-bonnet, which may number fifty to sixty, are valued at anywhere from two to five dollars a plume, according to size and quality."

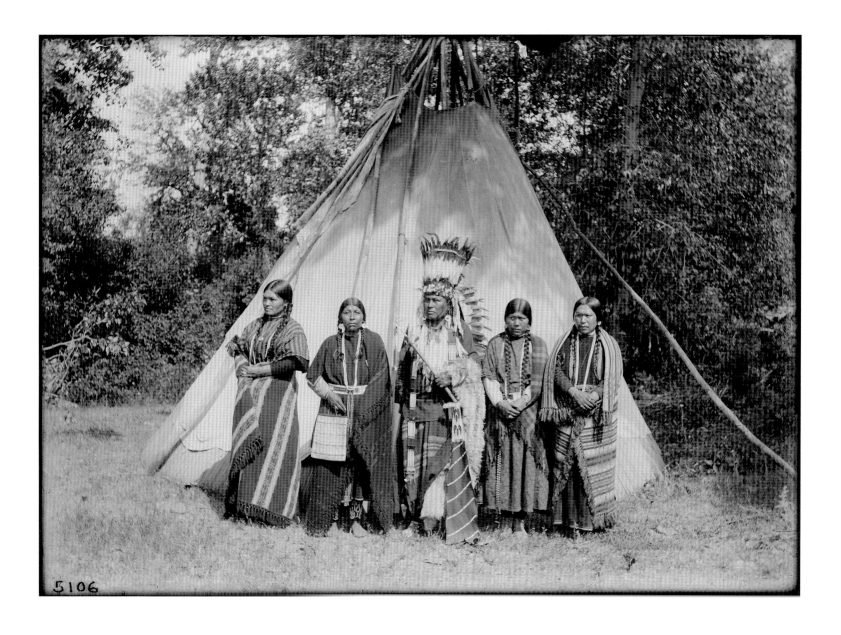

5106

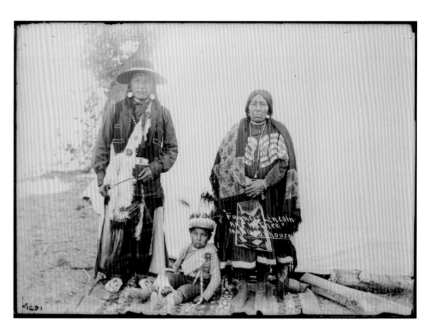

Francis Lincoln and Mother,
c. 1900. UO PH036-4691.

PLATE 16

Umatillas, c. 1900. NAA 02890-B-41.

Among the seven people in the group photo, Paul Showaway is at the far left and Francis Lincoln is third from the left. Although the inscription on the photo reports that this is a group of Umatillas, both of the identified men were of Cayuse ancestry. The shirt worn by the young man who is second from the left is now in the Doris Swayze Bounds collection at the High Desert Museum in Bend, Oregon.

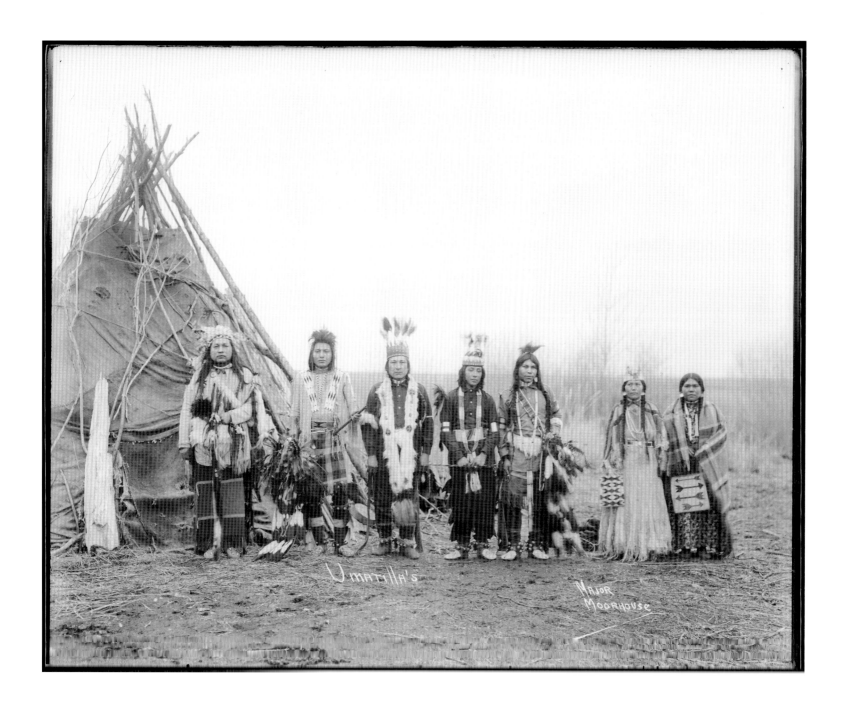

Umatilla's

Major
Moorhouse

Plate 17

Pa-loots-poo, Cayuse Tribe, c. 1900. NAA 03073-B-30.

Pa-loots-poo is remembered as having been an unusually industrious and talented woman. She tanned hides, made clothing and horse regalia, and was able to dig roots very quickly. These she processed both for storage and trade. She was a skilled beadworker and a weaver of cornhusk items. She had her own horses and was considered a wealthy person.

The bandolier-style horse collar with the central diamond (left center in the photograph) is now in the Doris Swayze Bounds collection at the High Desert Museum. Sometime after this photograph was made, much of the collar's wool cloth was replaced with buckskin fringe.

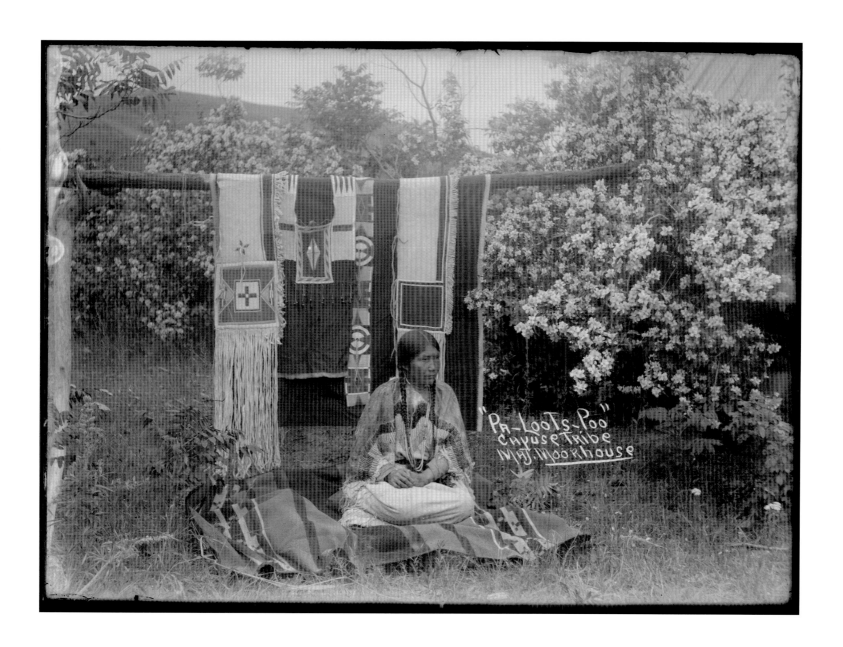

"Pa-Loots-Poo"
Cayuse Tribe
Maj. Moorhouse

Plate 18

Cayuse Tribe, c. 1900. NAA 03073-B-76.

After cotton and wool cloth was incorporated into the regional wardrobe, local women began to produce what became known as wing dresses. These garments, generally cut full and long, were brightly colored, and their bodices were often decorated with cowrie, dentalium, or other shells or with elk teeth. This decoration was generally applied in parallel, horizontal rows that followed the contour of the yoke. The garments were often trimmed with ribbon at the neck, sleeve, and hem.

As is evident here and in the photograph of Sheoships and his family (plate 15), women often wore wing dresses over a plain or print, long-sleeve cotton dress. Trade blankets with bright geometric designs and plaid patterns were standard accessories. Following local convention, the women here also wear beaded leggings with floral designs and undecorated moccasins.

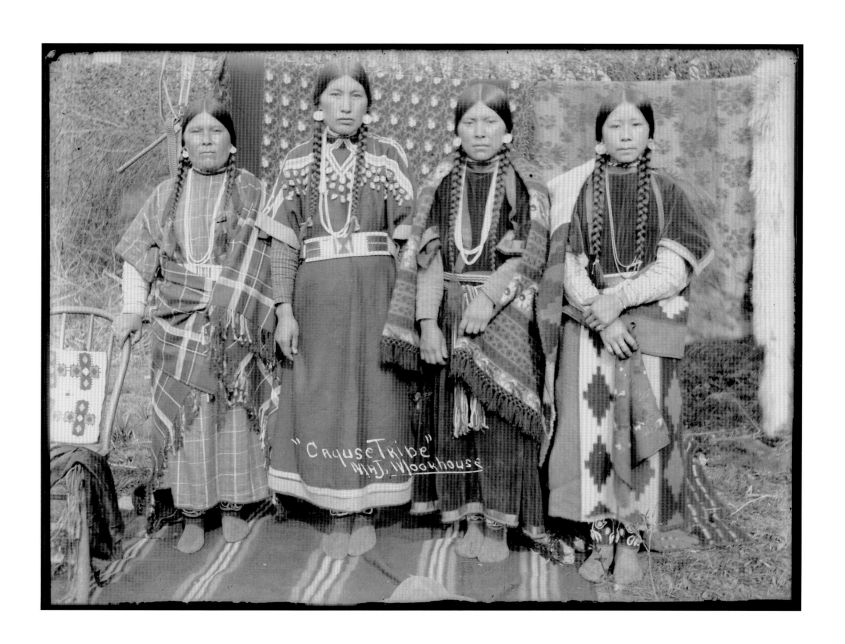

"Cayuse Tribe"
M. J. Woodhouse

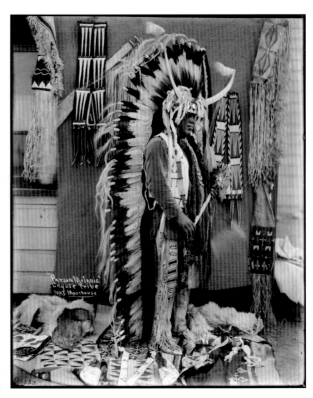

Parson Motanic, Cayuse Tribe,
c. 1900. UO PH036-4333.

PLATE 19

Motanic's Children, Cayuse Tribe, c. 1900.
UO PH036-4351.

Parson Motanic was a successful farmer on the Umatilla Reservation. For a time he was one of the largest property owners on the reservation, raising both livestock and wheat. After a storied conversion, Motanic became an ardent Presbyterian and served for many years as an elder in the Tutuilla Presbyterian Church. He was known locally for his size and strength, and he is said to have bested the famous wrestler Frank Gotch during an all-comers match.

Several Moorhouse photographs show Parson Motanic driving his Hudson automobile. In 1926 his daughter Esther became the first Indian woman crowned queen of the Pendleton Round-Up.

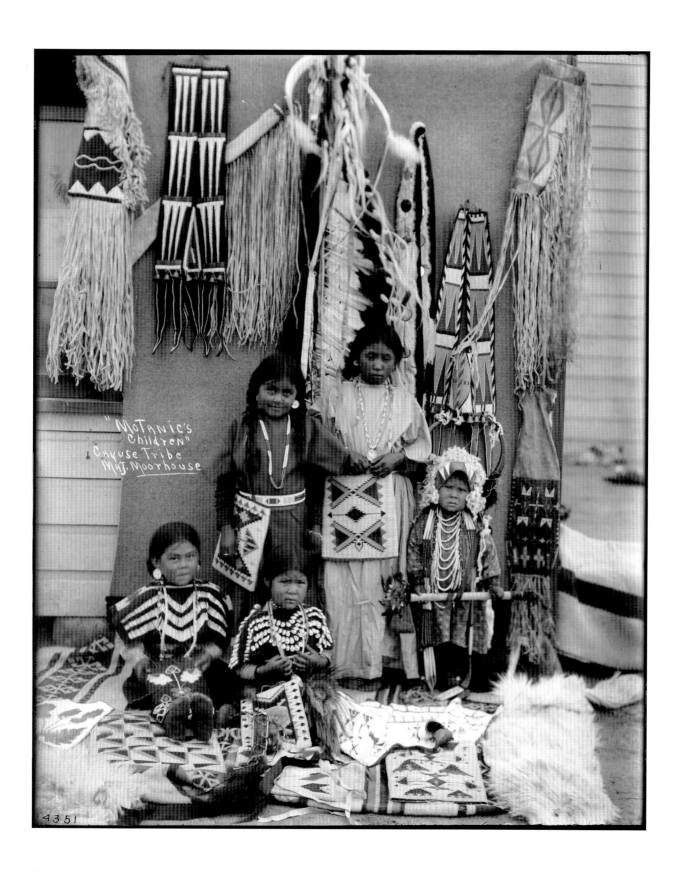

"MoTanic's Children" Cayuse Tribe Maj. Moorhouse

4351

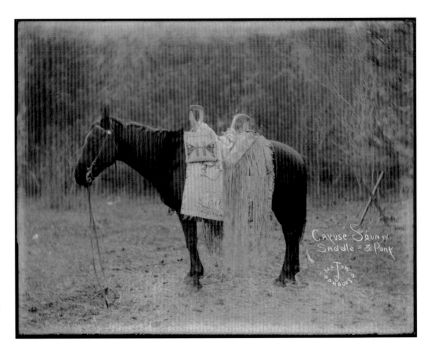

Cayuse Woman's Saddle and Pony, c. 1900. NAA 03073-C-04.

PLATE 20

Woman on Horse, c. 1900. UO PH036-6650.

The riding apparatuses seen in these photos are consistent with what white explorers observed throughout the Plateau during the nineteenth century. In 1805, Lewis and Clark's compatriot Patrick Gass reported that Nez Perce women's saddles were "made of wood nicely jointed, and then covered with raw skins, which when they become dry, bind every part tight, and keep the joints in their places. The saddles rise very high before and behind." A half-century later, members of Isaac Ingalls Stevens's Pacific Railroad Survey noted that among the Yakama and Klikitat, "the women sit astride, in a saddle made with a very high pommel and cantle."

In a letter written in 1846, the Presbyterian missionary Henry Harmon Spalding observed: "A blanket or robe is always thrown over the saddle covering the lower part of the person, even the feet, In my opinion the more modest way of riding." The woman here has one wool blanket with Transmontane-style blanket strips wrapped around her lower extremities and a second one draped over the seat of her saddle.

Plateau women frequently suspended bags from the fronts and backs of their saddles. The riderless horse here is further adorned with a Jacquard-woven coverlet. By the 1830s, many European craftspeople, who were prime producers of these textiles, had settled in the Midwestern states, which then yielded the highest percentages of Oregon Trail emigrants. Coverlets like this one came west and into Indian hands through trades made in the Grande Ronde and Umatilla River valleys and elsewhere. Plateau people may be seen in early photographs wearing them in place of buffalo robes and trade blankets.

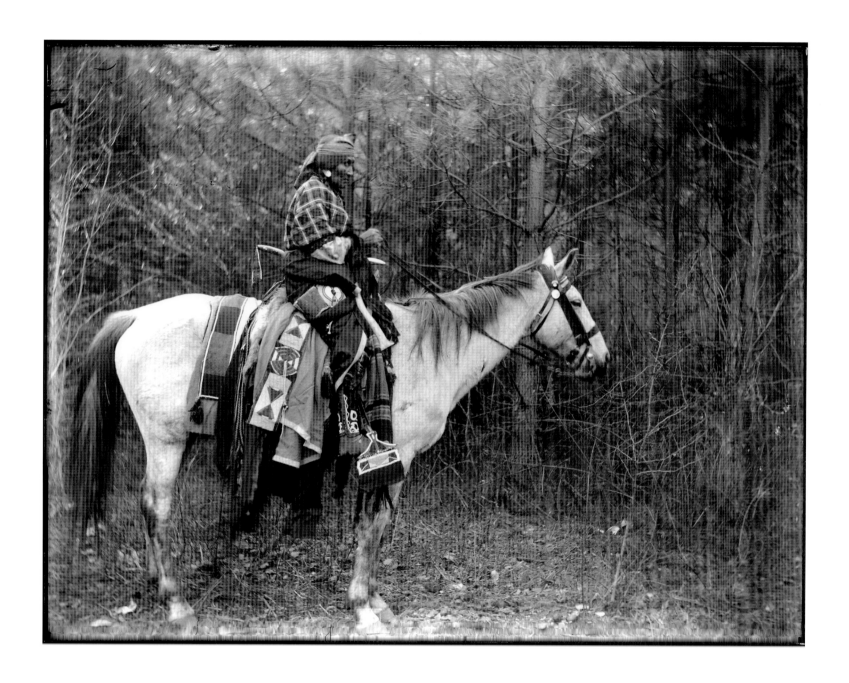

PLATE 21

Luke Minthorn, Cayuse Tribe, c. 1900. NAA 03073-B-23.

Luke Minthorn was the son of Ipnatsolatalk, who was also known as Sarah Minthorn. Sarah had converted to Christianity under the tutelage of Marcus and Narcissa Whitman. She was the first wife of the Cayuse headman Yellow Hawk, who was among the signers of the 1855 treaty establishing the Umatilla Indian Reservation.

Minthorn's Indian name translates as "Cougar Shirt." His saddle blanket in this photo has a mountain lion skin attached; saddle blankets of this type appear often in Moorhouse photographs. Quivers made of mountain lion pelts were also common in the region during the nineteenth century. Minthorn's feathered headdress was part of the Moorhouse collection that is now owned by the Vert Museum.

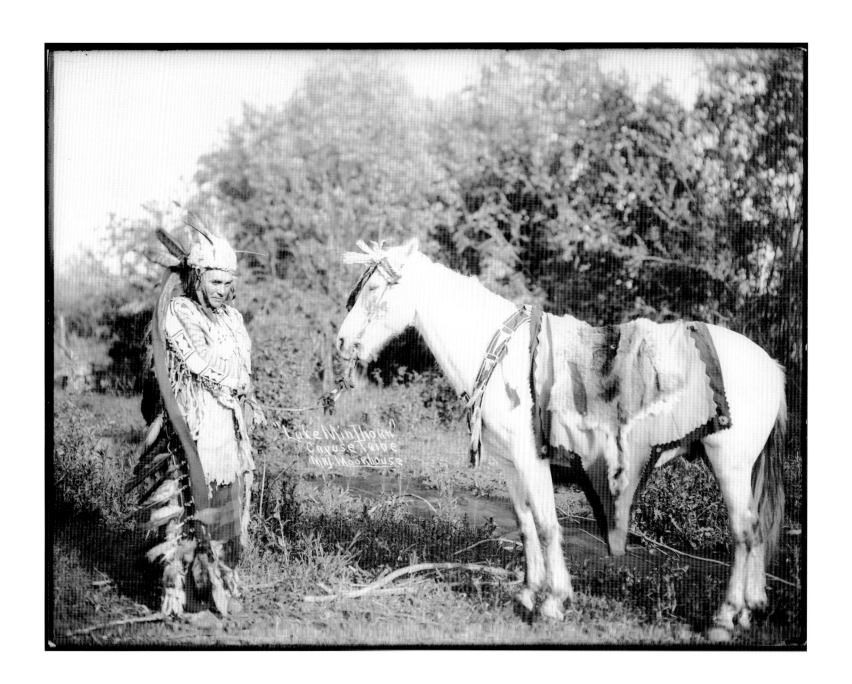

"Luke MinThorn"
Cayuse Tribe
Maj. Moorhouse

PLATE 22

His First Lesson, Cayuse Tribe, c. 1900. UO PH036-4207.

Horses were an important feature of Plateau Indian society, and children learned to ride at an early age. In describing the peoples of the southern Plateau during an 1835–36 reconnaissance, the pioneering missionary Samuel Parker wrote: "Their wealth consists in their horses, and in a great degree their consequence upon the number they possess; some owning several hundreds; and that family is poor whose numbers are not sufficient for every man, woman, and child to be mounted, when they are traveling from place to place; and also to carry all their effects. In these respects they are far better supplied than any tribes I saw east of the mountains."

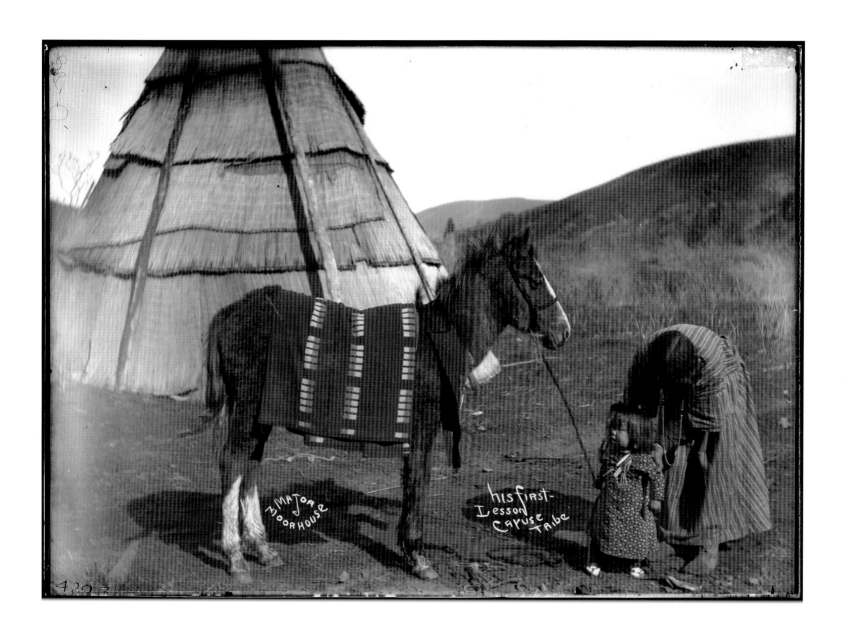

3 MAJOR
MOORHOUSE

his first
lesson
Cayuse
Tribe

PLATE 23

Umatilla Reservation, July 4, 1903. NAA 02690-B-63.

Independence Day was celebrated on the Umatilla Reservation at a site near Thorn Hollow. The year after this photo was taken, a *Pendleton East Oregonian* reporter filed a story with the headline "The Umatillas Are Patriotic":

> The 15-day celebration at the agency opened very promising, the attendance being large, the enthusiasm top notch, and the weather glorious.
>
> Seventy-five family tepees, occupied by full-bloods, are on the ground, and there are twice as many 'camps' occupied by mixed-bloods and a few whites. The attendance of residents of the reservation is larger than ever before, and there are a large number of visitors from the Snake, Lapwai, and Shoshone reservations.

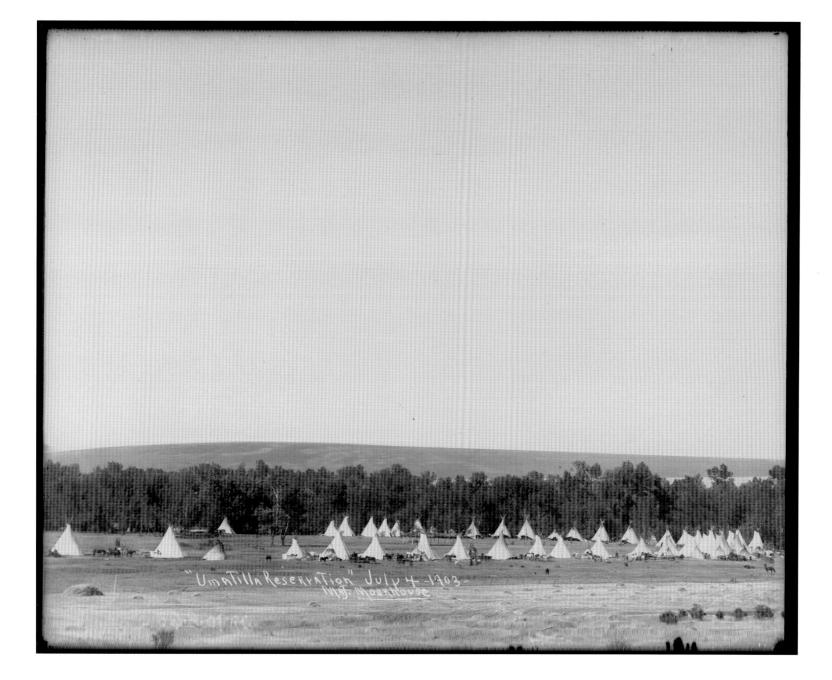

"Umatilla Reservation" July 4 -1903-
Maj. Moorhouse

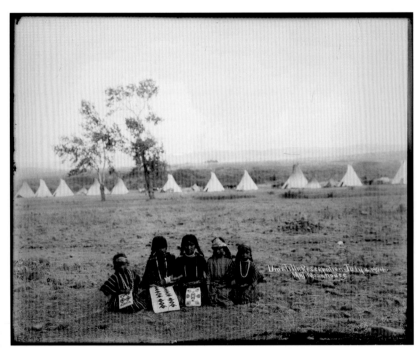

*Umatilla Reservation,
July 4, 1904.
UO PH036-5843.*

PLATE 24

Walla Walla Women on Horseback, July 4, 1903. UO PH036-5809.

The residents of Umatilla County and the Umatilla Reservation relished their annual Fourth of July celebrations. Outsiders were not always as enamored with the events. During Moorhouse's term as Indian agent, Benjamin H. Miller, a visiting Indian Service inspector, wrote:

> The citizens of Pendleton, made quite elaborate preparations for celebrating the 4th of July and the main feature of the display was the parading of two or three hundred Indians, men, women and children, and a war dance by a number of the head men. They were all dressed in their paint, furs, feathers and blankets, in good old Indian style, and presented a very striking appearance, but it did not seem to me that it was a performance that was beneficial in any way, and urged the Agent to discourage it in every way possible in the future. Of course it has no special influence upon the older Indians, but school boys and girls took part in the parade, and of course the effect upon them is to cause them to emulate their elders in these barbarous practices.

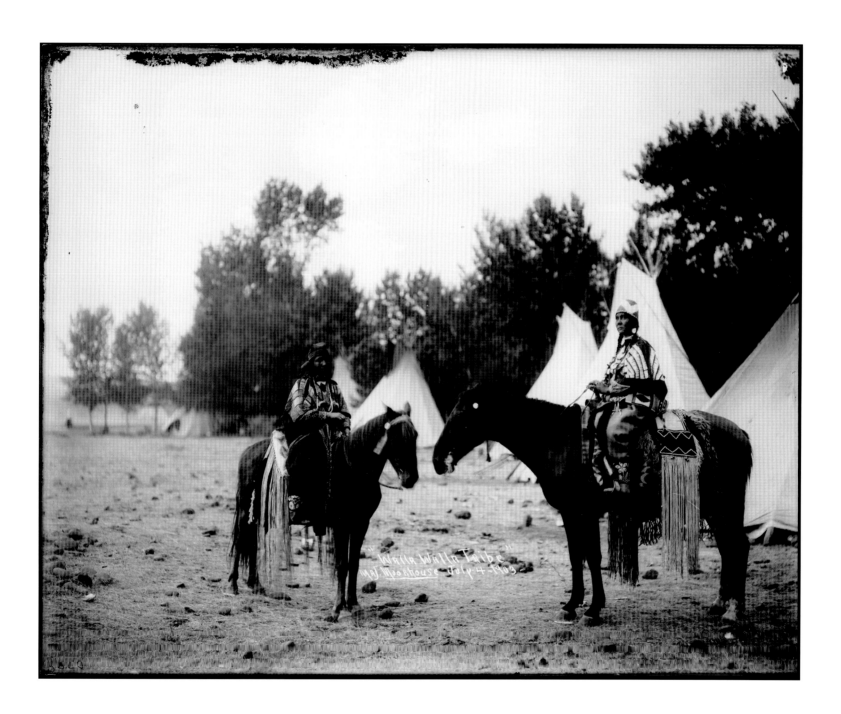

Red Hawk, Umatilla Tribe, July 4, 1903. UO PH036-4591.

William Parsons's 1902 history of Umatilla County included this assessment of the residents of the Umatilla Indian Reservation:

> The Indians inhabiting the lofty plateau, known now as the "Inland Empire," were mountain men—gifted with all the attributes of denizens of the highlands the world over. . . . Instead of inventing schemes to entrap the salmon and the sturgeon, they battled with the elk, the cougar, and the grizzly bear, becoming warriors, hunters, and heroes. They were horsemen and soldiers, and considering the quality of their weapons, were as dangerous a race as the whites ever encountered in their march across the continent. . . .
>
> As might be expected from their environments and habits, [local Indian men] were tall, muscular, and well-formed, and even now there may be seen on the reservation some of the finest men, physically, to be met anywhere. Red Hawk is a particularly fine sample of Indian physical development. He is six feet high, weighs two hundred and eighty pounds, without an ounce of superfluous flesh.

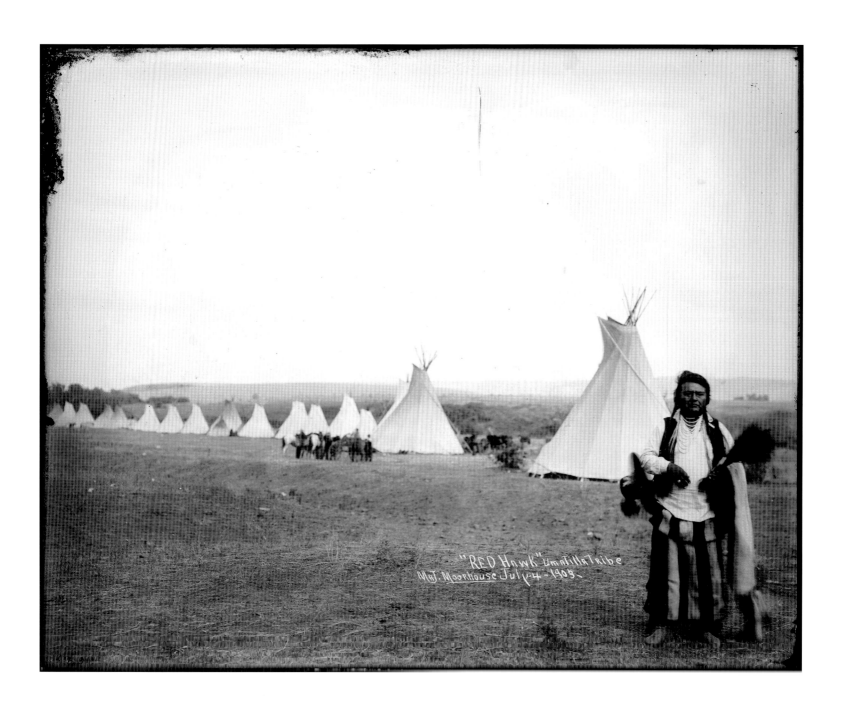

"RED Hawk" Umatilla Tribe
Maj. Moorhouse July 4 ~ 1903

Plate 26

Umatilla Reservation, July 4, 1903. UO PH036-5928.

The 1904 article "The Umatillas Are Patriotic" described portions of the local Independence Day celebration in this way:

> The war parade yesterday was participated in by 75 or 80 men, dressed in the habiliments of the old-time war-path, with a blood-curdling chorus of war-whoops pervading the entire performance, with a steady accompaniment of gun firing. The evolutions of the horsemen were much more skillful and attractive than has ever been seen on the reservation before, and the costumes showed more care in design.
>
> The parade was followed by the war dance in which 50 men took part. Probably a thousand Pendleton people attended yesterday and many will go again and again. The opening performance was interesting enough to encourage outsiders to return, and to pass the word along to others who may be looking for a very interesting place to spend a holiday.

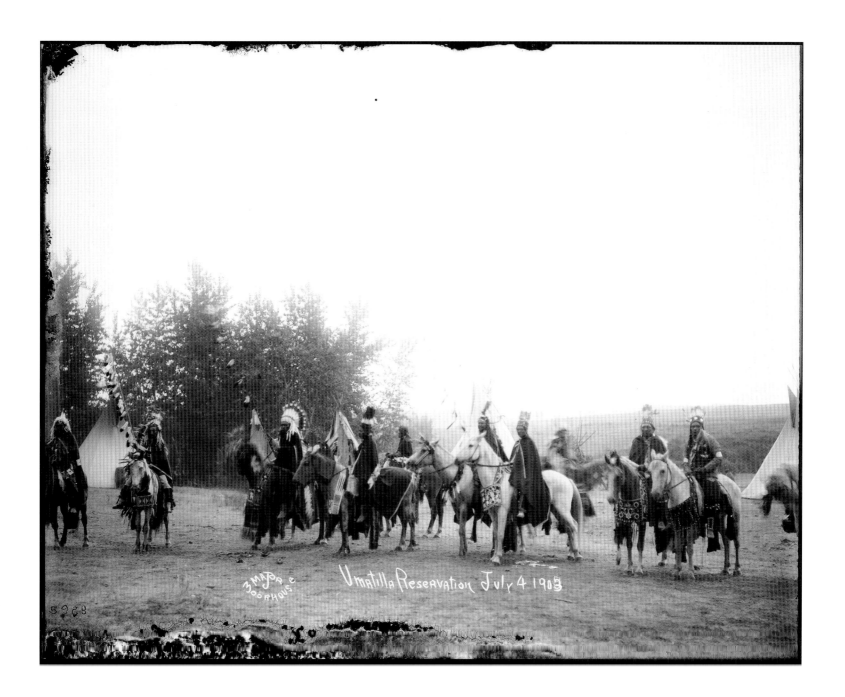

Umatilla Reservation July 4 1903

3 Major & Moorhouse

5968

PLATE 27

Hoosis Mox Mox, 1903. UO PH036-4628.

In the spring of 1885 the Palouse chief Big Thunder died. The following December, four hundred Palouse people gathered to select a new leader. Yellow Hair, or Sorrel Top (Husis Moxmox), became chief at that time. When this photograph was made he was about eighty-five years old. He lived another six years, drowning in the Umatilla River in May 1909.

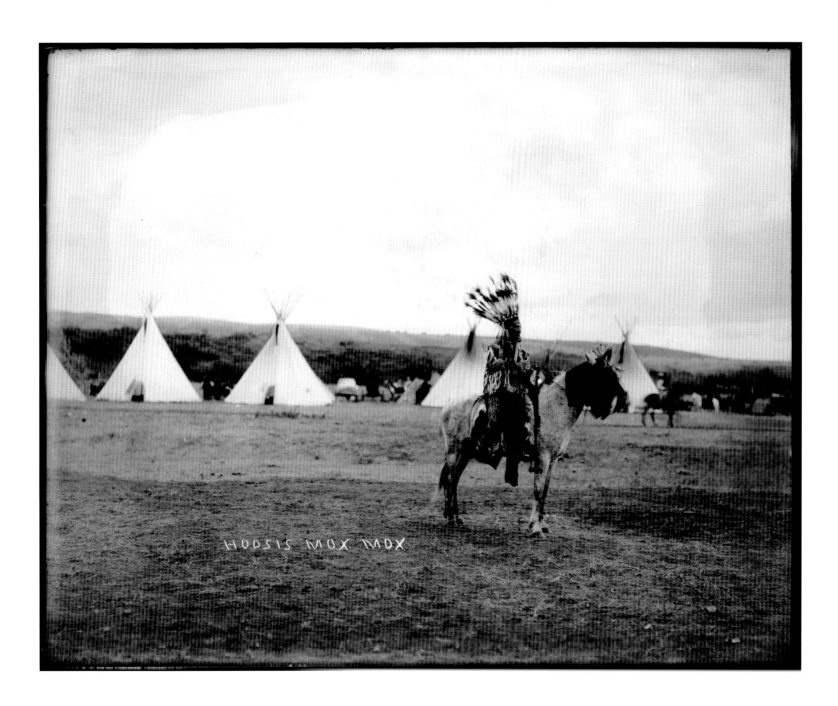

HOOSIS MOX MOX

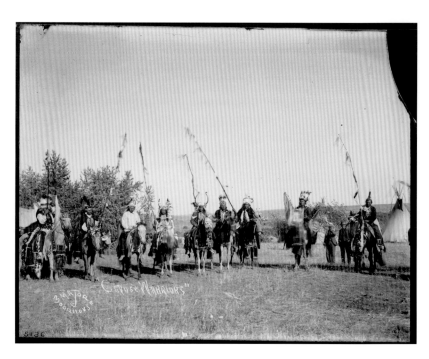

Cayuse Warriors, c. 1902. UO PH036-5136.

PLATE 28

Umatilla Reservation, July 4, 1903. UO PH036-5627.

In 1905, the *Pendleton East Oregonian* reported on "How Pendleton Spent the Fourth" on the Umatilla Reservation:

> From one corner of the grounds the war party dashed into view and it was a gorgeous sight. In the lead were the braves of the tribe decked in all the martial splendor that they could summon and with their horses likewise adorned. Following the older warriors came the youngsters of the tribe upon their ponies and behind them rode a dozen or more Indian girls. As the procession circled around the grounds the old men sat in front of their tepees wailing and wiping the tears from their eyes.
>
> Several times the party circled the encampment and then forming in line they advanced to the shade where the dance was to be held, and as they neared it they formed in a half circle around the place and dismounted.

In the larger photograph, Husis Moxmox is in the left foreground. Jim Kanine is at the far right, and Small Hawk is third from the right.

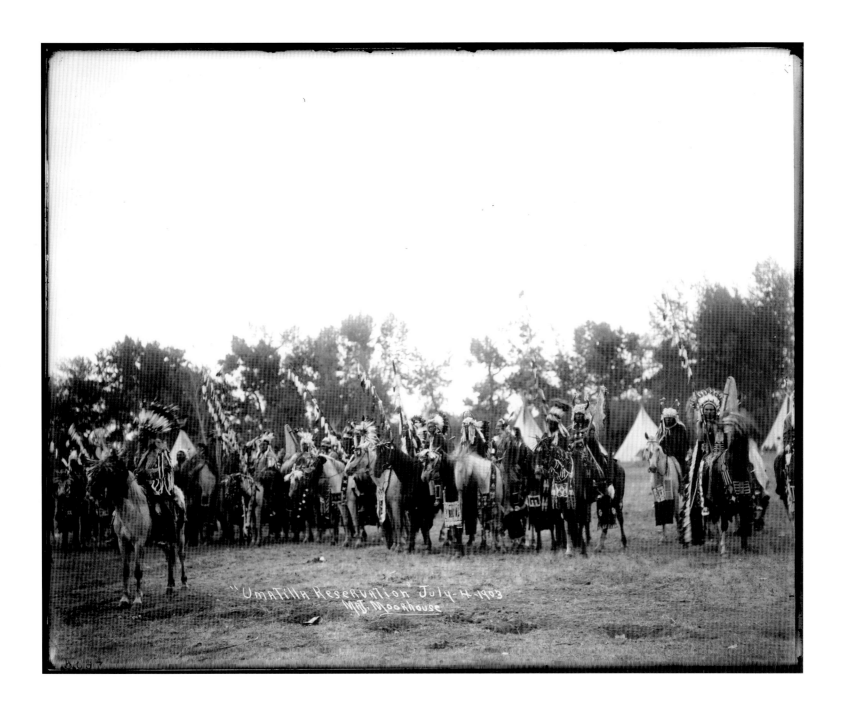

"Umatilla Reservation" July-4-1903
Maj. Moorhouse

PLATE 29

David Young Chief, Cayuse Tribe, 1903. NAA 03073-B-68.

The residents of the Umatilla Reservation acquired horses during the early eighteenth century and eventually came to possess considerable wealth in ponies. With this wealth developed a tradition of making beautiful equestrian ornaments. Moorhouse's photographs reveal that an abundance of such ornaments was still in use regionally at the beginning of the twentieth century. One item that is often evident in the photographer's images of the Umatilla Reservation is the horse mask. This was a masculine accessory that appeared most frequently among peoples linked by trade and marriage to the Cayuse.

The long horns visible on Young Chief's headdress were not from the head of an animal but were constructed from the ribs of an elk.

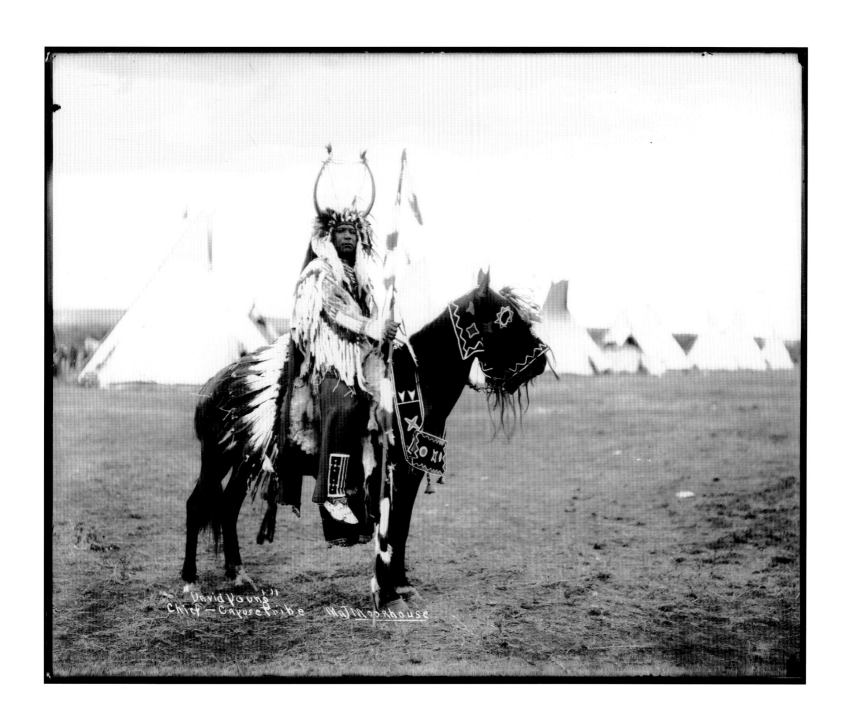

David Young,
Chief — Cayuse Tribe Major Moorhouse

PLATE 30

Chief No Shirt and Wife, Walla Walla Tribe, 1903. UO PH036-4432.

This image was taken at the Umatilla Reservation's 1903 Independence Day celebration. The saddle of Mrs. No Shirt (Thunder) rests on a Navajo chief blanket. Navajo and Spanish blankets became available to Plateau people after peace was established with the Shoshones, who had trade contacts to the south, during the 1820s. By the beginning of the twentieth century, Navajo blankets were in frequent use in the Columbia River region, and many appear in Moorhouse's photographs.

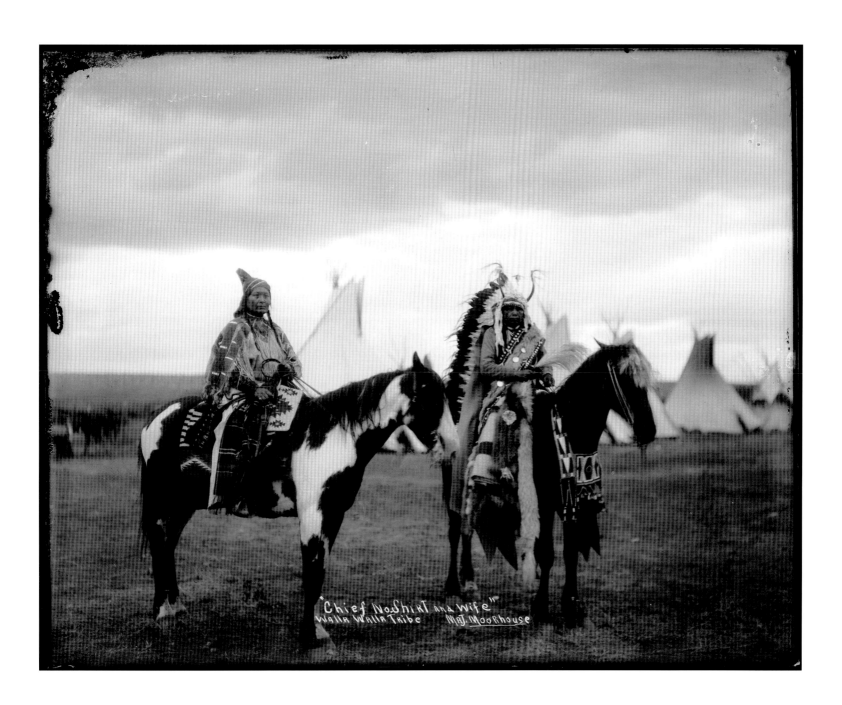

"Chief NoShirt and Wife"
Walla Walla Tribe Maj. Moorhouse

PLATE 31

Umatilla Reservation, July 4, 1903. UO PH036-4847.

Moorhouse identified these men as Young Chief, Whirlwind, and Chief No Shirt. In fact, the figure on the left, with the fringed guncase and imposing headdress, is probably Jim Kanine. Kanine was considered to be the last traditional chief of the Walla Wallas when he died in 1952. The man labeled "Whirlwind" is David Young Chief. No Shirt is correctly identified.

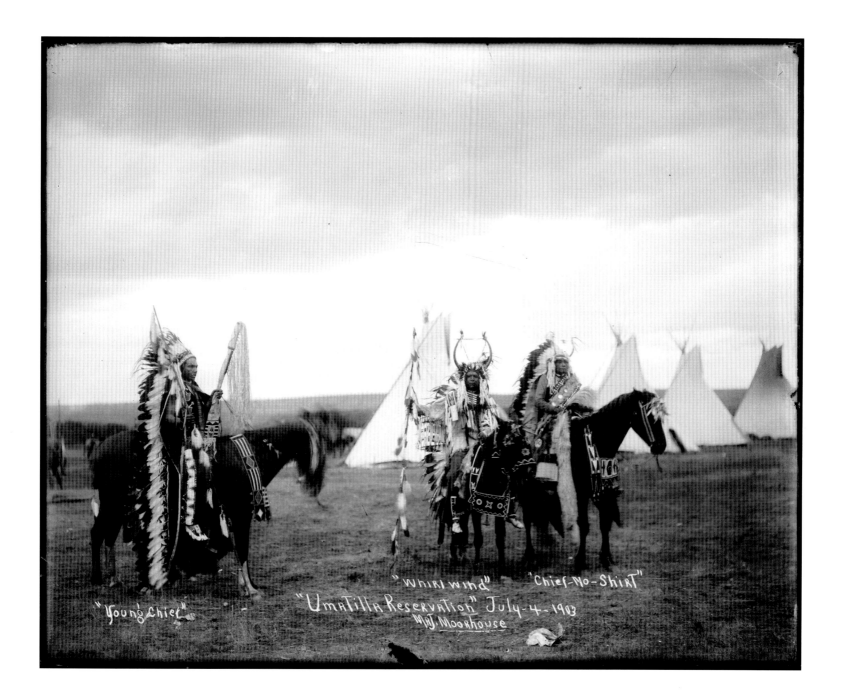

"Young Chief" "Whirl wind" "Chief-No-Shirt"
 "Umatilla Reservation" July-4-1903
 Maj. Moorhouse

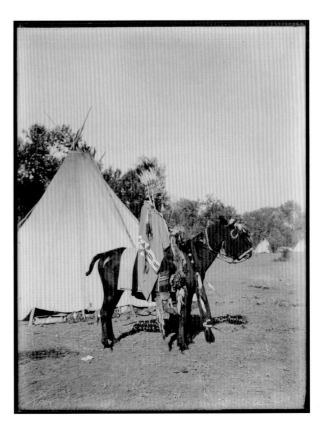

Kalyton, Cayuse, c. 1900.
NAA 03073-B-17.

PLATE 32

Umatilla Reservation, July 4, 1900. NAA 02890-B-36.

The July 4, 1900, photograph reproduced here shows Kalyton and his wife, both of whom were Cayuse. The headstall, horse collar, and saddle decoration on the woman's horse are all beaded in classic Transmontane style. The double saddlebag appears to be of central Plains origin, and the woman is wrapped in a Navajo chief blanket. Native trade systems resulted in the plains-dwelling Crow sharing the Transmontane beadwork style with Plateau peoples. Trade with Utes and Shoshones brought Navajo textiles and a limited number of Spanish goods into the southern Plateau.

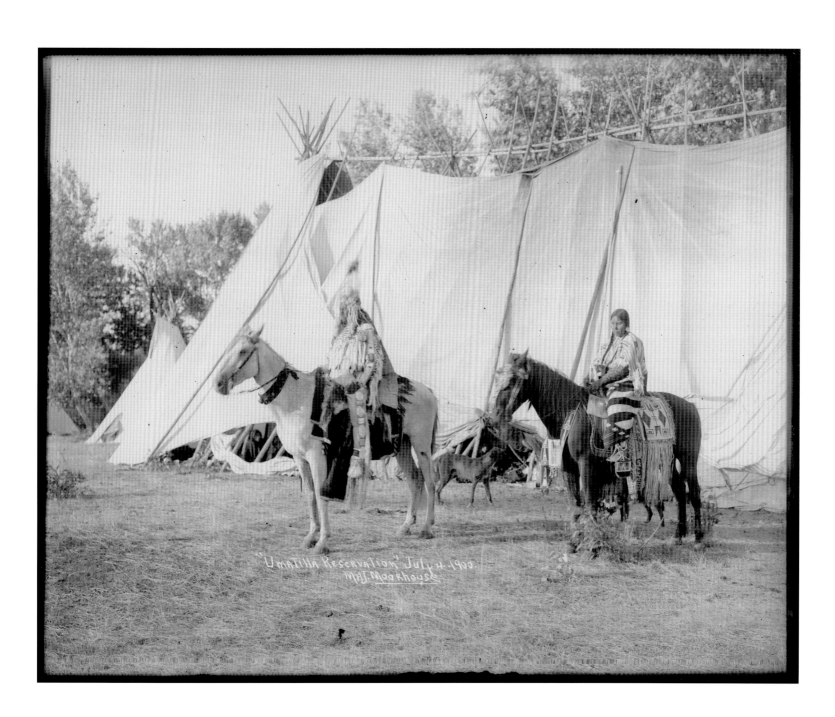

"Umatilla Reservation" July 4 1900.
Maj. Moorhouse

Plate 33

Umatilla Reservation, July 4, 1903. UO PH036-4846.

Between 1900 and 1910, Moorhouse made more than fifty photographs of Fourth of July celebrations on the Umatilla and Nez Perce Reservations. On this one he identified his subjects (left to right) as Dr. Whirlwind, Ta-wa-toi, Mrs. No Shirt, Chief No Shirt, and Red Elk. Most of these people appear in other Moorhouse images as well.

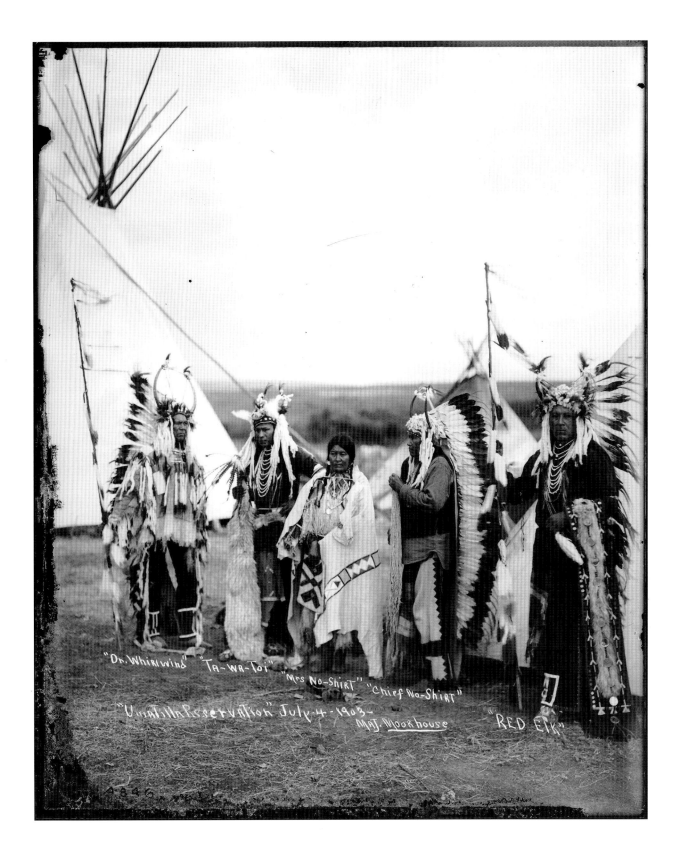

"Dr. Whirlwind" "Ta-wa-toi"
"Mrs No-Shirt" "Chief No-Shirt"
"Umatilla Reservation" July 4 1903
Maj. Moorhouse "Red Elk"

4846

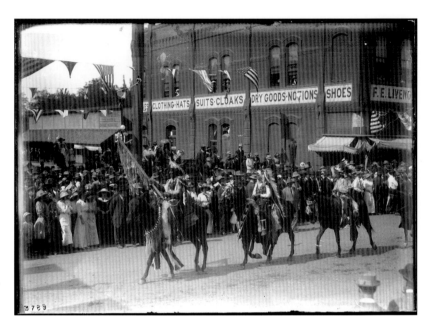

Lee Moorhouse or
O. G. Allen, *Round Up Parade,*
c. 1915. UO PH036-3729.

PLATE 34

Lee Moorhouse or O. G. Allen, *Indians at Round-Up,* 1912.

UO PH036-3710.

The 1912 Round-Up souvenir edition of the *Pendleton East Oregonian* contained an article titled "Indians Successful Farmers on Umatilla Reservation." It reminded readers: "The Round-up visitor is wrongly informed who has the impression that every Poor Lo upon the Umatilla reservation devotes his chief time to tribal dances, to riding in Round-up parades with much feathery adornment. . . . With the Indians as with white men, the Round-up is a carnival of the old time west rather than an exhibition of the spirit of the present. There are very few Indians who still try to live the old life 365 days of the year."

The men seen here in the infield of the Pendleton Round-Up arena are (left to right) Red Elk or Red Hawk, an unidentified man, Capt. Somkin, and Small Hawk.

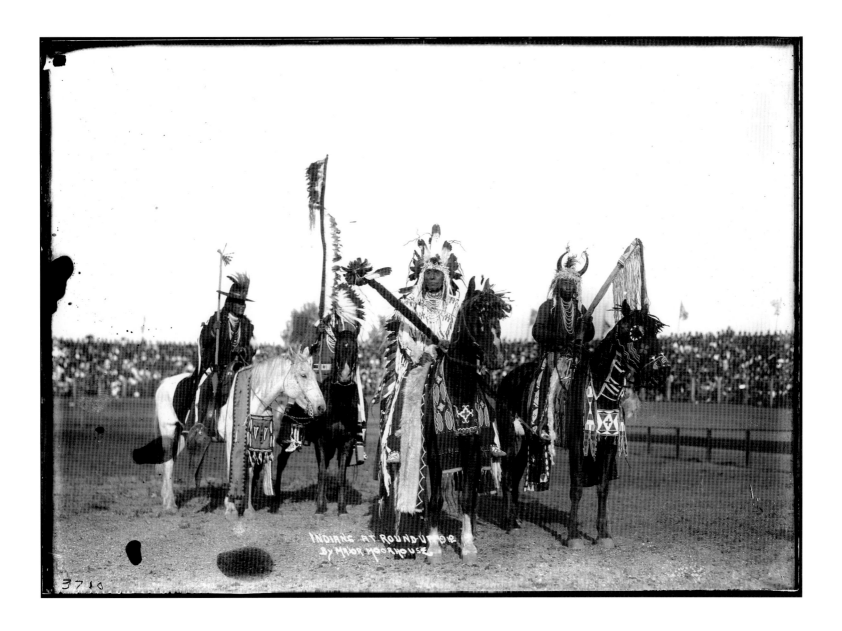

INDIANS AT ROUND-UP &
By Major Moorhouse

3710

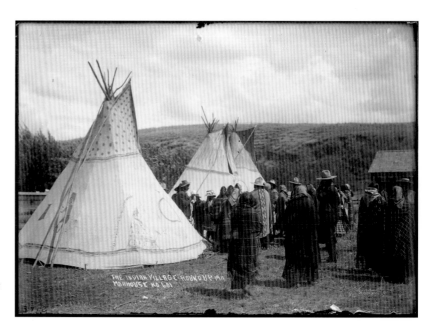

Lee Moorhouse or O. G. Allen, *The Indian Village at Round-Up, 1911.* UO PH036-3712.

PLATE 35

Lee Moorhouse or O. G. Allen, *Umatilla Indians, Round-Up, Pendleton, Oregon,* c. 1912. UO PH036-3702.

Roy Bishop was chairman of the Round-Up Committee on Indians in 1911. At the time he wrote that "in putting on a show as typical and genuine of wild and wooly west days as the Round-Up it is natural that the Indians number among its most interesting and conspicuous participants. Certainly no town in the West could supply such a feature so adequately as Pendleton."

Several years later, Charles Furlong described the event's Indian village:

> Here now you find about six hundred Indians, nearly the entire population of the reservation. . . . An open lane through the grove forms a village thoroughfare, on either side of which the tepees are pitched. The [wives] of some of the later arrivals are still busy unloading the cayuse-pulled rigs and pitching . . . their tepees of blue, white, striped, and variegated canvas. Children rollick about, turned-out horses feed nearby, and hunks of raw meat are cached high up on poles out of reach of the dogs. . . . An old Indian slowly rides his horse through the avenue of tepees . . . continuing his calls to the end of the village and rides slowly back. It is the Indian town crier, advising the village of orders in regard to preparing for the parade tomorrow. They will all be busy now putting finishing touches on their costumes.

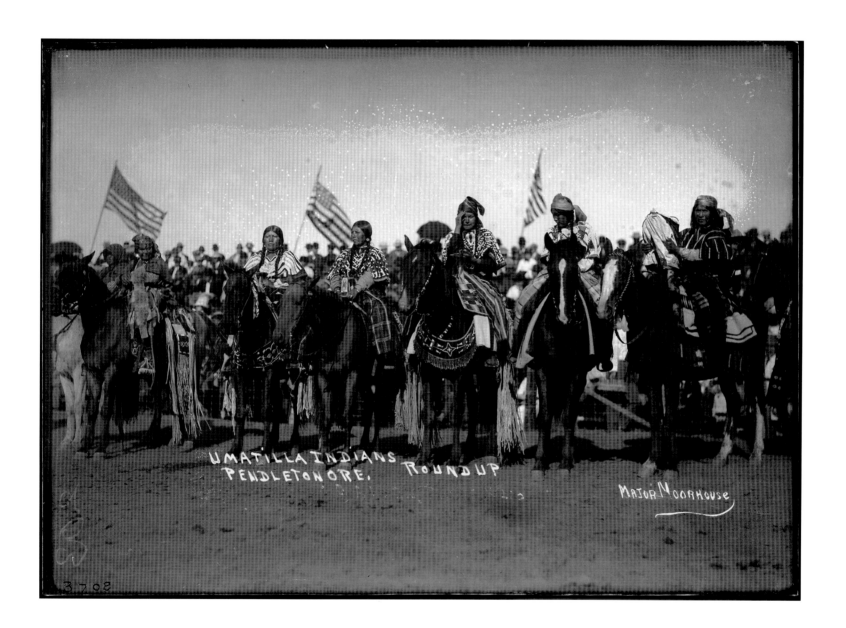

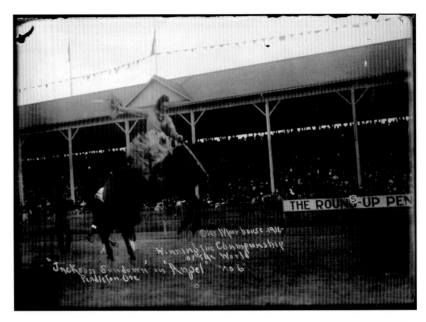

Jackson Sundown on Angel,
Winning the Championship of the
World, Pendleton, Oregon, 1916.
UO PH036-3318.

PLATE 36

Winners of the Bucking Contest, Round-Up, Pendleton, Oregon, 1915.
UO PH036-3398.

Between 1915 and 1923, the three Pendleton Round-Up cowboys seen in these photos together won the rodeo's bucking championship a total of six times. Hometown cowboy Lee Caldwell won the 1915 event, despite having to compete with an injured wrist. Second-place finisher Yakima Canutt was a native of Colfax, Washington. After completing an illustrious rodeo career, he became a successful Hollywood stuntman.

As a teenager, the third-place finisher in 1915, Jackson Sundown, had been among the nontreaty Nez Perce who sought to evade the U.S. military during the celebrated 1877 Nez Perce War. He later moved to Culdesac, Idaho. As a Round-Up contestant, Sundown gave several celebrated performances. He considered retirement after the 1915 competition but returned to capture the saddle bronc championship the following year, at the age of fifty-three.

The Hamley's and Company saddle that Sundown received for finishing first in 1916 is now in the collection of the Oregon Historical Society.

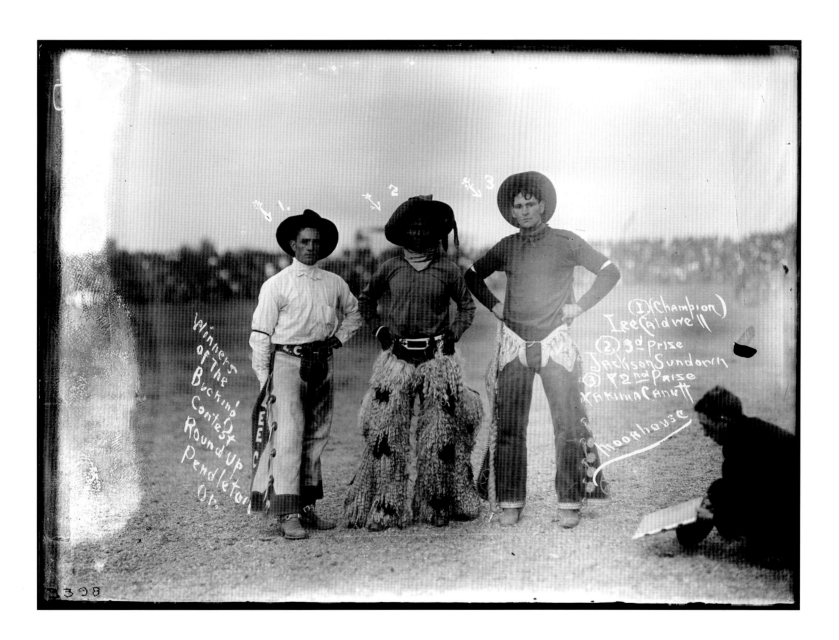

Winners
of The
Bucking
Contest
Round Up
Pendleton
Ore

① (Champion)
Lee Caldwell
② 3d Prise
Jackson Sundown
③ 1st 2nd Prise
Yakima Canutt

Moorhouse

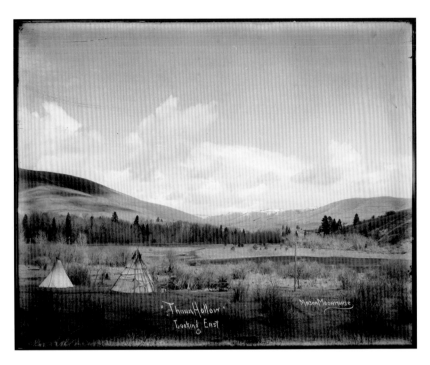

Thorn Hollow, Looking East,
c. 1900. UO PH036-5724.

PLATE 37

Whistling for Thorn Hollow, c. 1900. UO PH036-5725.

The larger photograph in this pair shows an Oregon Railway and Navigation Company freight train, with engine number 376, on the track near Thorn Hollow on the Umatilla Indian Reservation. Thorn Hollow sits along the Umatilla River about fifteen miles east of Pendleton.

The Oregon Railway and Navigation Company opened a route connecting Pendleton with the Snake River at Huntington, Oregon, in 1884. The line bisected the Umatilla Reservation and lay in proximity to many Indian settlements. During his two years as Indian agent, Lee Moorhouse continually sought redress from the railroad company for livestock killed by trains and dwellings destroyed by fires caused by sparks from smokestacks.

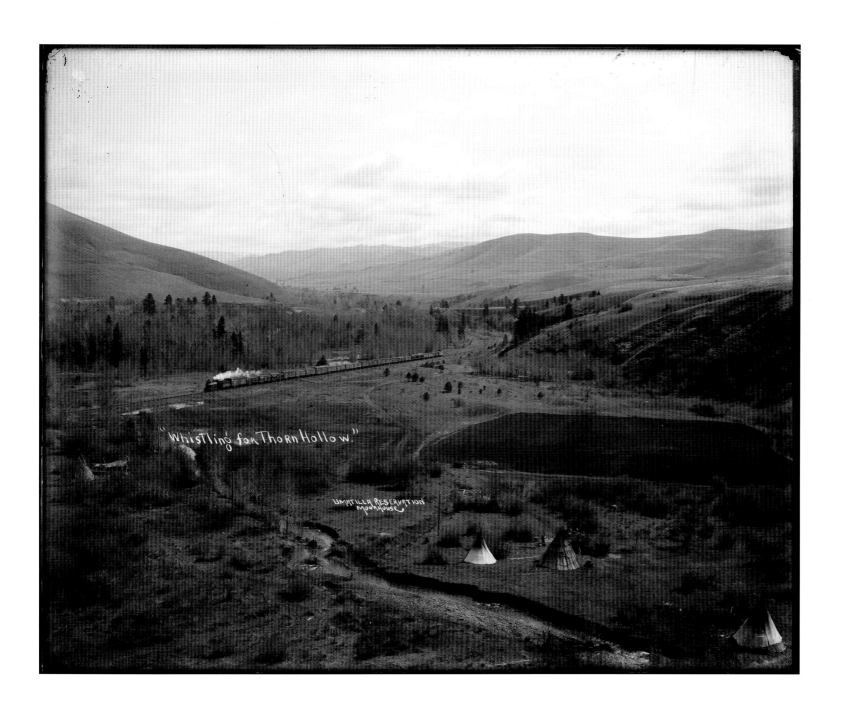

"Whistling for Thorn Hollow."

UMATILLA RESERVATION
MOORHOUSE

PLATE 38

Ume Somkin's Family, c. 1900. NAA 03073-B-58.

Moorhouse made numerous photographs of dwellings on the Umatilla Reservation, but only of those that were tule mat lodges or canvas tepees. In 1891 he had provided information to the Indian commissioner that was incorporated into the Indian Service's annual tabulation of "Religious, Vital, and Criminal Statistics." That year Moorhouse reported that the Umatilla Reservation was home to approximately one thousand residents and that thirty new homes had been built, bringing the reservation total of wooden houses to two hundred. The number certainly increased in the following decade, but the wooden structures appear in none of Moorhouse's photographs.

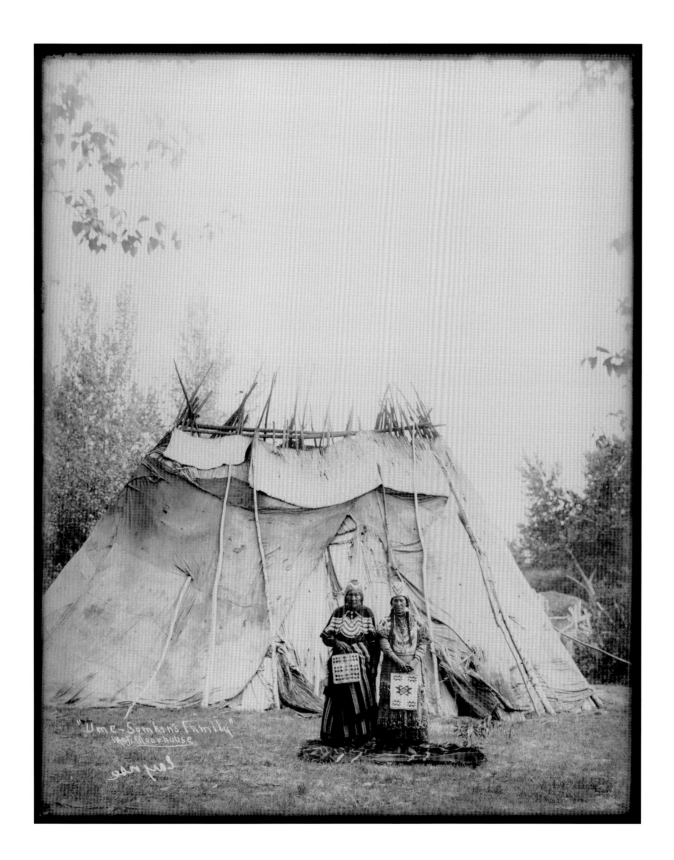

"Ume-Somkin's Family" Major Moorhouse

Plate 39

Interior of Mat Lodge, c. 1900. UO PH036-6354.

Mats made of tules, or bulrushes *(Scirpus acutus)*, were light and portable. They could be rolled up and moved from camp to camp, covering both winter longhouses and summer tepees. The rectangular mats were made by lining up a row of cut tules, their basal ends alternating with their tapered tips. These were then sewn together. Air pockets within the stems provided efficient insulation. Several layers of overlapping mats could protect the interior of a lodge from wind, moisture, and severe cold.

The floors of large winter structures were often excavated a foot or two below ground level. Tule mat roofs extended from the ground up to the narrow opening at the peak of the roof that served as a smoke hole.

This stereo image is one of more than three hundred in that format in the Lee Moorhouse Photograph Collection.

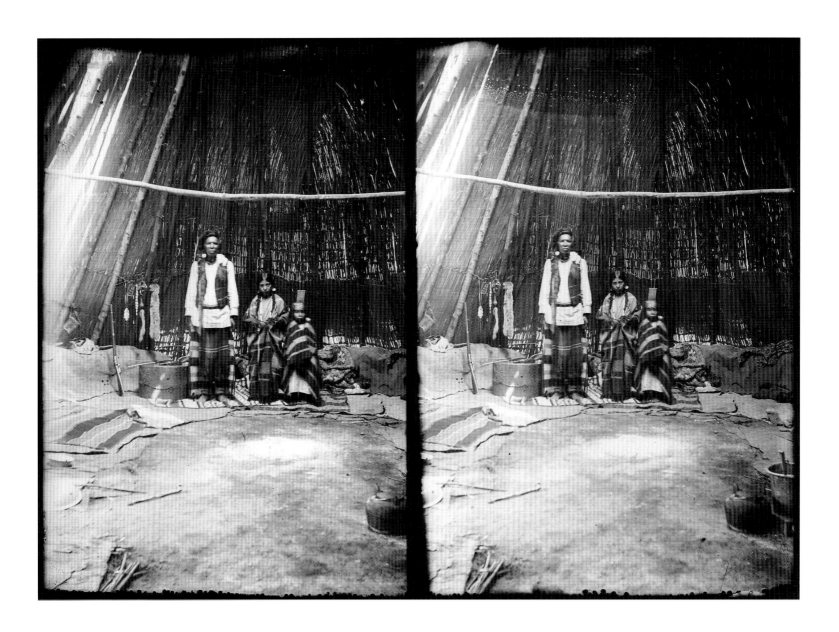

PLATE 40

Umatilla Council Lodge, c. 1900. NAA 02890-B-48.

Tule mat lodges were a hallmark of the Columbia River region. In October 1805 William Clark described the structures as they appeared near the confluence of the Snake and Columbia Rivers. He reported that they were covered with "large mats made of rushes" and ranged from fifteen to sixty feet in length. Their floor plan was generally oblong, and they stood about six feet high. Clark also observed that each had an opening running "the whole length of about 12 or 15 inches wide, left for the purpose of admitting light and for the Smok *[sic]* of the fire to pass."

In the upper Nez Perce country, the Corps of Discovery came upon one lodge that was estimated to be 150 feet long and to contain "24 fires and about double that number of families."

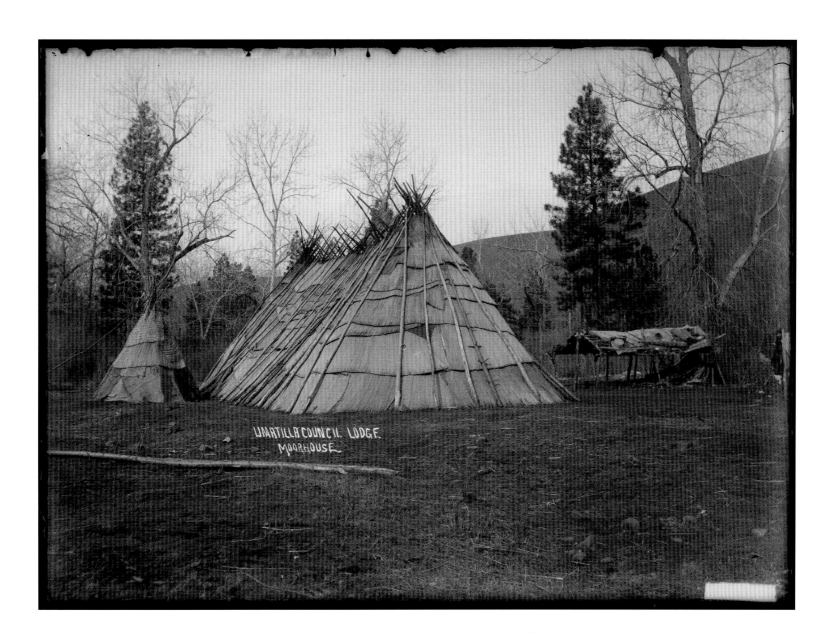

UMATILLA COUNCIL LODGE.
MOORHOUSE

Plate 41

Umatilla Reservation near Tu-Tu-Illa, 1903. UO PH036-5629.

Tutuilla Creek runs southeast to northwest near the western boundary of the Umatilla Indian Reservation. The locale known as Tutuilla is itself about seven miles southeast of Pendleton. The area is generally flat. After the land auctions and allotments of the early 1890s, this became a prime wheat-ranching area. A Presbyterian mission to the residents of the Umatilla Reservation was established at Tutuilla in 1883. It was served exclusively by Nez Perce ministers for the next fifteen years.

"Umatilla Reservation near Tu-Tu-Illa" 1903.
Maj. Moorhouse

Plate 42

Billy Barnhart's Camp on the Umatilla, c. 1900. NAA 02890-B-34.

This camp was situated on the Umatilla River in the open, arid country about ten miles west of Pendleton. Drying on the rack are Pacific lamprey (*Lampetra ayresi*), which local Indian people called eels. Lamprey were most easily harvested in places with rapids, because they could be taken off the sides of rocks or caught in nets. The most famous regional lamprey fishery was near present-day Pasco, Washington.

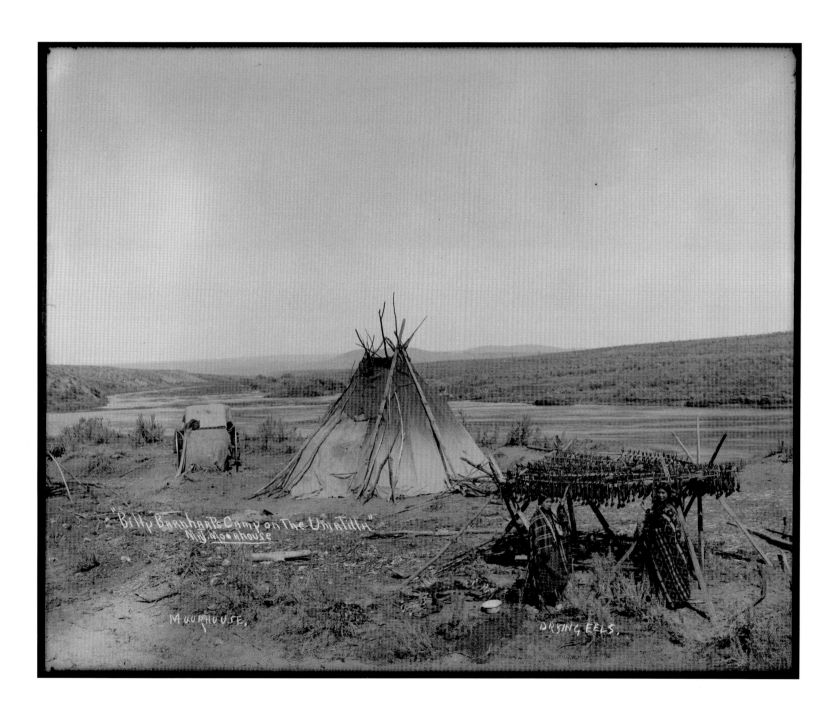

"Billy Barnhart's Camp on The Umatilla"
By Moorhouse

MOORHOUSE.

DRYING EELS.

PLATE 43

Umatilla Indian School, 1903. UO PH036-5447

During Lee Moorhouse's second year as Indian agent, Commissioner Thomas J. Morgan published the following "Instructions to Indian Agents in Regard to Inculcation of Patriotism in Indian Schools":

> On the campus of all the more important schools there should be erected a flagstaff, from which should float constantly, in suitable weather, the American flag . . . and students should be taught to reverence the flag as a symbol of their nation's power and protection.
>
> Patriotic songs should be taught to the pupils, and they should sing them frequently until they acquire complete familiarity with them. Patriotic selections should be committed [to memory] and recited publicly, and should constitute a portion of the reading exercises. . . .
>
> In all proper ways, teachers in Indian schools should endeavor to appeal to the highest elements of manhood and womanhood in their pupils, exciting in them an ambition after excellence in character and dignity of surroundings, and they should carefully avoid any unnecessary reference to the fact that they are Indians.

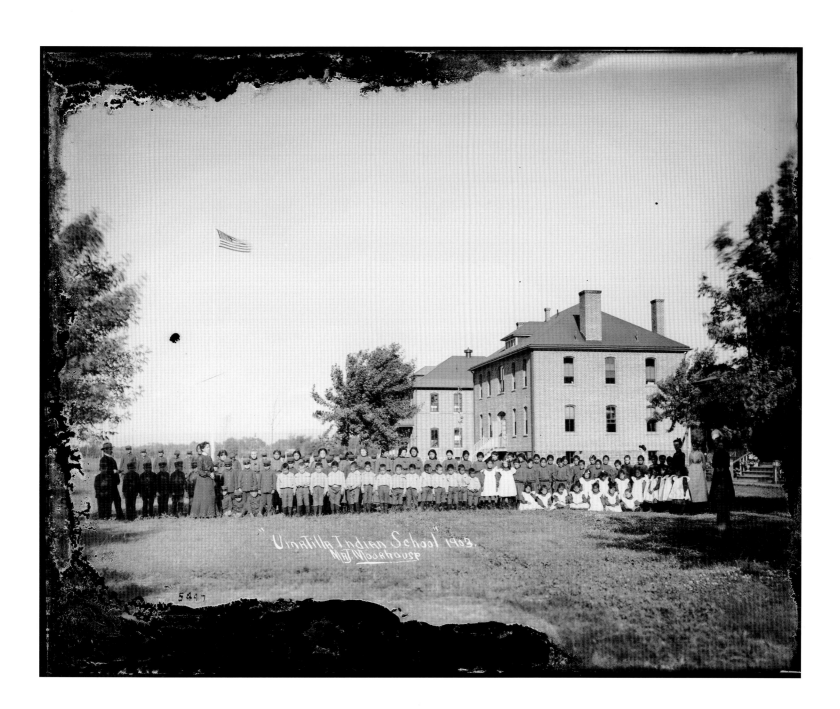

"Umatilla Indian School" 1903.
M.J. Moorhouse

5447

Plate 44

Pupils of the Umatilla Indian School, c. 1906. UO PH036-5461.

The 1890 "Rules for Indian Schools" contained this directive relative to recreation:

> Special hours should be allotted for recreation. Provision should be made for outdoor sports, and the pupils should be encouraged in daily healthful exercise under the eye of a school employé; simple games should also be devised for indoor amusement. They should be taught the sports and games enjoyed by white youth, such as baseball, hopscotch, croquet, marbles, bean bags, dominos, checkers. . . . Separate play grounds, as well as sitting rooms, must be assigned the boys and girls. In play and in work, as far as possible, and in all places except the school room and at meals, they must be kept entirely apart.

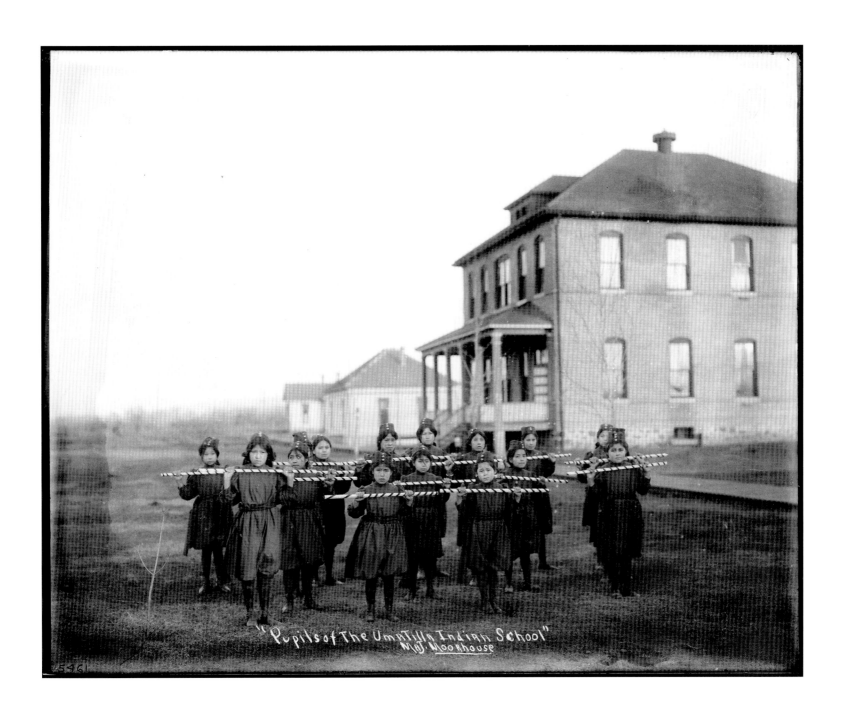

"Pupils of The Umatilla Indian School"
Maj. Moorhouse

Plate 45

Classroom, Umatilla Indian School, c. 1906. UO PH036-5478.

In July 1900, Superintendent Mollie V. Gaither reported on the Umatilla Boarding School:

> Our school closed with 100 children in attendance—about an equal number of girls and boys. Seventy-five of the number were under 12; 30 of them were mere babies, some only 3 years of age; only 2 over 16. We have a school of small children.
>
> . . .
>
> As I stated in previous reports, our general average is made low by the Indians not returning from their annual hunting and fishing trips until late. The children enter school as soon as they return, looking robust and well after their outings.

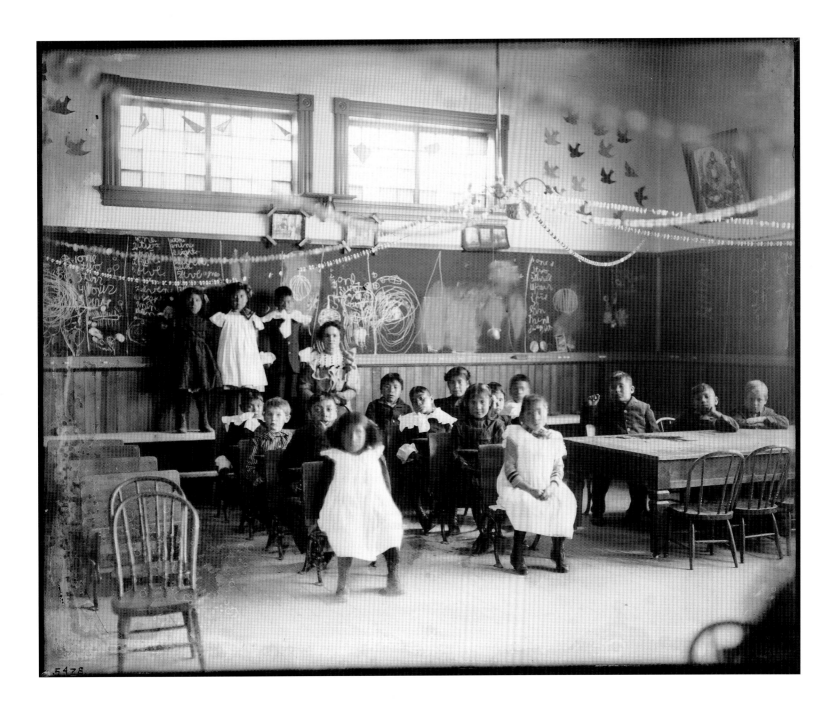

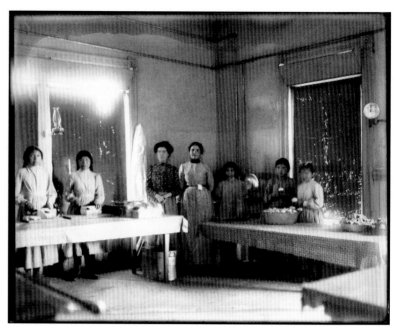

Classes in Domestic Science,
Umatilla Indian School, 1906.
UO PH036-5470.

PLATE 46
Classes in Domestic Science, Umatilla Indian School, 1906.
UO PH036-5471.

The 1890 "Rules for Indian Schools" stated:

> A regular and efficient system of industrial training must be part of the work of each school. At least half of the time of each boy and girl should be devoted thereto—the work to be of such character that they may be able to apply the knowledge and experience gained, in the locality where they may be expected to reside after leaving school. In pushing forward the school-room training of these boys and girls, teachers, and especially superintendents, must not lose sight of the great necessity for fitting their charges for the every-day life of their after years.
>
> . . .
>
> The girls must be systematically trained in every branch of housekeeping and in dairy work; be taught to cut, make, and mend garments for both men and women; and also be taught to nurse and care for the sick. They must be regularly detailed to assist the cook in preparing the food and the laundress in washing and ironing.

In 1901 Molly Gaither assessed the culinary labors of her female students: "Girls doing the kitchen work are taught to make bread and pies, the preparing and cooking of vegetables, the use of different cooking utensils, how to manage the range, to keep the kitchen clean, to take care of milk, to make butter, etc. This, of course, is a great advantage to them." The previous year she had reported that the girls had done "especially well" in the sewing room. A total of 1,376 garments had been made during the school year, "besides mending for 100 children."

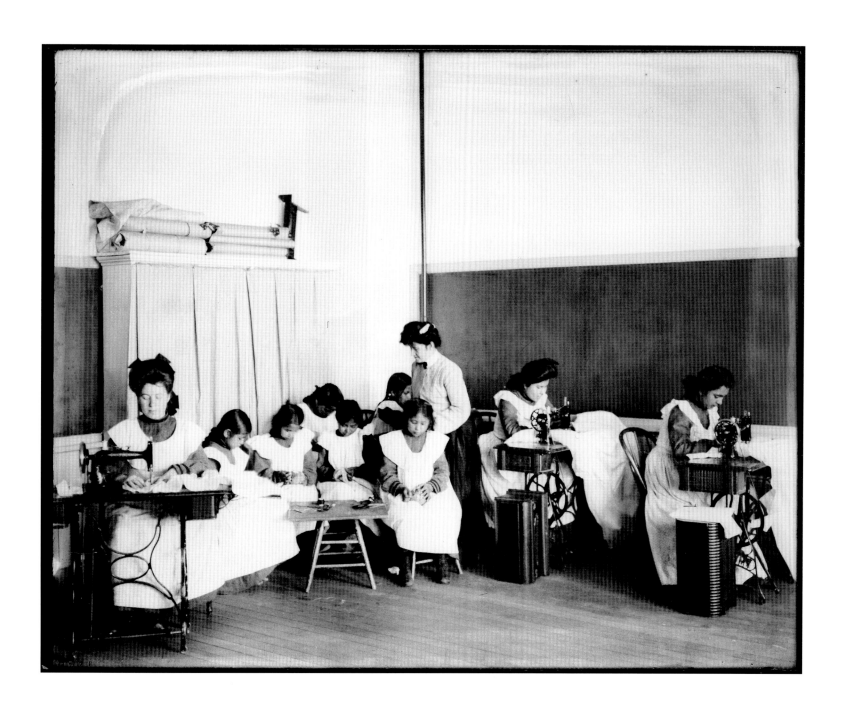

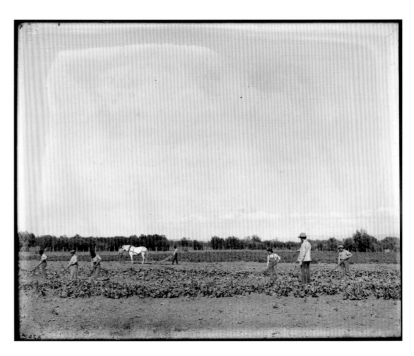

Instruction in Practical Agriculture,
Umatilla Indian School, 1906.
UO PH036-5465.

PLATE 47

Instruction in Practical Agriculture, Umatilla Indian School, 1904.
UO PH036-5527.

The "Industrial Work" section of the 1890 "Rules for Indian Schools" mandated: "The farm, garden, stock, dairy, kitchen, and shops should be so managed as to make the school as nearly self-sustaining as practicable, not only because Government resources should be as wisely and carefully utilized as private resources would be, but also because thrift and economy are among the most valuable lessons which can be taught Indians. Waste in any department must not be tolerated."

Molly Gaither's 1900 report further stated: "A garden of 10 acres produces well. Last year from 4 acres 500 bushels of large, fine potatoes were raised, and from one-fourth acre 50 bushels of large onions; besides, from the garden the school was supplied with cabbage, turnips, parsnips, beets, squash, carrots, salsify, and early vegetables. The lower part of the garden is rocky. This is sown for hay. It produced about 4 tons."

Six years later, Superintendent O. C. Edwards offered, "The employees, with rare exceptions, rendered faithful and efficient service during the entire year. The teachers did some excellent work in the individual gardens, which the children cultivated under their supervision. During the vacation months there were several instances of a child returning to the school with his parent to secure a ration of perishable vegetables which he had raised."

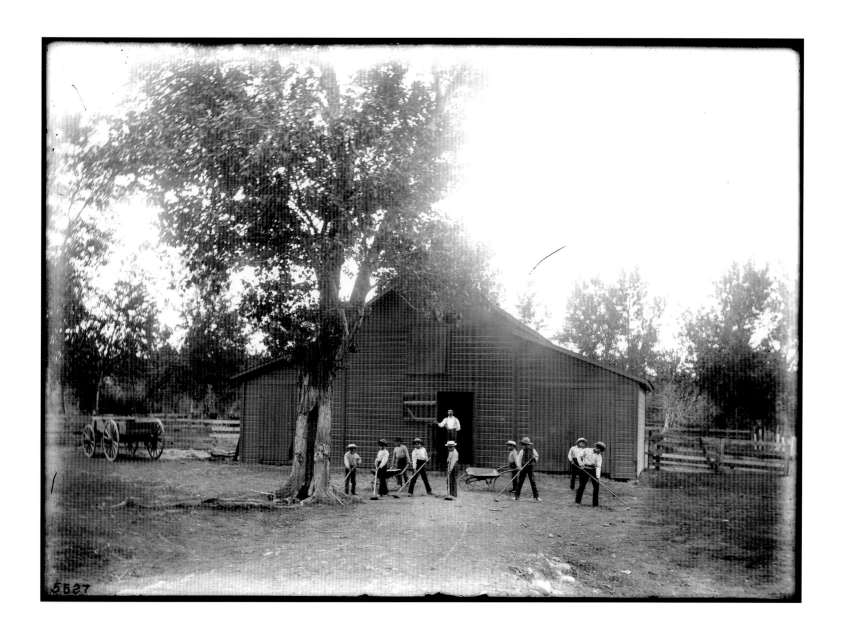

Plate 48

Boys' Band, St. Andrew's Roman Catholic Mission School, Umatilla Reservation, c. 1905. UO PH036-5575.

St. Andrew's Catholic Mission was located four miles southeast of the Umatilla Agency. The mission's boarding school, the Kate Drexel Institute, opened in 1890 with four resident nuns and thirteen pupils. The student body rapidly grew, and an addition was built several years later. In his July 1891 report to the commissioner of Indian affairs, Lee Moorhouse reported: "The average attendance for the year has been about 45 pupils, and I understand that the expense of running the school has thus far been borne wholly by the Church. I visited the school several times during the year, and always found the class rooms and dormitories looking neat and tidy, and the children well clothed and provided for and making rapid progress in learning."

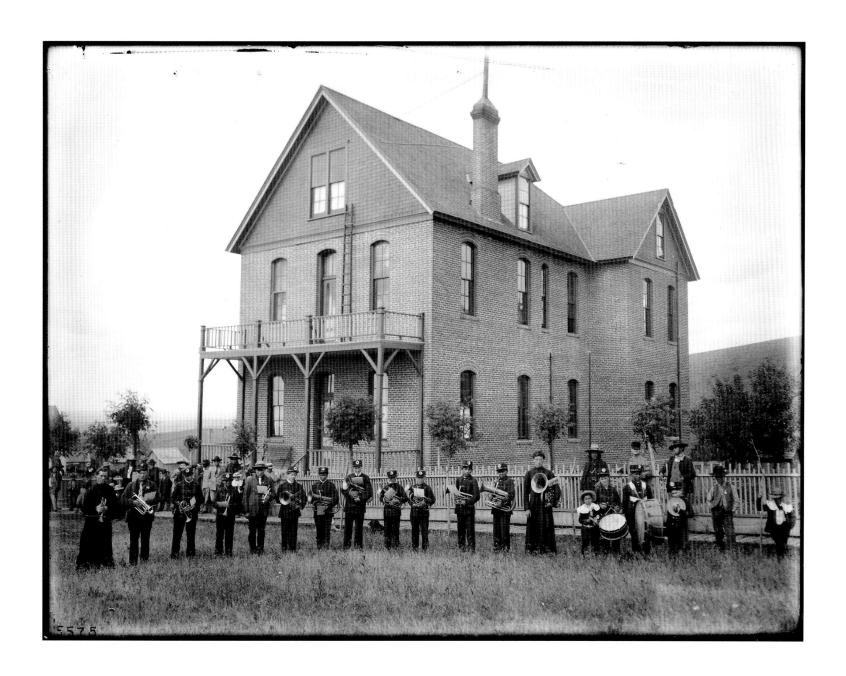

Presbyterian Mission,
Christmas 1900.
UO PH036-5540.

Plate 49

Indian Presbyterian Church, Umatilla Reservation, c. 1905.

UO PH036-5555.

The residents of the Umatilla Reservation were without a white Protestant missionary for a half-century following the death of Dr. Marcus Whitman in 1847. Nez Perce preachers, however, served the Presbyterian faithful during the 1880s and 1890s. In 1899 the Reverend James M. Cornelison arrived in Pendleton and began more than forty years of service at the Tutuilla Indian Mission. Cornelison married Lee Moorhouse's daughter Celestine ("Lessie") in 1930 and was living in the Moorhouse family home in Pendleton when it was destroyed by fire in 1966.

The two men in black suits near the center of the group photograph are Nez Perce ministers. James Cornelison is the sixth man from the right. He was known to the local Indian population as *soyáapo soyapo,* or "little white man."

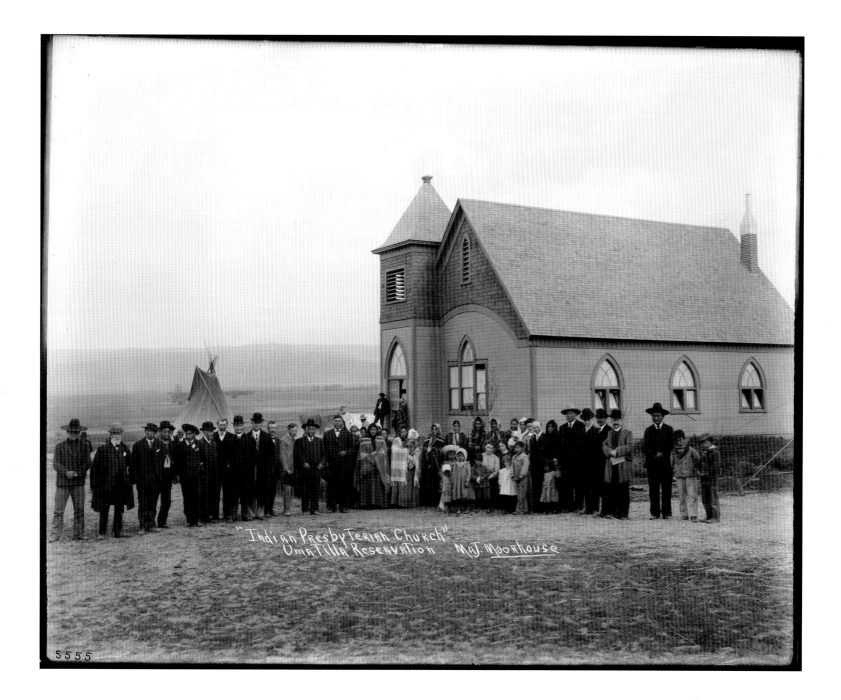

"Indian Presbyterian Church"
Umatilla Reservation Maj. Moorhouse

5555

Plate 50

Converts of Dr. Marcus Whitman, Umatilla Reservation, c. 1900.
NAA 02890-B30.

Moorhouse identified these women as A-wa-wa Ne-ta, Its-ka-ka, Its-wash-pa-lo, Nuen-sa-poo, Ish-tansh, Ip-na-so-la-talc, and Atok-sus-pum. They were the surviving converts of the missionaries Marcus and Narcissa Whitman, who were killed at their mission station at Waiilatpu in November 1847. In "The Moorhouse Indian Photos," a 1905 article in the magazine *The Coast,* the photographer was quoted as saying of Ip-na-so-la-talc, "This old Indian woman remembers well her teachers and can sing English hymns and recite bits of scripture in English and yet cannot talk a word of the language. These were taught her years ago by that famous couple. She has a book which Mrs. Whitman gave her and which she treasures dear as her life."

In the same article, a photo of the woman identified here as Nuen-sa-poo is identified as "Ip-na-sal a-talc, Last Living Pupil of Dr. Marcus Whitman and Wife."

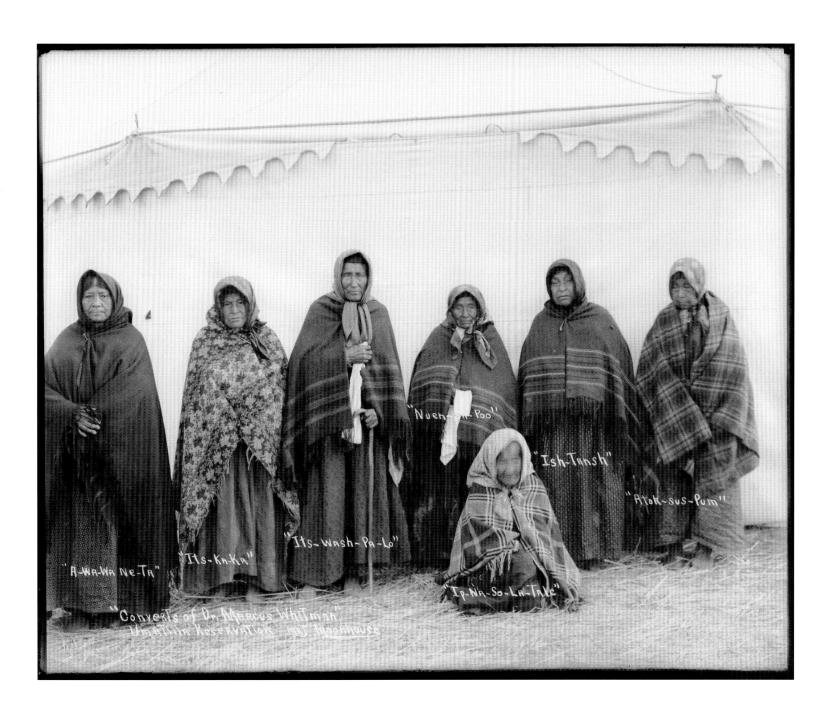

"A-Wa-Wa Ne-Ta" "Its-Ka-Ka" "Its-Wash-Pa-Lo" "Nuen-sh-Poo" "Ish-Tansh" "Atok~sus~Pum"

"Ip-Na-So-La-Talc"

"Converts of Dr. Marcus Whitman"
Umatilla Reservation Maj Moorhouse

PLATE 51

Dwellings of Columbia River Indians, c. 1900. UO PH036-6111.

Moorhouse took this photograph on the Columbia River near present-day Umatilla, Oregon. The starkness of the land immediately adjacent to this portion of the Columbia River is evident. The artist Paul Kane traveled through the region in July 1847 and wrote: "I . . . took a gallop of seven or eight miles into the interior, and found the country equally sterile and unpromising as on the banks of the stream. . . . the ride, although uninteresting as regarded landscape—for not a tree was visible as far as the eye could reach—was still a delightful change to me from the monotony of the boats."

About a similar photograph that appeared in *The Coast* in 1905, Moorhouse wrote, "This is on the direct route of the early day staging when the pioneers came across the plains in covered wagons—'Prairie Schooners'—and is on the banks of a river than which there is no grander nor more picturesque in the world. Fabled in Indian lore and famous in pioneer history and tales, that river rushes and tumbles on in all the majesty and splendor of picturesque beauty and romantic scenery, ever a changing panorama of glory and delight."

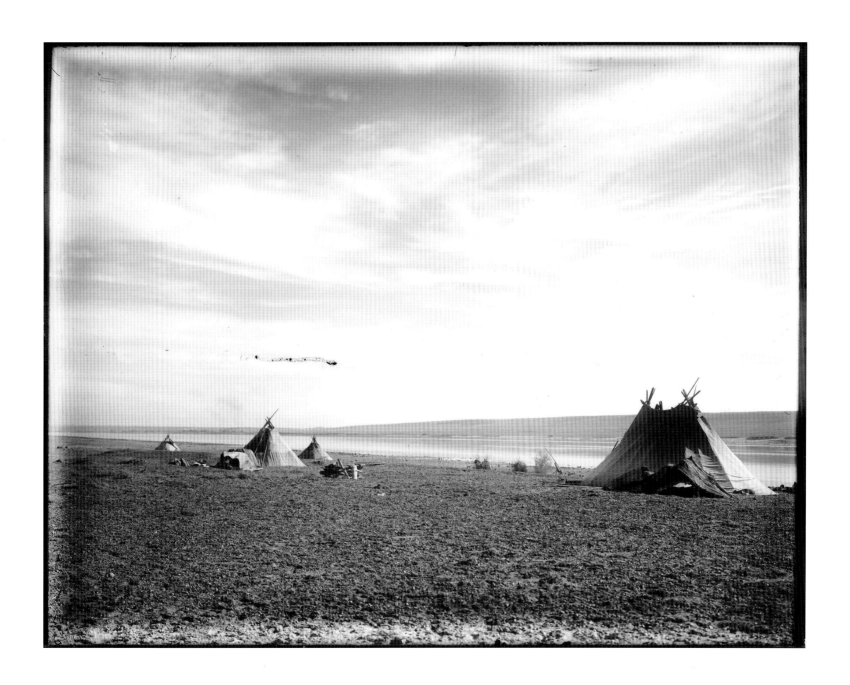

PLATE 52

Log Canoe on Columbia River, c. 1900. UO PH036-6172.

The people who lived along the middle Columbia River used dugout canoes for transportation and fishing. The Umatillas were especially known for their canoe-making ability. Various tree species, including driftwood logs, were used in canoe construction. Rather than the use of adzes to shape canoe interiors, the local method was to build fires in the chosen logs. The superiority of this technique was noted by the Corps of Discovery's Patrick Gass, who in October 1805 noted: "All the men are now able to work; but the greater number are very weak [from dysentery]. To save them from hard labour, we have adopted the Indian method of burning out the canoes."

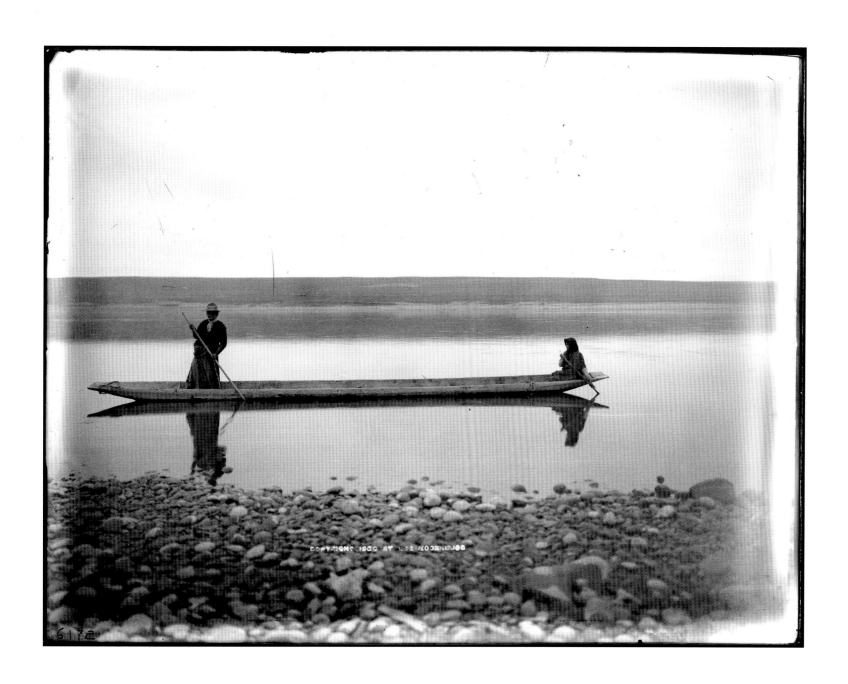

6172

PLATE 53

Palouse Tribe, near Pasco, Washington, c. 1900. NAA 02901-H.

Palouse territory once extended along both sides of the Snake River from the confluence of the Snake and Columbia Rivers eastward nearly to the confluence of the Snake and Clearwater Rivers. The Palouse were not assigned any autonomous territory during the 1855 treaty negotiations. Some Palouse leaders signed the 1855 Walla Walla Treaty, but few of their people relocated to the Yakama Reservation. In the decades that followed, several governmental commissions considered the situation of those Palouse who were yet living on their ancestral land. Palouse people now live on a variety of Northwest reservations.

Moorhouse took this photograph at Ainsworth, Washington, which lies immediately north of the confluence of the Snake and Columbia Rivers. Historically, numerous Wanapum people also lived in the settlement. A Northern Pacific Railroad bridge across the Snake River was completed there in 1884.

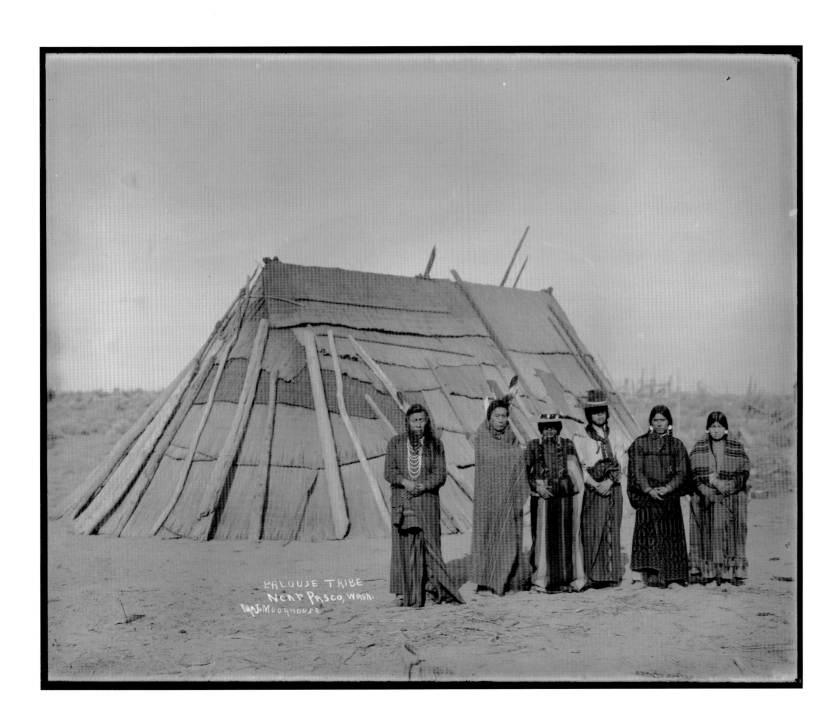

PALOUSE TRIBE
NEAR PASCO, WASH.
MAJ. MOORHOUSE

Plate 54

Columbia River, near Wallula, Washington, 1902. UO PH036-1836.

These basalt formations are on the east bank of the Columbia River at Wallula Gap. They lie several miles downriver from the confluence of the Snake and Columbia Rivers and near the site of Fort Nez Perces. Paul Kane described the rocks in this way during his 1847 passage: "As we approached the place where the Walla-Walla debouches into the Columbia river, we came in sight of two extraordinary rocks projecting from a high steep cone or mound about 700 feet above the level of the river. These are called by the voyagers the Chimney Rocks, and from their being visible from a great distance, they are very serviceable as landmarks."

The rocks are also known as the Twin Sisters and the Cayuse Sisters. According to one legend, Coyote fell in love with three sisters who were building a salmon trap on the river. Each night he destroyed their trap, and each day the women rebuilt it. One day Coyote found them crying and learned that they were starving because of their inability to trap fish. Coyote promised to provide them a working fish trap if they would become his wives. They agreed, Coyote kept his promise, and a long point of stones now marks the remains of Coyote's fish trap. In time Coyote became jealous over his wives. He changed two of them into these pillars, while the third became a downstream cave. Coyote then became a rock on the opposite side of the river so that he could watch over them all forever.

The Wanapum, too, held that the pillars were sisters, but that they were two wicked women who preyed on people, killing and eating them. The Creator heard the prayers of those in distress and sent a great bird that killed the women and turned them into stone.

Wishram Indian Village, c. 1900. UO PH036-4568.

In modern usage the name of these people is spelled Wishxam, but it appeared in many variants in the past. In the section "The Chinookan Tribes" in his *The North American Indian,* Edward S. Curtis offered the following: "The reader's first mental picture of the Wishham should be a scattered village community on the banks of the mighty Columbia. Their homes were not tents of skin, nor wickiups of reeds, but rather substantial structures of rived timbers and planks. Close before the village flows the river, and behind it rise the bare or scantily wooded bluffs. They neither wandered far in quest of buffalo nor tilled the soil, but for sustenance depended on the fish taken from the river, and on roots and plants gathered from hillside and meadow."

This view looks east. The village was situated on the north bank of the Columbia River about seven miles upriver from The Dalles, Oregon. It was covered by the waters of Lake Celilo when The Dalles Dam was completed in 1957.

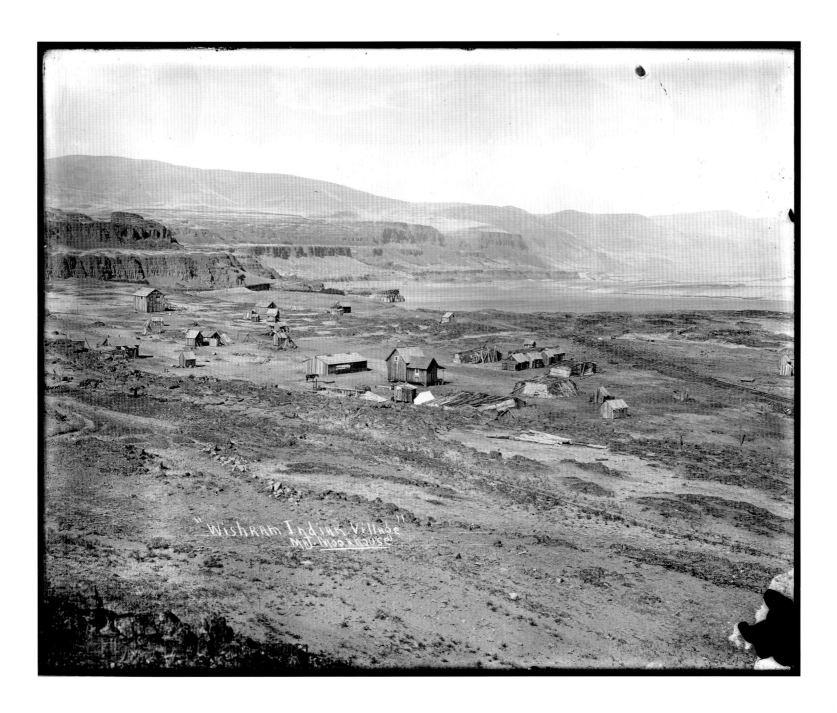

"Wishram Indian Village"
Maj. Moorhouse

PLATE 56

Wishram Indians, Columbia River, c. 1900. UO PH036-4565.

These Wishxam women are all carrying twined or beaded bags, and several wear classic Plateau-style hide dresses. The women on the left are heavily adorned with shell jewelry, including large quantities of dentalium (*Dentalium pretiosum* and others).

Before white contact, the area around Celilo Falls was the most important trade center in the Pacific Northwest. The people of The Dalles region specialized in processing dried salmon and prepared an estimated 1 million pounds each year solely for trade purposes. Trade goods from all compass points exchanged hands here, and dentalium shells from the Pacific coast functioned as a common currency. European and American fur traders also used the shell as a trade commodity.

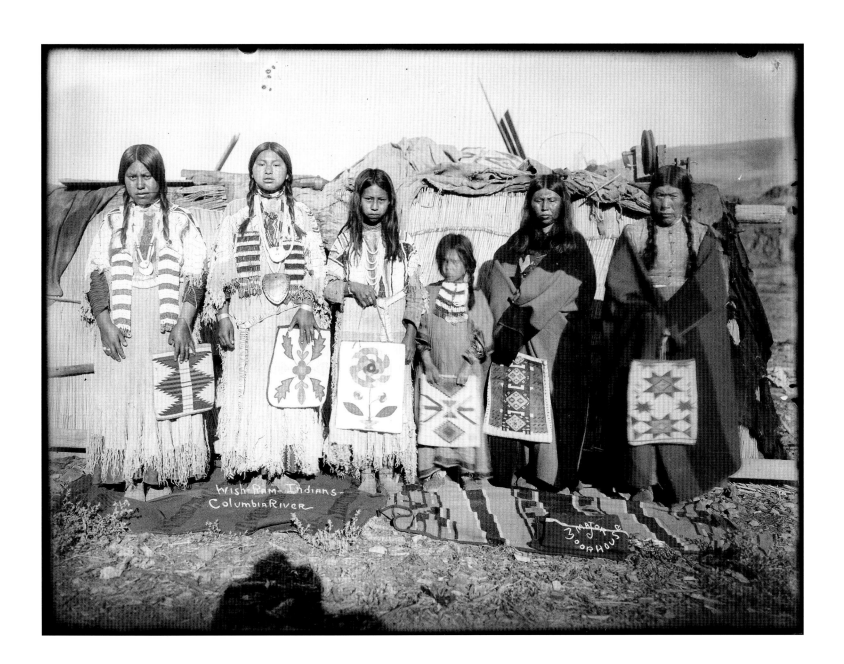

Wish-Ram-Indians-
Columbia River

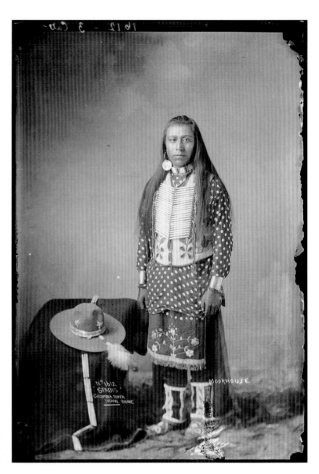

Thomas H. Rutter (signed "Moorhouse"),
Spadis, Columbia River Indian Brave, c. 1900.
UO PH036-4151.

PLATE 57

Wishram Indians, Columbia River, c. 1900. UO PH036-5030.

Moorhouse identified the men in the group photo as John Walitsee, Tots-homi, and Martin Spedees. Martin Spedis was the youngest of the three. He was a leader on the Yakama Indian Reservation during the 1930s and 1940s. The North Yakima photographer Thomas H. Rutter made at least two portraits of him, although both are now signed "Moorhouse." In the one reproduced above, Spedis is standing. He is seated in the other view (NAA 03012-C-6), which is titled *Spadis, Columbia River Chief.*

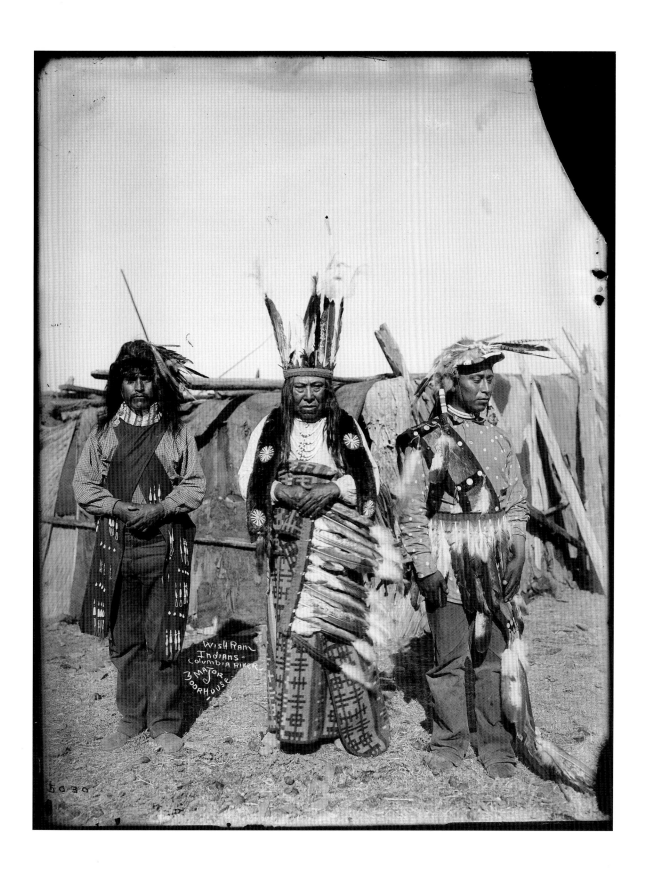

Plate 58

Wishram Indians with Hand Bells, c. 1905. UO PH036-4567.

The Indian Shaker Church was founded by a Southern Coast Salish man, John Slocum, in 1882. In the very early 1890s Slocum and several of his colleagues visited the Yakama Reservation and there cured a Wishxam woman. The religion then attracted many regional adherents.

Crosses, candles, and other Christian symbols are used in Shaker services. These people are holding a variety of sizes of the handbells that were used in their worship. The photo was taken in the vicinity of Spearfish Village, on the Washington side of the Columbia River near present-day Horsethief Lake State Park.

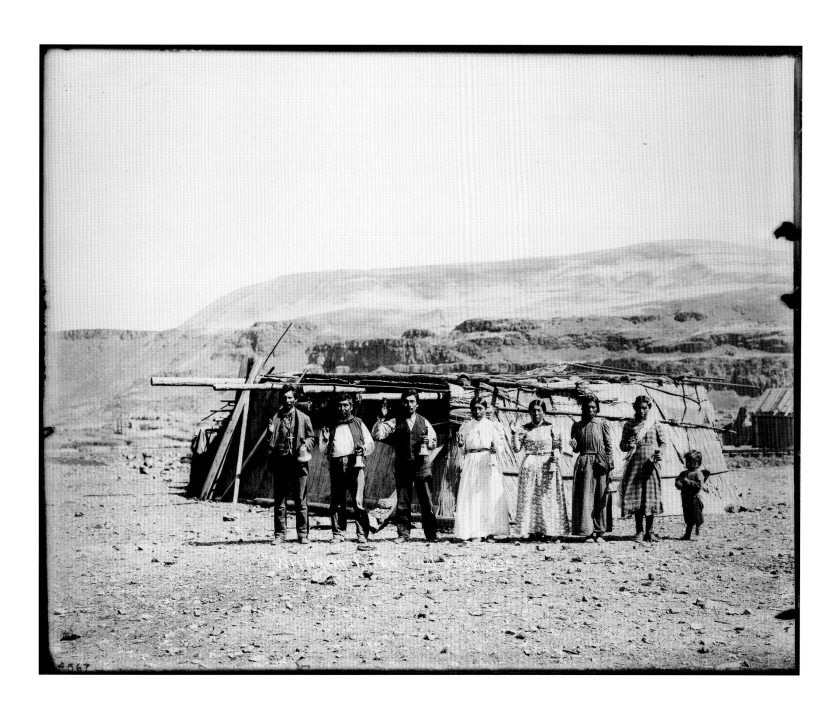

PLATE 59

"Stone Implements" Owned by Subert Brothers, The Dalles, Oregon, c. 1903. UO PH036-6239.

Francis A. Seufert and Theodore J. Seufert were New Yorkers who came to The Dalles area in the early 1880s. There they established a cannery and constructed multiple fishwheels.

For several generations the white residents of the middle Columbia River region collected stone objects found at the traditional campsites of Indian families. Portions of the Seufert collection are included in the holdings of the Columbia Gorge Discovery Center and Museum in The Dalles and at the Maryhill Museum of Art in Goldendale, Washington. The carved wooden male figure on the middle shelf is in the collection of the Field Museum of Natural History. It was reportedly collected on upper Memaloose Island before 1905 and acquired from Fred Harvey.

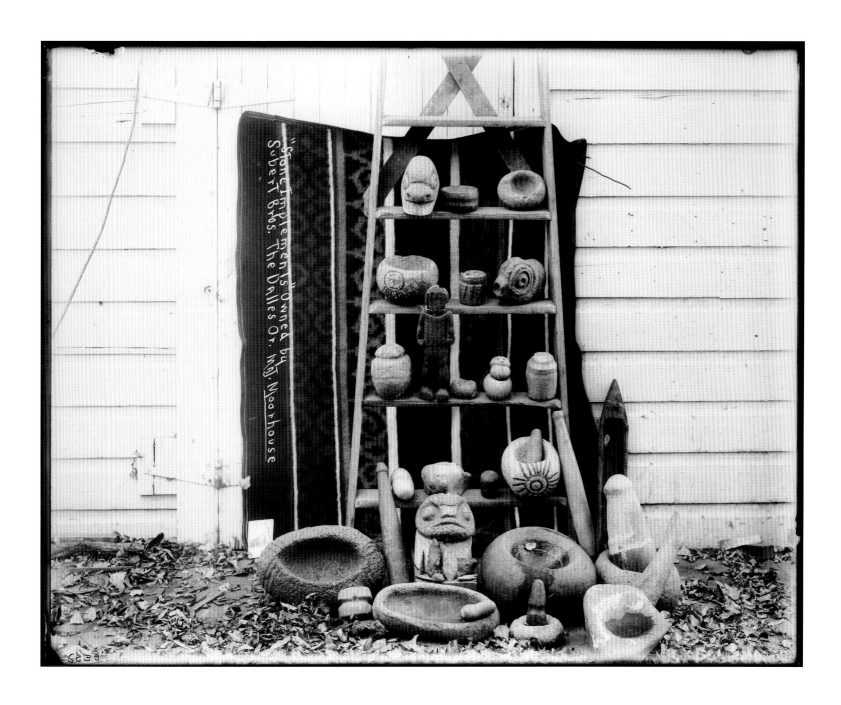

PLATE 60

Warm Springs Indian Agency, 1901. UO PH036-5581.

Agent P. Gallagher's 1896 report to the commissioner of Indian affairs (published the following year) described the Warm Springs Reservation in this way:

> This reservation is situated in middle Oregon, on the eastern slope of the Cascade Range, along the summit of which runs the west boundary. The northern boundary is nearly 50 miles south from the Columbia River in an almost direct line, and the agency lies in the southeastern part of the reservation only a mile or two from the Des Chutes River, which bounds us upon the east. . . .
>
> Altogether upland, with but a very small area of arable bottom lands lying along the creeks and rivers, this country offers but poor opportunities for the successful raising of crops. Added to this, the northern end of the reservation is annually visited by a swarm of crickets which utterly annihilate all attempts at farming. . . .
>
> The total population, according to the last census, was 945, divided among half a dozen tribes, viz, Warm Springs, Wascos, Teninos, Pi-Utes, and John Days.

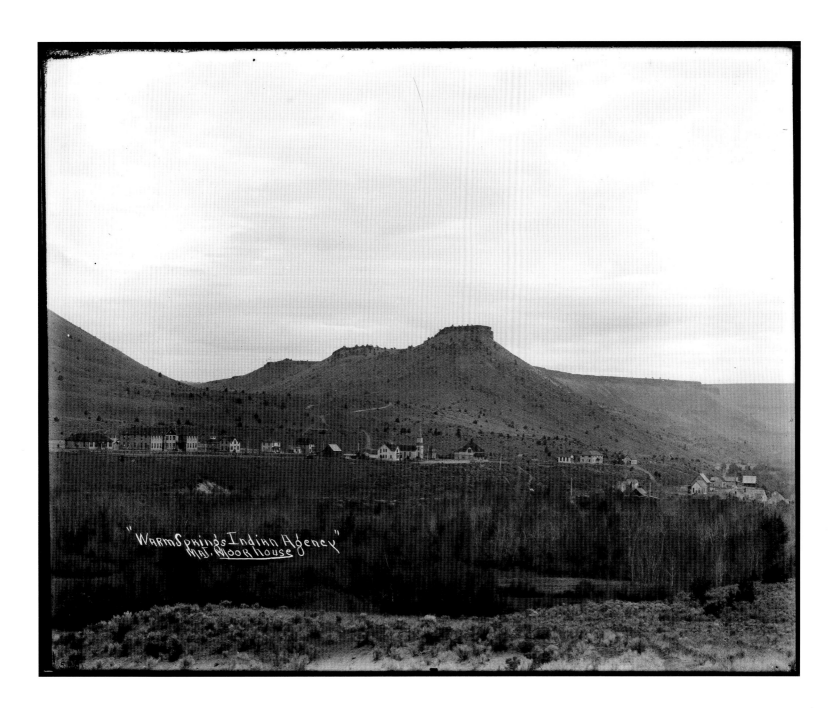
"WarmSprings Indian Agency"
Maj. Moorhouse

PLATE 61

Indian School, Warm Springs Reservation, 1901. UO PH036-5590.

In 1906, Claude C. Covey, the superintendent in charge of the Warm Springs Agency, described the local school in the following manner:

> This reservation has a boarding school at the agency, built in 1896, to accommodate 150 children. Children now on the reservation who should be in school number about 120. Much trouble has been experienced during the past in enrolling these children at the beginning of school, as the parents would take them away to the mountains and then to the hop picking and not return till almost winter. Before school opened last fall the Indians were told that all children who entered late would be kept during vacation as a summer detail. Over 40 children were kept a portion of the time and 8 all summer. This is having a very beneficial effect this year, as school opens to-day with an attendance of 79 compared with 28 two years ago today.

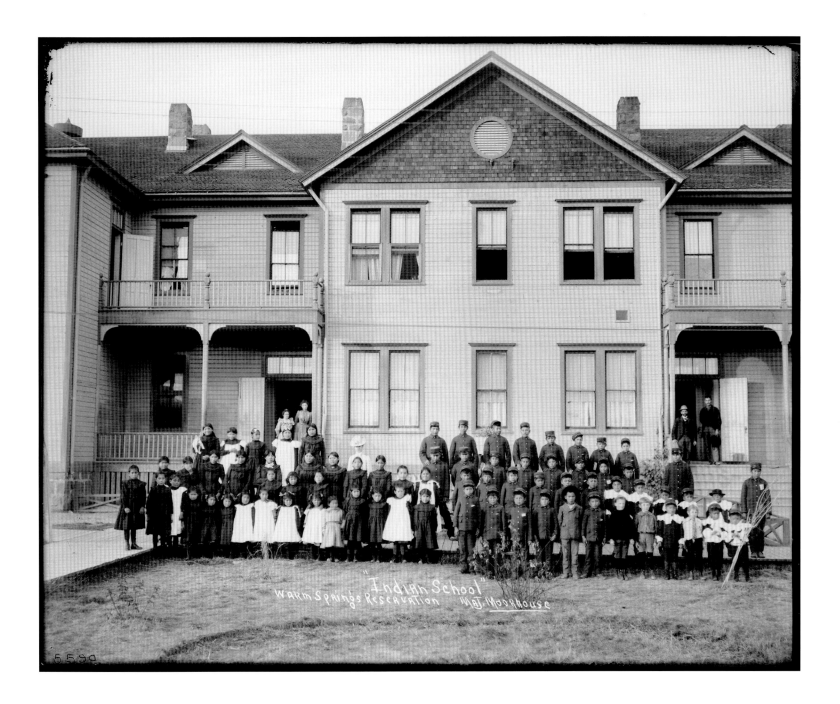

"Indian School"
Warm Springs Reservation Maj. Moorhouse

Nez Perce Reservation, July 4, 1906. UO PH036-2901.

This photograph as taken in the Lapwai Valley, a short distance above the confluence of Lapwai Creek and the Clearwater River. Many other parts of the Nez Perce Reservation are more heavily wooded than this one. Three decades before Moorhouse photographed the locale, Emily McCorkle FitzGerald, the recently arrived wife of a physician stationed at Fort Lapwai, described it: "[W]e are surrounded on all sides with high hills, not covered as our lovely old hills at home [Pennsylvania] are with big trees, but with prairie grass. There is not a tree or bush from one end of them to the other. Our post, though, is right on a little stream, the Lapwai, and its banks have some nice, big trees (mostly cottonwoods) on both sides."

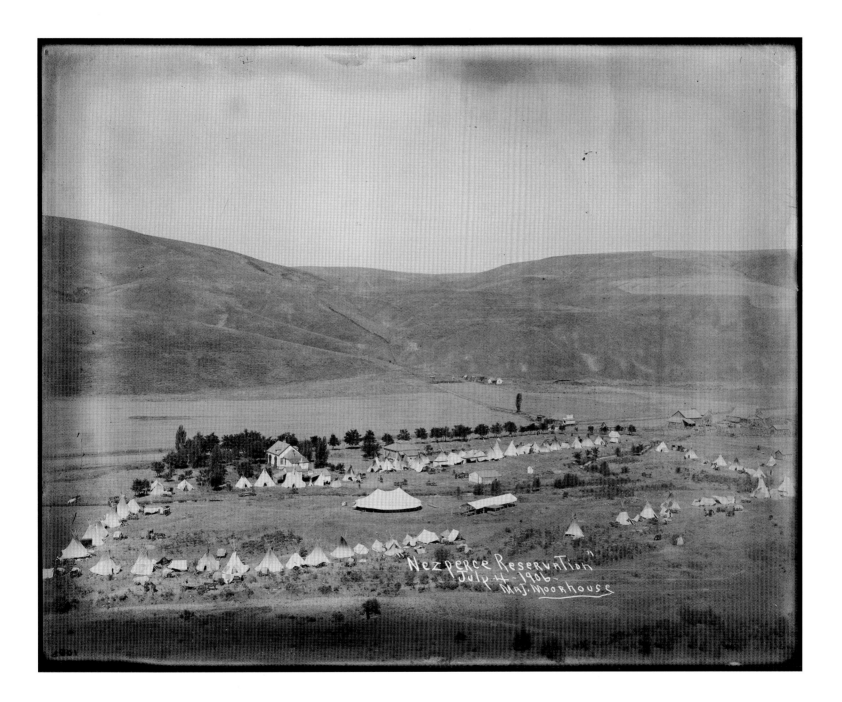

"Nezperce Reservation"
July 4 - 1906 -
Maj. Moorhouse

PLATE 63

Nez Perce Reservation, July 4, 1906. UO PH036-2902.

During the 1870s, the missionary sisters Kate and Sue McBeth instituted a celebration among the Christian Nez Perce that coincided with annual root gathering and Independence Day events. Other Nez Perce used the Fourth of July holiday as an opportunity to parade in traditional dress and race horses.

In 1887, Agent George W. Norris persuaded the two groups to hold adjacent celebrations at the Lapwai Agency. A decade later, the more traditional celebration was perceived to be adversely influencing some Christian young people, and a two-week camp meeting at a separate location was inaugurated. The parade-based event continued to be held in the Lapwai area, but Commissioner Thomas Morgan mandated that it not occur on agency property.

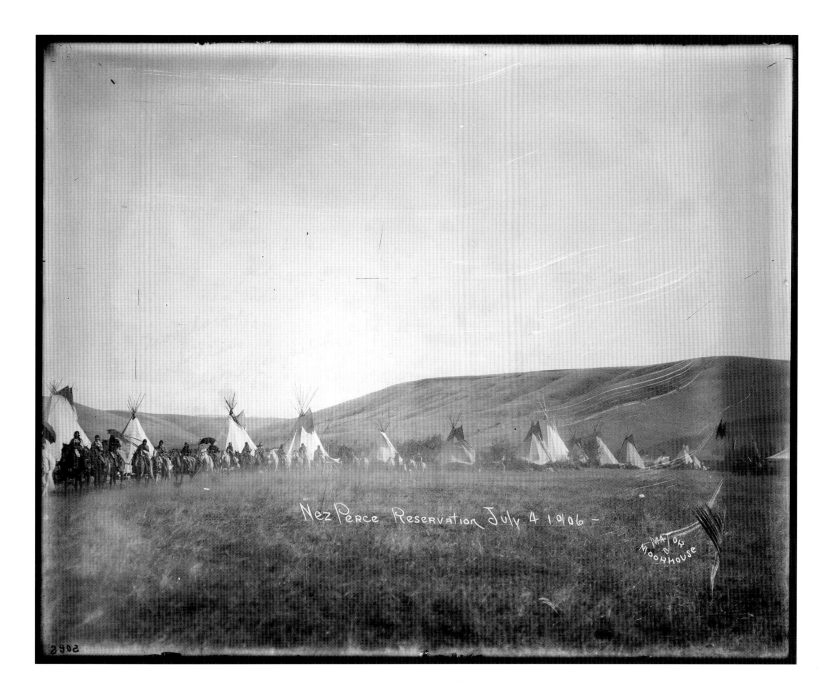

Nez Perce Reservation July 4 1906 -

PLATE 64

Nez Perce Women, 1906. UO PH036-5147.

Horses figured prominently in Plateau life, and Native people devoted considerable attention to producing beautiful equestrian accessories. Writing in the 1830s, the pioneer missionary Samuel Parker expressed his admiration of Plateau horses and their riders:

> Some of the daughters of the chiefs, when clothed in their clean, white dresses made of antelope skins, with their fully ornamented capes coming down to the waist, and mounted upon spirited steeds, going at full speed, their ornaments glittering in the sun-beams, make an appearance that would not lose in comparison with equestrian ladies of the east.
>
> Their horses are not less finely caparisoned with blue and scarlet trimmings about their heads, breasts, and loins, hung with little brass bells.

Parker's contemporary, Henry Harmon Spalding, was not known as a proponent of American Indian finery. He nonetheless wrote to friends shortly after his 1836 arrival at the Hudson's Bay Company's Fort Nez Perces: "Let me tell the dear Christian ladies who lay out the Lord's money to appear fine, could they see a Nez Perces woman with herself and [horse] equipped, pass through one of their cities, they would go to their drawing room, take down their sham trappings and cast them into the fire, as not worth noticing in comparison with the splendid equipage of a Nez Perce lady and her milk-white steed."

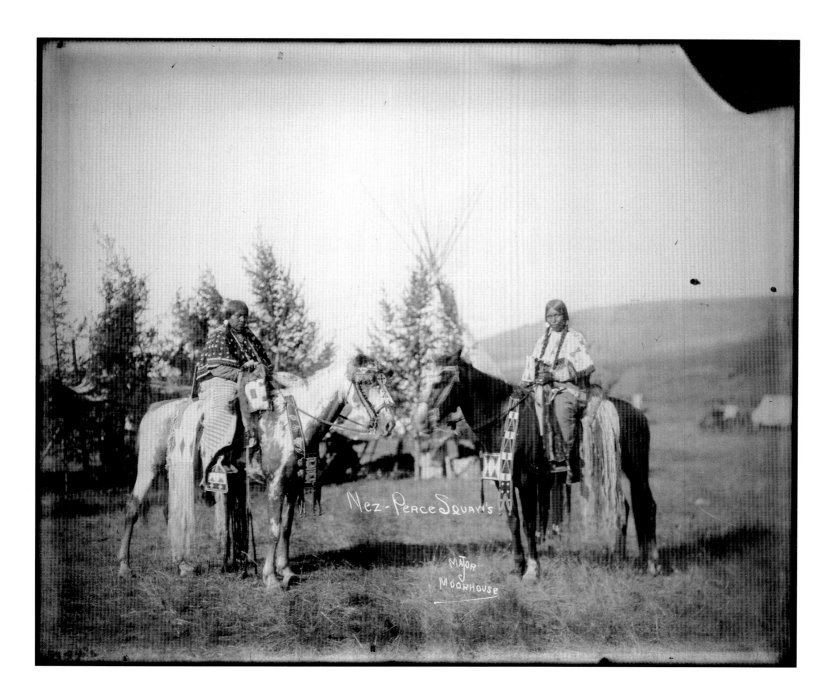

Nez-Perce Squaw's

Major Moorhouse

PLATE 65

Nez Perce Tribe, 1906. NAA 02987-B-16.

Several critics of the Fourth of July celebrations in the Lapwai Valley claimed that the events were instituted and given their initial impetus by employees of the Hudson's Bay Company. The missionary Kate McBeth, quoted in Allen C. Morrill's *Out of the Blanket,* described them as providing considerable opportunity for traditional singing and dancing, gambling, and horse racing, with "warriors dressed in sweeping eagle feathers, riding on horses with silver mounted trappings; women in their gay blankets and highly colored handkerchiefs around their heads and daintily embroidered moccasins on their feet forever on the go or busy about their teepees; children and dogs everywhere."

A report written by William B. Dew, superintendent of the Fort Lapwai School, on July 13, 1906, recalled that at the recently completed Independence Day celebration, "the majority of this tribe, as well as delegations from others, were present, and the festivities continued for 10 days."

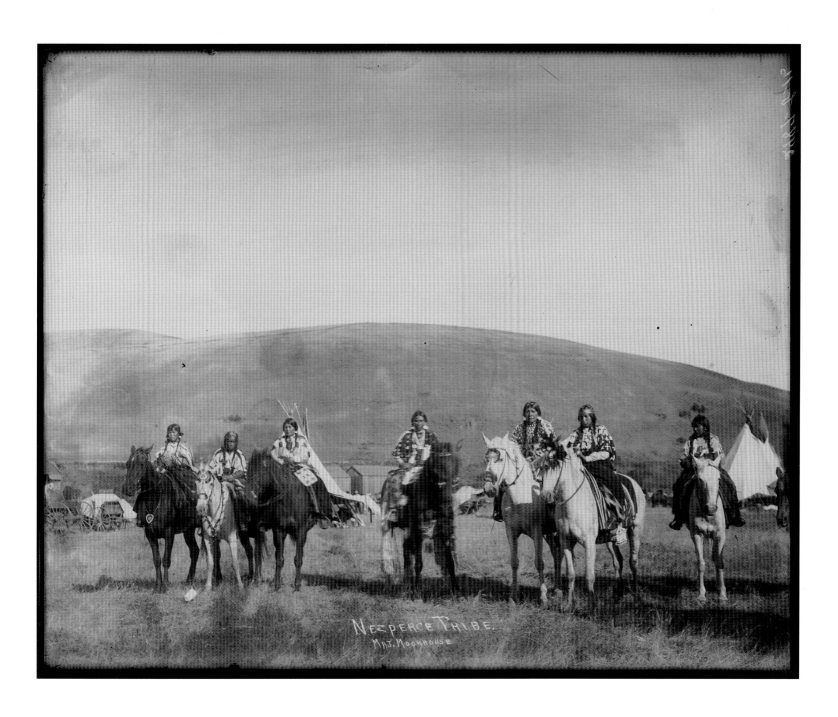

Nez Perce Tribe.
Maj. Moorhouse

174

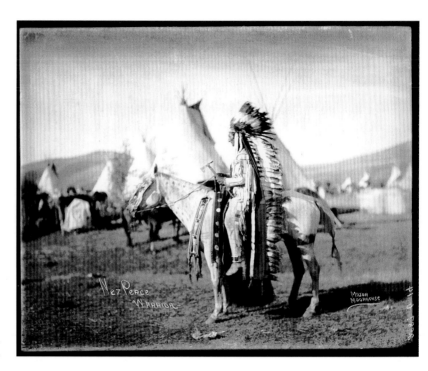

Nez Perce Warrior, 1906.
NAA 02987-B-14.

PLATE 66

Yellow Bull, Nez Perce Tribe, 1906. NAA 02987-B-11.

The subject of these photographs is Espowyes (also rendered Ess-how-ess and Ess-ko-ess), who was also known as "Light in the Mountain." He was a veteran of Indian wars in the buffalo country and was a fighter of note during the 1877 conflict. In 1878, Espowyes, Yellow Bull, and the Palouse leader Husishusis Kute (Bald Head), in company with Lieutenant G. W. Baird, traveled from Fort Leavenworth, Kansas, to Canada. There they spoke with the Nez Perce who had escaped across the international border following the Battle of Bear Paw. White Bird and others with him chose not to rejoin their compatriots, because the U.S. government had exiled those people to Indian Territory and had not returned them to Idaho, despite promises made during negotiations at Bear Paw.

With Yellow Bull, Espowyes was also one of the speakers at the 1905 dedication of the memorial to Chief Joseph in Nespelem, Washington. Why Moorhouse erroneously identified his subject in the first photo of this pair is a mystery. He would have been familiar with both Espowyes and Yellow Bull after attending and photographing the dedication of the memorial only the year before.

A celebrated Edward H. Latham photograph of Chief Joseph shows the Nez Perce leader at a 1901 Nespelem Independence Day celebration. In these photos, Espowyes's horse wears the same horse collar that then appeared on Joseph's horse.

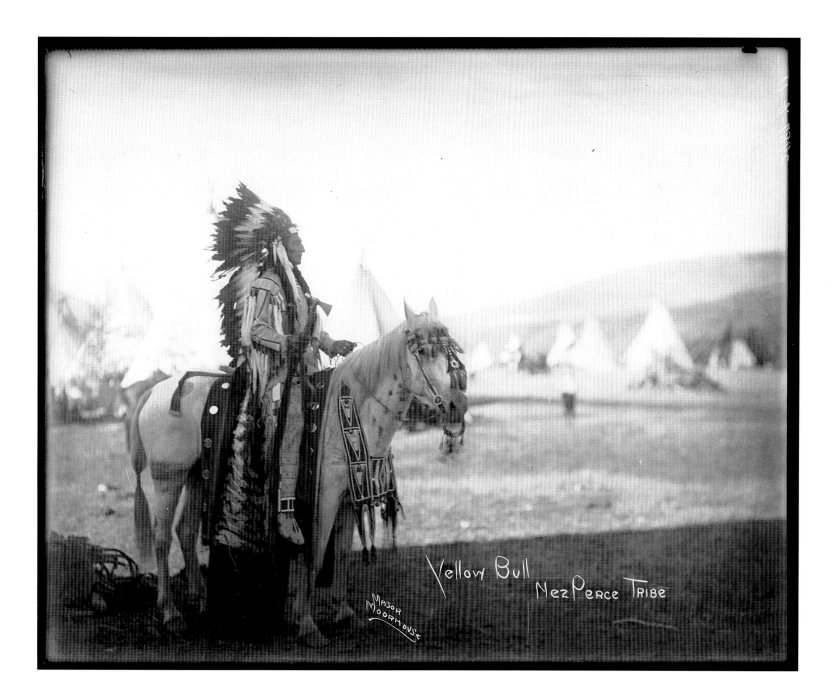

Yellow Bull
Nez Perce Tribe

Major
Moorhouse

PLATE 67

Nez Perce Warriors no. 2, July 4, 1906. NAA 02987-B-12.

In this group of riders, Yellow Bull is the man farthest to the right among those wearing feather headdresses. Espowyes is also in a headdress, immediately to the left of Yellow Bull.

This photograph and the two immediately preceding it show signs of limited emulsion deterioration. Chemical changes during the last century have caused some Moorhouse negatives to fade, stain, and yellow. The deterioration rate was accelerated prior to 1948, when the plates were stored in a basement and subject to water damage.

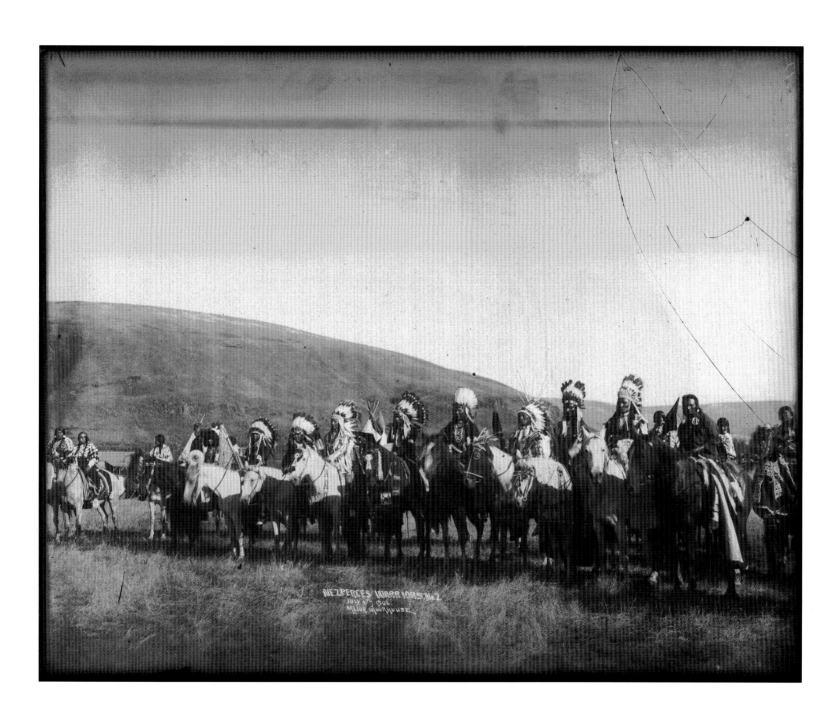

NEZ PERCES WARRIORS No 2
JULY 4th 1906
MAJOR MOORHOUSE

Indian School, Pupils, and Teachers at Nespelem, Washington, 1903. UO PH036-5597.

PLATE 68

Nespelem, Washington, 1903. UO PH036-5593.

Chief Joseph and other nontreaty Nez Perce were settled near Nespelem when their exile in Indian Territory ended in 1885. In 1889, a large portion of the surrounding Colville Reservation was opened to mining. Before that time, Nespelem had largely been a depot where Indians drew their supplies, although the government did maintain a blacksmith shop and a commissary there. The influx of miners turned the settlement into something of a regional supply center.

A federal day school first opened in Nespelem in 1890. At that time, Chief Joseph and Chief Moses argued that a boarding school would more efficiently provide an education for students, and they discouraged parents from sending their children to the day school. By 1911, six day schools were in operation on the Colville Reservation. Three of these closed the following year because of a lack of teachers.

When these photos were taken, Nespelem was a subagency for the Colville Reservation. In 1912–13 the Colville Agency headquarters were moved here from Fort Spokane.

"Nespelem Wash."
Maj. Moorhouse

PLATE 69

Home of Chief Joseph at Nespelem, Washington, 1903. NAA 02987-B-04.

In his 1901 thesis, "Chief Joseph, the Nez Perce," Edmond S. Meany wrote: "The Government built for Chief Joseph, a small rough-board, battened house and a barn on the farm he selected about four miles from the sub-agency. The Chief will not live in his house and the roof of his barn is broken in. He prefers to live in the traditional tepee, winter and summer, and this tepee he has pitched near the sub-agency, so he can be near his people and the school."

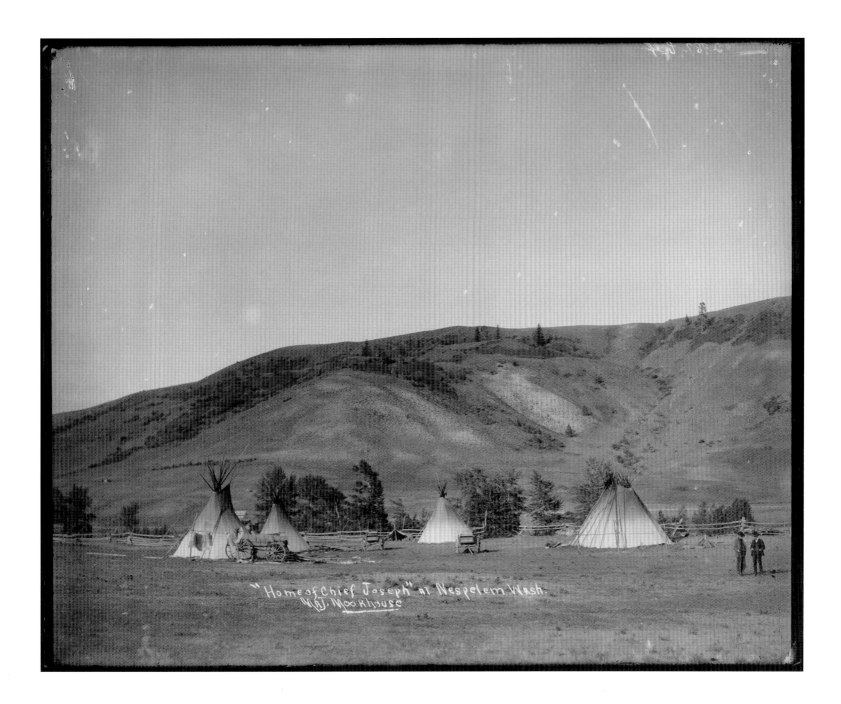

"Home of Chief Joseph" at Nespelem Wash.
W.J. Mookhouse

PLATE 70

Colville Indians, Nespelem, Washington, 1905. NAA 03034-B.

This photograph was probably taken in 1905, when Moorhouse visited the Colville Reservation to photograph the dedication of the memorial to Chief Joseph. Peo Peo Tholekt appears on the left. He was a nephew of Joseph's and a veteran of the 1877 Nez Perce conflict. He owned an allotment on Idaho's Nez Perce Reservation but came to Nespelem for the events honoring the memory of the departed leader.

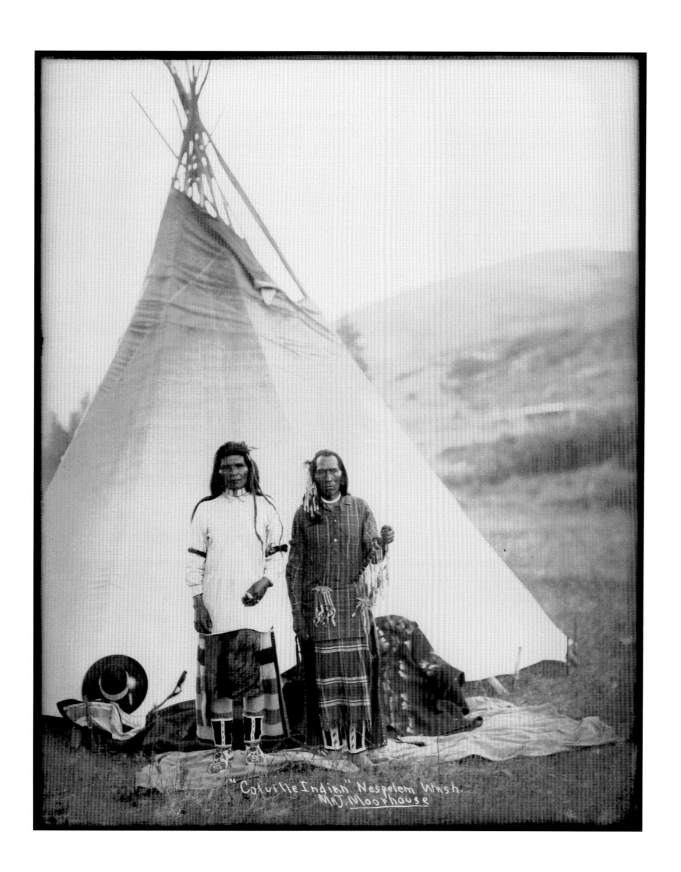

"Colville Indian" Nespelem Wash.
MaJ. Moorhouse

Colville Indians, Nespelem, Washington, 1905. NAA 03034-C.

PLATE 71

Unveiling Monument over Chief Joseph's Grave at Nespelem, Washington, June 20, 1905. UO PH036-4978.

The August 1905 report of John McAdam Webster for the Colville Agency included this sad note: "The death at Nespilem, on the twenty-first of September, 1904, of Joseph, chief of the Nez Percés, was a noteworthy event. Whatever the faults of this man, he was a born leader and the peer of our historically great red men. On June 20, 1905, at Nespilem, the place of his exile, a handsome monument of white marble was dedicated to his memory, with appropriate ceremonies, by the Washington State Historical Society, Mr. Edmund S. Meany, professor of history in the University of Washington, making the presentation in a scholarly oration. Unique and interesting addresses were also delivered by blind old Yellow Bull, sole surviving war chief of the Nez Percés [pictured]; Ess how iss, a subchief [at far left]; and Albert Waters, an intelligent and solemn young man who five days before had been elected by the Nespilem Nez Percés as the successor of Joseph. The Nez Percés are clannish and independent, but bear an excellent reputation among their neighbors."

The June 25, 1905, *Seattle Post-Intelligencer* described in this way an event it headlined "The Reburial of Chief Joseph": "The word potlatch is not in common use among the Indians here. When they refer to it they call it a feast and usually it commemorates the dead. . . . The Chief Joseph potlatch took place Friday. It was one of the greatest affairs of the kind we have any record of. The huge council lodge was filled. At the head of the lodge were gathered heaps of the worldly possessions of the late Chief Joseph. Around these sat his three nephews . . . the official announcer . . . [and] Chief Joseph's younger widow. Back of these relatives sat the blind chief, Yellow Bull. From this end of the long tepee or council lodge were ranged the men, all reclining on reed mats and robed in brilliant blankets for nearly half the length of the lodge. And beyond the men were the women and children."

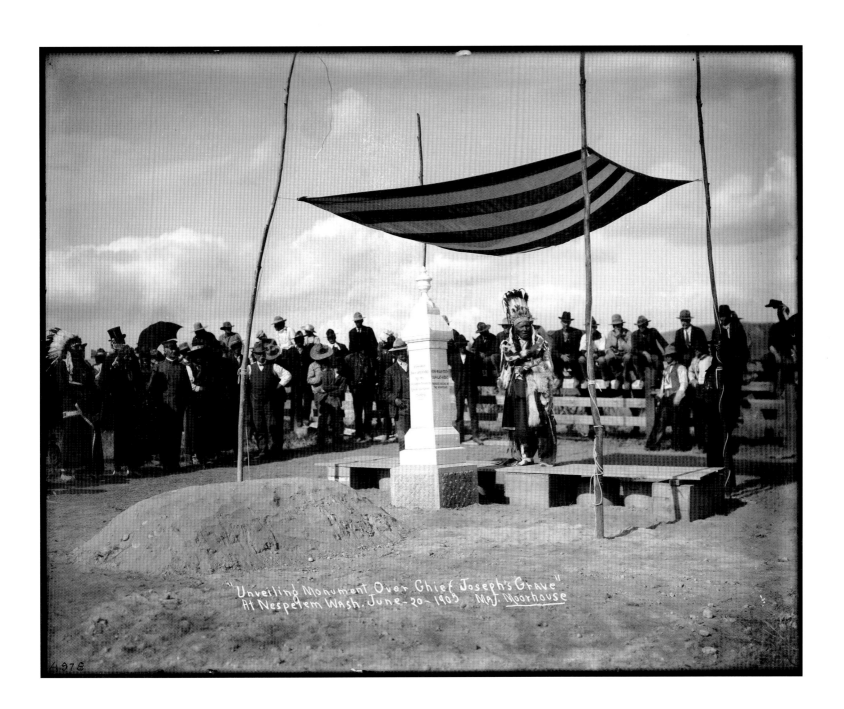

"Unveiling Monument Over Chief Joseph's Grave"
At Nespelem Wash. June-20-1905 Maj. Moorhouse

4978

PLATE 72

St. Ignatius, Montana, c. 1901. UO PH036-2976.

In his 1891 report on the Flathead Reservation, Agent Peter Ronan reported: "The school for this reservation is situated at St. Ignatius Mission, at the foot of the lofty Rocky Mountain spur known as the Mission range, and one of the most healthful and picturesque spots in the State of Montana." In 1906 one of Ronan's successors, Samuel Bellew, continued:

> The mission schools, under the charge of the Jesuit Fathers, Sisters of Providence, and Ursuline nuns at St. Ignatius, have had an increased enrollment the past year 1905–1906, with an average attendance of 183. These are nonaided schools and are doing excellent work. . . .
>
> Missionary work is confined exclusively to the Catholics. St. Ignatius Mission at St. Ignatius is conducted by the Jesuit Fathers. . . . They have a large, well-built brick church at the mission, where services are regularly held, and a smaller frame edifice at the [Jocko] agency. . . . The Indians are nearly all communicants and the attendance at worship is good. The Fathers are very zealous in their work, visiting the sick, administering the last rites to the dying, and burying the dead. On occasions when the services of a priest can not be obtained one of the older Indians conducts the funeral services in a dignified, reverent manner, that is very impressive.

The structure in the center of the photograph is the St. Ignatius Mission church. To the left of it are two buildings making up the Jesuit Scholasticate (boys' boarding school). After World War I, one of these buildings became a Jesuit residence and seminary while the other remained in use as a boy's residence and school. The white buildings to the right are the girls' residence and school and the Ursuline convent. The Ursulines taught the younger female students, and the Sisters of Providence taught the older girls.

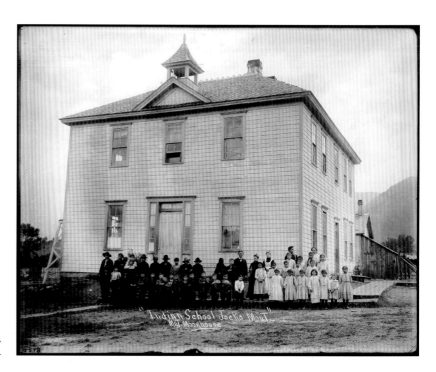

Indian School, Jocko, Montana,
c. 1901. UO PH036-5578.

PLATE 73

Flathead Reservation near Jocko Agency, Montana, c. 1901. NAA 03012-B.

The 1855 Hell Gate Treaty established the Flathead Indian Reservation for some Interior Salish people (Flathead and Upper Pend d'Oreille) and a band of Kootenai. The Jocko Agency was established in the Jocko River Valley the following year. This new reservation was intended to relocate the three groups from their traditional lands to the general vicinity of the St. Ignatius Mission. In 1887 a band of Kalispel was also moved to the reservation. Those Flatheads who had resisted relinquishing their Bitterroot Valley land were forcibly removed to the reservation in 1891.

In September 1901 Superintendent Charles F. Werner reported the following about the Flathead Reservation school: "The agency day school terminated and the boarding school opened on the 11th of February and closed for vacation the last week in June. The total number of boys enrolled for the year was 25 and girls 17, making a total of 42 children, while the school can accommodate 20 boys and 15 girls. This is only a small percentage of the number of children on the reservation who are of school age and are not in any school. Yet it was with no little difficulty that we obtained the desired number, since the agency has such difficulty in getting the Indian police to do their duty."

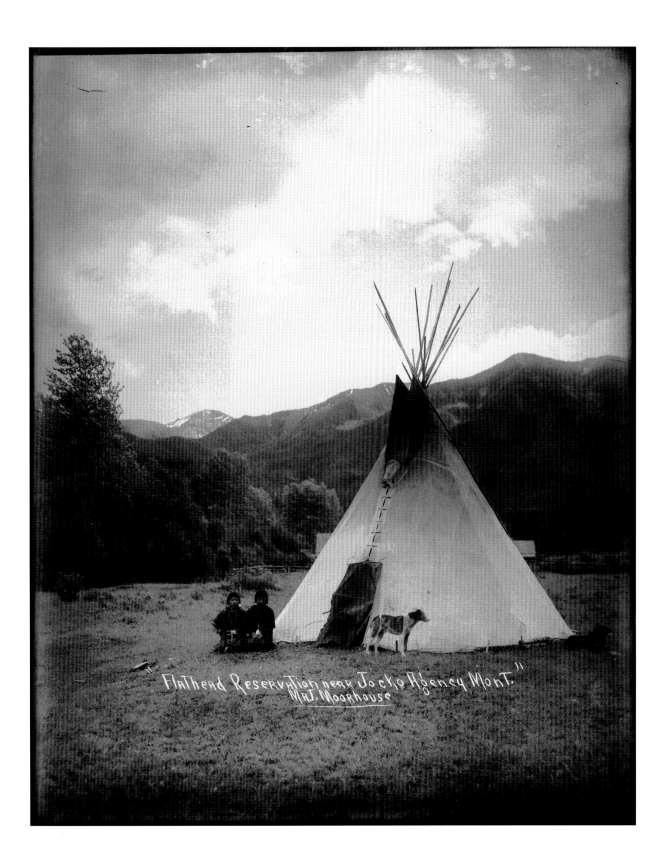

"Flathead Reservation near Jocko Agency Mont."
Maj. Moorhouse

PLATE 74

Elk Tooth Decoration, Crow Tribe, 1901. NAA 03436-G

Both Plains and Plateau peoples prized elk tushes as ornaments. In 1851 the Swiss artist Rudolph Kurz commented that the dresses of some Crow women were decorated "with rows on rows of elk's teeth placed horizontally across front and back. . . . since they are so few, [they] are very expensive; 100 of them cost as much as a pack horse, i.e. $20.00."

Moorhouse took this photograph in 1901, when he paid a visit to the nearby Little Bighorn battlefield. He made thirty photos of the historic site at that time.

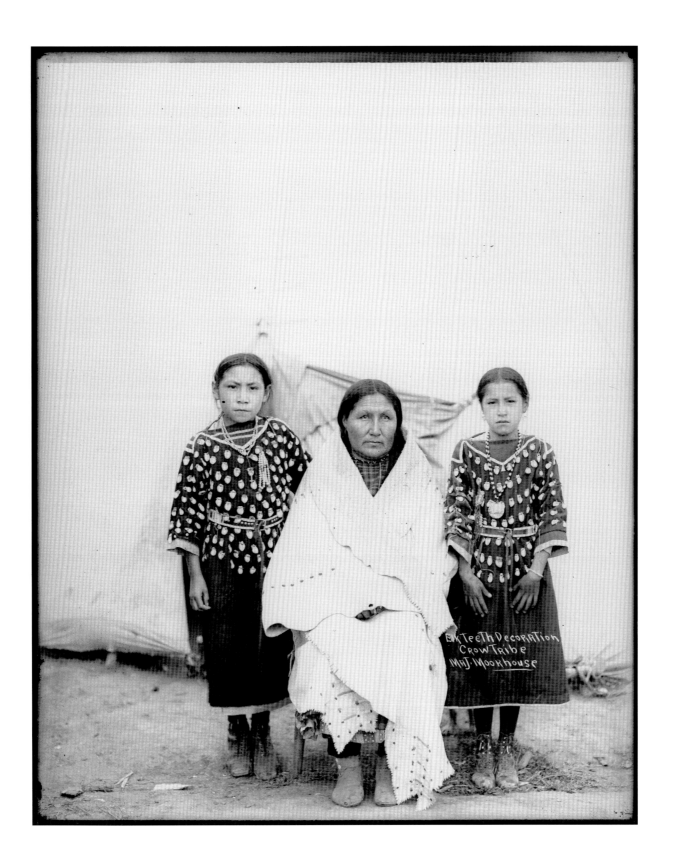

Plate 75

Thomas H. Rutter, *White Swan, Head Chief of Yakimas,* 1900. NAA 02880-C-12.

White Swan (Joe Stwire), a Klikitat, was the first elected chief of the Yakamas. He assumed this role in 1868 with encouragement from Methodist minister and then agent Rev. James H. Wilbur. White Swan had been one of Wilbur's early converts. After his conversion he became an opponent of those who continued to practice traditional Indian religions. White Swan appears in the Moorhouse Collection in over a dozen Rutter photos. Many of these are group shots.

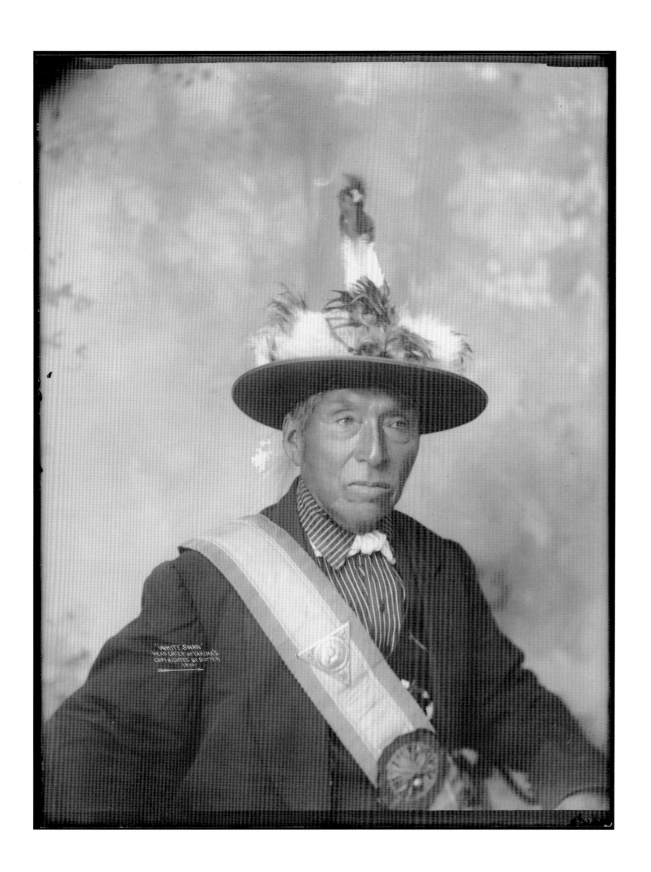

WHITE SWAN
HEAD CHIEF OF YAKIMAS
COPYRIGHTED BY RUTTER
1900

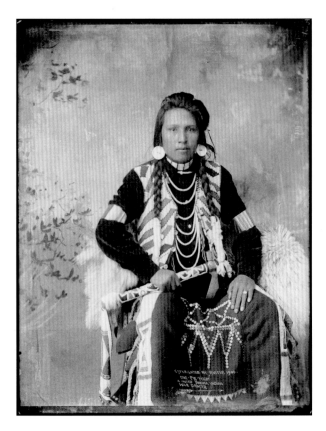

194

Thomas H. Rutter,
One-Pie-High, a Noted Indian War Dancer,
c. 1900. NAA 02880-C-06.

PLATE 76

Thomas H. Rutter (signed "Moorhouse"), *Yakima,* c. 1900.
UO PH036-5129.

The backdrop evident in these photos appears behind various Yakama subjects in photographs bearing Moorhouse's signature but actually taken by Rutter. The formality, composition, and quality of Rutter's portraits stand them in marked contrast to the images Lee Moorhouse made in his backyard studio.

A second Rutter image (not shown) of the man here called "Yakima" identifies him as "Alexander" (UO PH036-4785). In both instances he wears the same leggings and breechclout and holds the same tomahawk as those seen here on One-Pie-High.

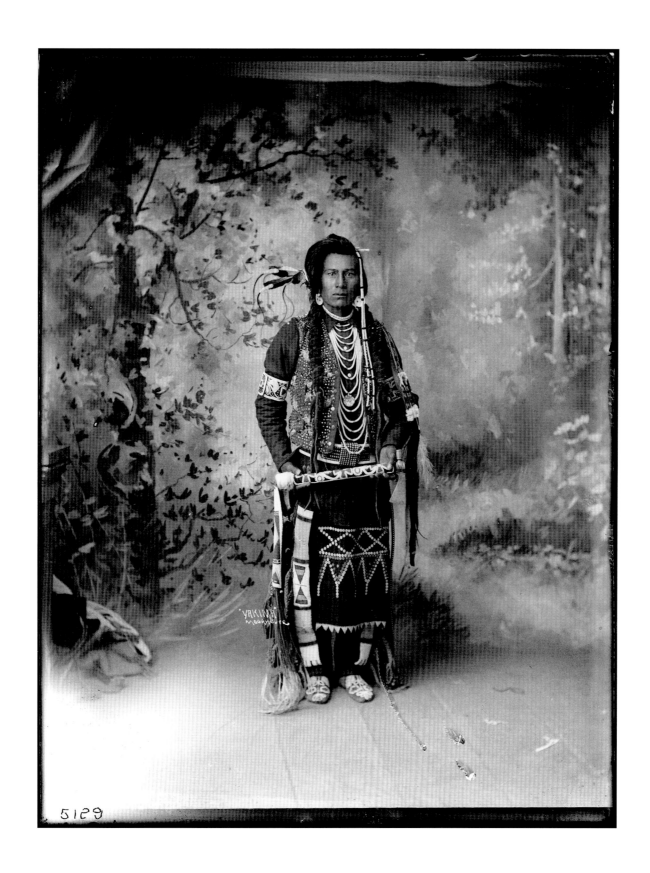

PLATE 77

Thomas H. Rutter, *Captain Jack and Family, Yakima Indians,* c. 1900.
NAA 02880-C-03.

As was true on the Umatilla Reservation, Yakama women of this period wore wing dresses over long-sleeve cotton dresses. Beaded belt pouches such as the one worn here by Captain Jack were standard masculine accessories.

The plain backdrop evident in this photo allowed the photographer to white-out the area behind his subjects. This technique was applied in numerous images from Rutter's studio, many of which also show flooring covered with straw.

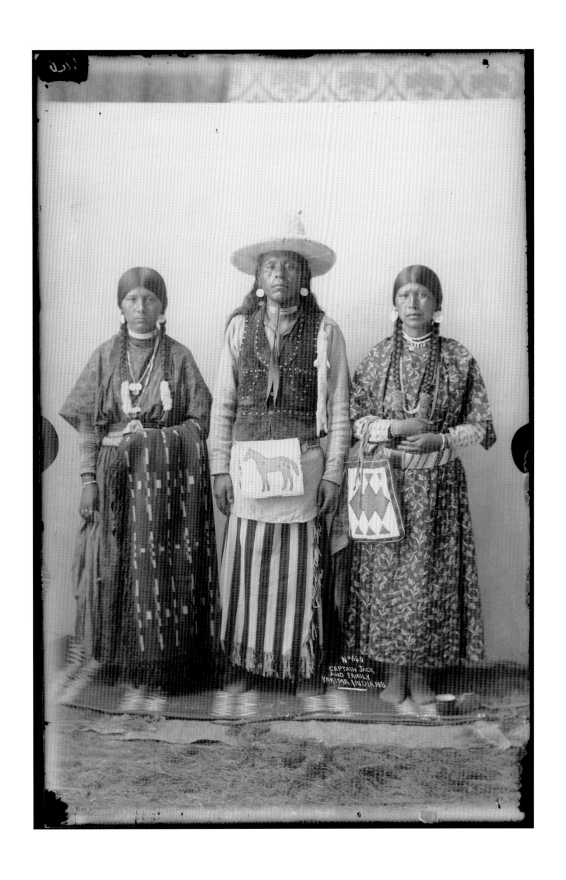

Nº 660
CAPTAIN JACK
AND FAMILY
YAKIMA INDIANS

PLATE 78

Thomas H. Rutter, *Yakima Indian Children with Dog,* c. 1900. UO PH036-4840.

These young people are Mattie (left), her sister, and her brother, Tom-keo, the children of Who-is and Susan Spencer, of Klickitat, Washington. Mattie Spencer was the maternal grandmother of the noted Klikitat basket maker Nettie Jackson.

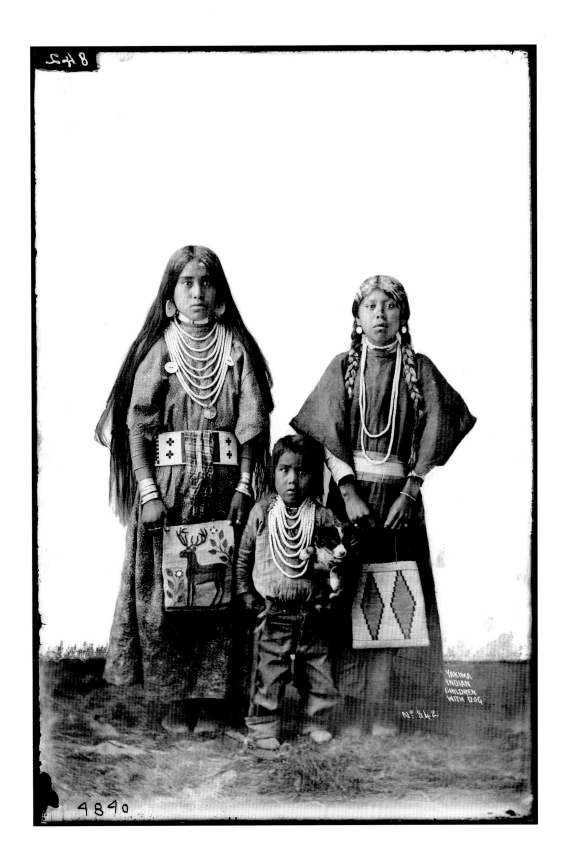

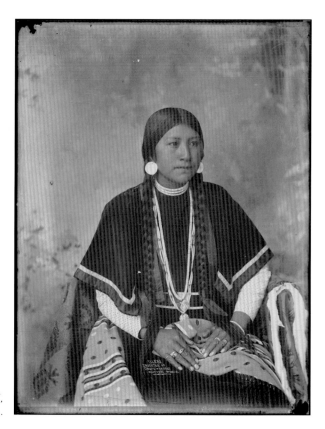

Thomas H. Rutter, *Ellen, Daughter of Shuta-Moni,*
c. 1900. NAA 02880-C-08.

Thomas H. Rutter, *Wife and Daughter of Shuta-Mo-Ne,* 1900.
NAA 02880-C-09.

A fair number of the photographs that can be attributed to Thomas Rutter were taken outside of his studio. This image of the wife and daughter of Shuta-Moni is one of several views taken on the same day. The paint visible on the younger woman's face in the larger photo suggests that the image might have been recorded coincident with some traditional religious activity. Rutter also made a formal likeness of her in his North Yakima studio.

In his other images, the photographer rendered "Shuta-Moni" as "Shut-a-mo-wani" (UO PH036-4157 and -4158) and "Shet-Mo-On-E" (NAA 02880-C-7).

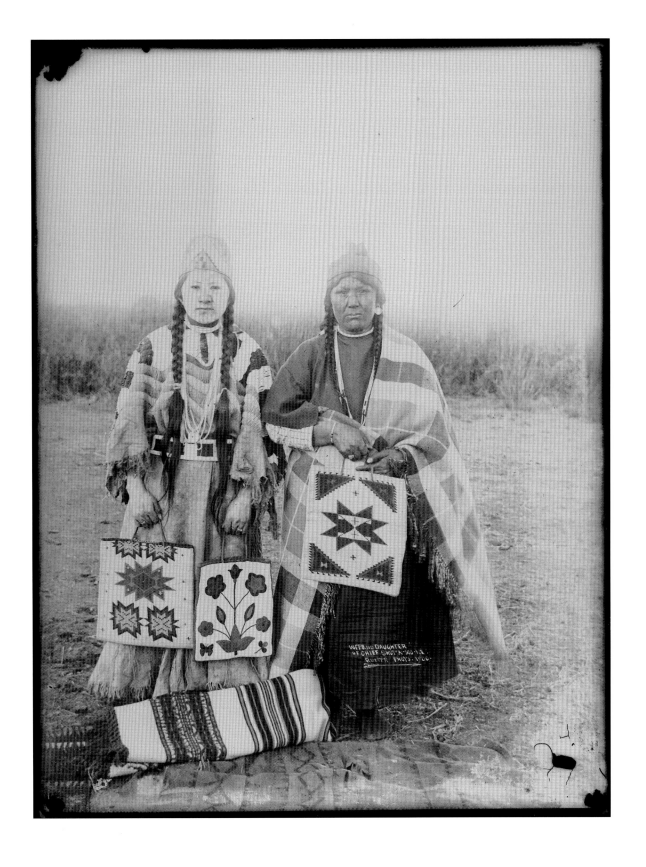

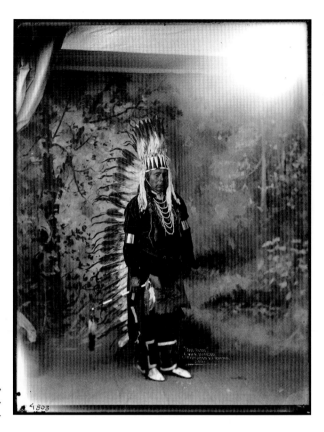

Thomas H. Rutter,
Yah-teen, Yakima Indian in Dancing Costume,
c. 1900. UO PH036-4803.

PLATE 80

Thomas H. Rutter, *Yakima Indian War Dancers at Fairgrounds,* 1903.
NAA 02880-C-19.

In the group photo of this pair, the central figure with the upright headdress is a man elsewhere identified as "Yah-teen." He appears in two Rutter studio portraits. One is reproduced here, and the other is UO PH036-4835.

Plateau people have a long tradition of adorning their faces and bodies with paint. The man to the right of the drum has a pattern of white dots painted on his bare legs.

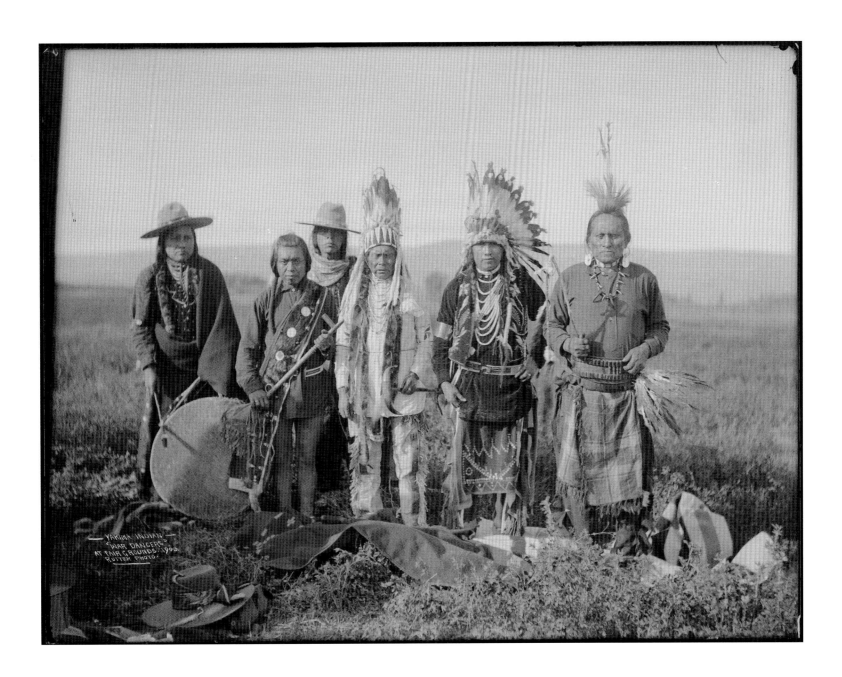

1. Henry Bowman's son, Walter Scot Bowman, became a Pendleton commercial photographer of some note. The W. S. Bowman photo collection—approximately 360 images—is in Special Collections at the University of Oregon's Knight Library.

2. Sarah Ella Willis was her husband's junior by six years. She, too, had attended Whitman Seminary. The couple ultimately had four children: Celestine ("Lessie"), Augusta ("Gussie"), Mark, and LaVelle.

3. Fred Lockley, "Major Moorhouse Brings Fame to Babes," *Oregon Sunday Journal,* August 17, 1913.

4. Patrick Gass, *The Journals of the Lewis and Clark Expedition,* vol. 10, *The Journal of Patrick Gass, May 14, 1804–September 23, 1806,* ed. Gary E. Moulton (Lincoln: University of Nebraska Press, 1996), 166.

5. Lawrence Kip, "The Indian Council at Walla Walla, May and June 1855: A Journal," *Sources of the History of Oregon* 1, no. 2 (1897): 16.

6. John Work, *The Snake Country Expedition of 1830–1831: John Work's Field Journal,* ed. Francis D. Haines (Norman: University of Oklahoma Press, 1971), 5; John Charles Fremont, *Report of the Exploring Expedition to the Rocky Mountains* [1845] (Ann Arbor, Mich.: University Microfilms, 1966), 174. Alvin Josephy, in his *The Nez Perce Indians and the Opening of the Northwest* (New Haven, Conn.: Yale University Press, 1965), 122–23, makes reference to Cayuse at the Rocky Mountain rendezvous of 1834.

7. "Wild West in West, This Is the Land of the Strenuous Life," *Pendleton East Oregonian,* August 21, 1902.

8. William Parsons and W. S. Shiach, *An Illustrated History of Umatilla County by Colonel William Parsons and of Morrow County by W. S. Shiach* (W. H. Lever, 1902), 168. In describing nearby Fort Nez Perces in 1841, George Simpson found the Columbia River passage through the region to be similarly bleak: "The fort is surrounded by a sandy desert, which produces nothing but wormwood, excepting that the horses and cattle find a little pasturage on the hills. . . . This district of the country is subject to very high winds . . . which, sweeping over the sands, raise such a cloud of dust as renders it dangerous, or even impossible, to leave the house during the continuance of the gale. The climate is dry and hot, very little rain falling at any season." Sir George Simpson, *An Overland Journey Round the World during the Years 1841 and 1842* (Philadelphia: Lea and Blanchard, 1847), 99.

9. J. P. Wager, *Umatilla County, the Heart of the Great "Inland Empire"* (Pendleton: East Oregonian Publishing Company, 1885), 4.

10. Petition, January 16, 1889, Box 637, Field Office Appointment Papers, 1849–1907, Oregon—Indian Agency—Umatilla, Record Group 48: "Records of the Office of the Secretary of the Interior," National Archives, Washington, D.C. (hereafter RG 48, NA).

11. Lee Moorhouse, "Report of Umatilla Agency," in *Fifty-eighth Annual Report of the Commissioner of Indian Affairs to the Secretary of the Interior, 1889* (Washington, D.C.: Government Printing Office, 1889), 275–76.

12. "Back from Washington," *Pendleton East Oregonian,* December 23, 1889.

13. Benjamin H. Miller, Umatilla Agency Inspection Report, July 31, 1890, National Archives Microfilm Publication M1070, roll 54: Reports of Inspection of the Field Jurisdictions of the Office of Indian Affairs, 1873–1900, Record Group 48: "Records of the Office of the Secretary of the Interior," and Record Group 75: "Records of the Bureau of Indian Affairs," National Archives, Washington, D.C.

14. Ibid.

15. Ibid.

16. "Today's Sales," *Pendleton East Oregonian,* April 10, 1891.

17. "Sale of the Reservation Lands," *Walla Walla Daily Statesman,* April 18, 1891.

18. Lee Moorhouse, "Report of Umatilla Agency," in *Sixtieth Annual Report of the Commissioner of Indian Affairs to the Secretary of the Interior, 1891* (Washington, D.C.: Government Printing Office, 1891), 378.

19. Lee Moorhouse, "Report of Umatilla Agency," in *Fifty-ninth Annual Report of the Commissioner of Indian Affairs to the Secretary of the Interior, 1890* (Washington, D.C.: Government Printing Office, 1890), 209.

20. Daniel Dorchester to secretary of interior, November 29, 1890, Box 34, Charges and Protests Files, 1849–1907, RG 48, NA.

21. Ibid.

22. J. N. Dolph, John N. Mitchell, and Binger Hermann to J. W. Noble, December 11, 1890, Box 34, Charges and Protests Files, 1849–1907, RG 48, NA.

23. Lee Moorhouse to Binger Hermann, December 17, 1890, Box 34, Charges and Protests Files, 1849–1907, NA.

24. F. W. Vincent to Binger Hermann, December 17, 1890, Box 34, Charges and Protests Files, 1849–1907, NA.

25. W. C. McKay to Binger Hermann, December 17, 1890, Box 34, Charges and Protests Files, 1849–1907, NA.

26. James P. Bushee and James B. Eddy to the Oregon congressional delegation, December 24, 1890, Box 34, Charges and Protests Files, 1849–1907, RG 48, NA.

27. Petition, December 23, 1890, Box 34, Charges and Protests Files, 1849–1907, RG 48, NA.

28. Ibid. In the fall of 1889, a council was held on the Pine Ridge (Sioux) Reservation and a delegation was appointed to visit western Indians to learn more about a reported messiah. "The delegates chosen were Good Thunder, Flat Iron, Yellow Breast, and Broken Arm, from Pine Ridge; Short Bull and another from Rosebud, and Kicking Bear from Cheyenne River agency." James Mooney, *The Ghost Dance Religion and the Sioux Outbreak of 1890* (Lincoln: University of Nebraska Press, 1991 [1896]), 820. "On the 11th day of March, 1890, three Indians from Dakota, giving their names as Broken Arm, Elk Horn, and Kicks Back, appeared at the Umatilla Agency, in eastern Oregon, where they remained two weeks. They came without official leave, making their way across the country via the Shoshone Agency. They were quiet, well-behaved men, and made no disturbance. They conversed chiefly by signs, not knowing many words in common with the Western Indians. . . . they remained long enough to gather up the old story of the Messiah which infatuated the Oregon Indians thirty-five years before. Fearing lest, if they remained much longer, they might attempt to reinaugurate the ghost dance, Agent Moorhouse bought tickets, put these Indians on the train, and sent them home." Daniel Dorchester, "Report of the Superintendent of Indian Schools," in *Sixtieth Annual Report of the Commissioner of Indian Affairs to the Secretary of the Interior, 1891,* vol. 1 (Washington, D.C.: Government Printing Office, 1891), 529. Ironically, the petition that contains mention of this delegation was penned only a week before the tragic events at Wounded Knee, South Dakota, that are now synonymous with the Ghost Dance.

29. J. W. Strange to the Oregon congressional delegation, December 17, 1891, Box 34, Charges and Protests Files, 1849–1907, RG 48, NA.

30. J. W. Strange to Daniel Dorchester, December 17, 1890, Box 34, Charges and Protests Files, 1849–1907, RG 48, NA.

31. J. N. Dolph and John H. Mitchell to John W. Noble, December 29, 1890, Box 34, Charges and Protests Files, 1849–1907, RG 48, NA.

32. Daniel Dorchester to commissioner of Indian affairs, February 3, 1891, p. 2, Box 34, Charges and Protests Files, 1849–1907, RG 48, NA.

33. Quoted in Dorchester to commissioner of Indian affairs, p. 6, op cit.

34. Dorchester to commissioner of Indian affairs, pp. 9–10, op cit.

35. J. N. Dolph to John W. Noble, March 12, 1890, Box 34, Charges and Protests Files, 1849–1907, RG 48, NA.

36. "Strange vs. Moorhouse," *Pendleton East Oregonian,* March 27, 1891.

37. "He Leaves Tomorrow," undated *Pendleton East Oregonian* article, Box 637, Field Office Appointment Papers, 1849–1907, RG 48, NA.

38. Lee Moorhouse to John H. Mitchell, March 29, 1891, Box 34, Charges and Protests Files, 1849–1907, RG 48, NA.

39. Lee Moorhouse to J. N. Dolph, March 29, 1891, Box 637, Field Office Appointment Papers, 1849–1907, RG 48, NA.

40. J. N. Dolph to J. W. Noble, April 10, 1891, Box 637, Field Office Appointment Papers, 1849–1907, RG 48, NA.

41. In an April 1908 article Moorhouse wrote that he had "been among" the Indians of the Umatilla Reservation for more than thirty years, "and for the past ten years [I] have been making photographs of them." Major Lee Moorhouse, "The Umatilla Indian Reservation," *The Coast* 15, no. 4 (1908): 235. A February 1901 letter of introduction written for Moorhouse by author Eva Emery Dye said, "About four years ago Major Moorhouse took up amateur photography." Eva Emery Dye to A. C. McClurg and Company, February 18, 1901, A82: "Lee Moorhouse, Letters Received," Special Collections and University Archives, University of Oregon Libraries.

42. Numerous images in the Moorhouse Collection at the University of Oregon are the work of other photographers. Moorhouse acquired these images and sold some of them as his own. Pendleton photographer Charles Moore's signature appears on a number of the photographs of farm machinery and harvesting activities that are now credited to Moorhouse.

43. Many Pendleton Round-Up photos in the Moorhouse Collection are not the photographer's own work. O. G. Allen, whose portable darkroom bore the inscription "O. G. Allen, Itinerant Artist, Pendleton, OR," made many of these. Allen was active in Pendleton after about 1910 and was an official Round-Up photographer in 1911 and 1912. He suffered periodic bouts of mental illness. In a celebrated August 1913 episode, Allen escaped from St. Anthony's Hospital, stole a car, drove through the front door of the Pendleton Drug Store, and stood in the car yelling, "Let 'er buck." He was then jailed, admitted to the Eastern Oregon State Hospital, released into the care of his family, and taken to Iowa. At the time this occurred, Allen was a partner with Earl E. Gustin in Pendleton's Electric Studio. Additional Round-Up photos in the Moorhouse collection are by Gustin. After Allen's departure, Gustin had a brief partnership with the noted rodeo photographer Ralph R. Doubleday.

44. Lee Moorhouse, "Securing Indian Photographs," in his *Souvenir Album of Noted Indian Photographs,* 2nd ed. (Pendleton: East Oregonian Print, 1906), n.p.

45. Lee Moorhouse, "Indian Photography," in *American Annual of Photography for 1904* (New York: Anthony and Scovil, 1903): 80.

46. Ezra Meeker to Lee Moorhouse, December 3, 1912, A82: "Lee Moorhouse, Letters Received," Special Collections and University Archives, University of Oregon Libraries.

47. Moorhouse, "Indian Photography," 80–81.

48. Moorhouse, "Indian Photography," 81–82.

49. "The Moorhouse Indian Photos," *The Coast* 9, no. 6 (1905): 221.

50. *Cayuse Twins no. 3* (with a 1917 copyright) is PH036–5075 in Special Collections and University Archives, University of Oregon, Eugene.

51. For Moorhouse's extended commentary about Cayuse infanticide, see "Moorhouse Indian Photos," 225–29.

52. Narcissa Whitman, *The Letters of Narcissa Whitman* (Fairfield, Wash.: Ye Galleon Press, 1986), 55.

53. "Judges Award the Prize in the Poetry Contest," *Pendleton Tribune,* April 18, 1901.

54. Ibid.

55. Huffman was sometimes referred to as the poet laureate of eastern Oregon. He wrote his contributions to the *Souvenir Album* while serving as managing editor of the *Pendleton East Oregonian* newspaper. Lockley was a well-known essayist who was then circulation manager and part owner of the *East Oregonian.*

56. Eustace Cullinan, in Moorhouse, *Souvenir Album,* n.p.

57. Bert Huffman, "Lament of the Umatilla," in Moorhouse, *Souvenir Album,* n.p.

58. Fred Lockley, "Umatilla County—Old and New," in Moorhouse, *Souvenir Album,* n.p.

59. Indian imagery by regional photographers Carl S. Wheeler, H. M. Rice, and W. S. Bowman are also included in the Moorhouse Collection.

60. The shirt is now accession no. 1/4445 in the National Museum of the American Indian.

61. "Moorhouse Collection of Indian Curios," in Moorhouse, *Souvenir Album,* n.p.

62. "Indian Museum for Pendleton Is Suggested," *Pendleton East Oregonian,* January 10, 1927.

63. "Moorhouse Collection of Photographs," Historical Records Survey: 1937, Division of Women's and Professional Projects, Works Progress Administration. Oregon Collection, Oregon State Library, Salem.

64. "Historical Art Given Library," *Portland Sunday Oregonian,* January 2, 1949.

65. Lockley, "Major Moorhouse Brings Fame."

REFERENCES

Bellew, Samuel. "Report of Agent for Flathead Agency." In *Annual Reports of the Department of the Interior, 1906,* 256–57. Indian Affairs. Report of the Commissioners and Appendixes. Washington, D.C.: Government Printing Office, 1906.

Bishop, Roy T. "The Redskin at the Round-Up." *Pendleton East Oregonian,* special Round-Up edition, 1911.

Covey, Claude C. "Report of Superintendent in Charge of Warm Springs Agency." In *Annual Reports of the Department of the Interior, 1906,* 336–38. Indian Affairs: Report of the Commissioners and Appendixes. Washington, D.C.: Government Printing Office, 1906.

Curtis, Edward S. *The North American Indian,* vol. 8. Norwood, Mass.: Plimpton Press, 1911.

Dew, William B. "Report of Superintendent of Fort Lapwai School." In *Annual Reports of the Department of the Interior, 1906,* 215–17. Indian Affairs: Report of the Commissioners and Appendixes. Washington, D.C.: Government Printing Office, 1906.

Dorchester, Daniel. "Report of the Superintendent of Indian Schools." In *Sixtieth Annual Report of the Commissioner of Indian Affairs to the Secretary of the Interior, 1891,* vol. 1, 480–538. Washington, D.C.: Government Printing Office, 1891.

Edwards, O. C. "Report of Superintendent in Charge of Umatilla Agency." In *Annual Reports of the Department of the Interior, 1906,* 333–36.

Indian Affairs: Report of the Commissioners and Appendixes. Washington, D.C.: Government Printing Office, 1906.

FitzGerald, Emily McCorkle. *An Army Doctor's Wife on the Frontier: The Letters of Emily McCorkle FitzGerald from Alaska and the Far West, 1874–1878.* Edited by Abe Laufe. Lincoln: University of Nebraska Press, 1986 [1962].

Fremont, John Charles. *Report of the Exploring Expedition to the Rocky Mountains.* Ann Arbor, Mich.: University Microfilms, 1966 [1845].

Furlong, Charles Wellington. *Let 'Er Buck: A Story of the Passing of the Old West.* New York: Putnam's, 1921.

Gaither, Molly V. "Report of Superintendent of Umatilla Boarding School." In *Annual Report of the Commissioner of Indian Affairs for the Year 1901,* 354–55. Washington, D.C.: Government Printing Office, 1901.

———. "Report of Umatilla Boarding School." In *Annual Report of the Commissioner of Indian Affairs for the Year 1900,* 365–66. Washington, D.C.: Government Printing Office, 1900.

Gallagher, P. "Report of Warm Springs Agency." In *Report of the Secretary of the Interior,* vol. 2, 280–83. U.S. House of Representatives, 54th Congress, 2nd Session. Washington, D.C.: Government Printing Office, 1897.

210 REFERENCES Gass, Patrick. *The Journals of the Lewis and Clark Expedition,* vol. 10, *The Journal of Patrick Gass, May 14, 1804–September 23, 1806.* Edited by Gary E. Moulton. Lincoln: University of Nebraska Press, 1996.

Harper, J. Russell, ed. *Paul Kane's Frontier.* Fort Worth, Texas: Amon Carter Museum, 1970.

Josephy, Alvin. *The Nez Perce Indians and the Opening of the Northwest.* New Haven, Conn.: Yale University Press, 1965.

Kennedy, James Bradford. "The Umatilla Indian Reservation, 1855–1975: Factors Contributing to a Diminished Land Resource Base." Ph.D. diss., Oregon State University, 1977.

Kip, Lawrence. "The Indian Council at Walla Walla, May and June 1855: A Journal." *Sources of the History of Oregon* 1, no. 2. Eugene, Oreg.: Star Job Office, 1897.

Kurz, Rudolph Friederich. *Journal of Rudolph Friederich Kurz.* Translated by Myrtis Jarrell; edited by J. N. B. Hewitt. Lincoln: University of Nebraska Press, 1970 [1937].

Lancaster, Samuel Christopher. *The Columbia: America's Great Highway through the Cascade Mountains to the Sea.* Portland, Oreg.: Samuel Christopher Lancaster, 1915.

"Letters of Reverend H. H. Spalding and Mrs. Spalding, Written Shortly after Completing Their Trip across the Continent." *Oregon Historical Quarterly* 13, no. 4 (1912): 371–79.

Lewis, Meriwether, and William Clark. *The Journals of the Lewis and Clark Expedition,* vol. 5, *July 28–November 1805.* Edited by Gary E. Moulton. Lincoln: University of Nebraska Press, 1988.

Meany, Edmond S. "Chief Joseph, the Nez Perce." Master's [of Letters] thesis, University of Wisconsin, 1901.

Mooney, James. *The Ghost Dance Religion and the Sioux Outbreak of 1890.* Lincoln: University of Nebraska Press, 1991 [1896].

Moorhouse, Lee. "Indian Photography." In *American Annual of Photography for 1904,* 77–83. New York: Anthony and Scovil, 1903.

——. "Report of Umatilla Agency." In *Fifty-eighth Annual Report of the Commissioner of Indian Affairs to the Secretary of the Interior, 1889,* 275–76. Washington, D.C.: Government Printing Office, 1889.

——. "Report of Umatilla Agency." In *Fifty-ninth Annual Report of the Commissioner of Indian Affairs to the Secretary of the Interior, 1890,* 209. Washington, D.C.: Government Printing Office, 1890.

——. "Report of Umatilla Agency." In *Sixtieth Annual Report of the Commissioner of Indian Affairs to the Secretary of the Interior, 1891,* 378. Washington, D.C.: Government Printing Office, 1891.

——. *Souvenir Album of Noted Indian Photographs.* 2nd ed. Pendleton: East Oregonian Print, 1906.

——. "The Umatilla Indian Reservation." *The Coast* 15, no. 4 (1908): 235–50.

"The Moorhouse Indian Photos." *The Coast* 9, no. 6 (1905): 221–28.

Morgan, Thomas J. "Instructions to Indian Agents in Regard to Inculcation of Patriotism in Indian Schools." In *Fifty-ninth Annual Report of the Commissioner of Indian Affairs to the Secretary of the Interior, 1890,* clxvii. Washington, D.C.: Government Printing Office, 1890.

Morrill, Allen Conrad. *Out of the Blanket: The Story of Sue and Kate McBeth, Missionaries to the Nez Perces.* Moscow, Idaho: University Press of Idaho, 1978.

Parker, Samuel. *Journal of an Exploring Tour beyond the Rocky Mountains.* Minneapolis, Minn.: Ross and Haines, 1967 [1838].

Parsons, William, and W. S. Shiach. *An Illustrated History of Umatilla County by Colonel William Parsons and of Morrow County by W. S. Shiach.* W. H. Lever, 1902.

"Religious, Vital, and Criminal Statistics." In *Sixtieth Annual Report of the Commissioner of Indian Affairs to the Secretary of the Interior, 1891,* 72–91. Washington, D.C.: Government Printing Office, 1891.

Ronan, Peter. "Report of Flathead Agency." In *Sixtieth Annual Report of the Commissioner of Indian Affairs to the Secretary of the Interior, 1891,* 275–79. Washington, D.C.: Government Printing Office, 1891.

"Rules for Indian Schools." In *Fifty-ninth Annual Report of the Commissioner of Indian Affairs to the Secretary of the Interior, 1890,* cxlvi–clx. Washington, D.C.: Government Printing Office, 1890.

Simpson, Sir George. *An Overland Journey Round the World during the Years 1841 and 1842.* Philadelphia: Lea and Blanchard, 1847.

Stevens, Isaac Ingalls. "Narrative and Final Report of Explorations for a Pacific Railroad." In *Reports of Explorations and Surveys . . . for a Railroad from the Mississippi River to the Pacific Ocean,* vol. 12, part 1. U.S. Congress, Senate Executive Document, 36th Congress, 1st Session. Washington, D.C.: Thomas H. Ford, 1860.

Wager, J. P. *Umatilla County, the Heart of the Great "Inland Empire."* Pendleton: East Oregonian Publishing Company, 1885.

Webster, John McAdam. "Report of Agent for Colville Agency." In *Annual Report of the Commissioner of Indian Affairs for the Year 1905,* 355–57. Washington, D.C.: Government Printing Office, 1905.

Werner, Charles F. "Report of Superintendent of Flathead School." In *Annual Report of the Commissioner of Indian Affairs for the Year 1901,* 260–61. Washington, D.C.: Government Printing Office, 1901.

Whitman, Narcissa. *The Letters of Narcissa Whitman.* Fairfield, Wash.: Ye Galleon Press, 1986.

Wilkes, Charles. *Narrative of the United States Exploring Expedition during the Years 1838, 1839, 1840, 1841, 1842,* vol. 4. Philadelphia: C. Sherman, 1844.

Work, John. *The Snake Country Expedition of 1830–1831: John Work's Field Journal.* Edited by Francis D. Haines. Norman: University of Oklahoma Press, 1971.

FURTHER READING

Anastasio, Angelo. "The Southern Plateau: An Ecological Analysis of Intergroup Relations." *Northwest Anthropological Research Notes* 6, no. 2 (1972): 109–229.

Black, Samuel. *"faithful to their Tribe & Friends": Samuel Black's 1829 Fort Nez Perces Report*. Edited by Dennis Baird. Moscow, Idaho: University of Idaho Library, 2000.

Cebula, Larry. *Plateau Indians and the Quest for Spiritual Power, 1700–1850*. Lincoln: University of Nebraska Press, 2003.

Doty, James. *Journal of Operations of Governor Isaac Ingalls Stevens of Washington Territory in 1855*. Edited by Edward J. Kowrach. Fairfield, Wash.: Ye Galleon Press, 1978.

Drury, Clifford M. *Marcus and Narcissa Whitman and the Opening of Old Oregon*. 2 vols. Glendale, Calif.: Arthur H. Clark, 1973.

Gidley, Mick. *Kopet: A Documentary Narrative of Chief Joseph's Last Years*. Seattle: University of Washington Press, 1981.

Gunkel, Alexander. "Culture in Conflict: A Study of Contrasted Interrelationships between Euroamericans and the Wallawalla Indians of Washington State." Ph.D. diss., Southern Illinois University, 1978.

Heizer, Robert Fleming. "Walla Walla Indian Expeditions to the Sacramento Valley." *California Historical Quarterly* 21, no. 1 (1942): 1–7.

Hunn, Eugene S. *Nch'i-Wána, "The Big River": Mid-Columbia Indians and Their Land*. Seattle: University of Washington Press, 1990.

———. "The Plateau." In *The First Oregonians: An Illustrated Collection of Essays on Traditional Lifeways, Federal-Indian Relations, and the State's Native People Today*, edited by Carolyn M. Buan and Richard Lewis, 8–14. Portland: Oregon Council for the Humanities, 1991.

Lansing, Ronald. *Juggernaut: The Whitman Massacre Trial, 1850*. Pasadena, Calif.: Ninth Judicial Circuit Court Historical Society, 1993.

Loeb, Barbara Ellen. "Classic Intermontane Beadwork: Art of the Crow and Plateau Tribes." Ph.D. diss., University of Washington, 1983.

Miller, Christopher L. *Prophetic Worlds: Indians and Whites on the Columbia Plateau*. New Brunswick, N.J.: Rutgers University Press, 1985.

Nicandri, David L. *Northwest Chiefs: Gustavus Sohon's Views of the 1855 Stevens Treaty Councils*. Tacoma: Washington State Historical Society, 1986.

Ray, Verne F. "Native Villages and Groupings of the Columbia Basin." *Pacific Northwest Quarterly* 27, no. 2 (1936): 99–152.

———. "Tribal Distribution in Eastern Oregon and Adjacent Regions." *American Anthropologist,* n.s. 40, no. 3 (1938): 384–415.

Relander, Click. *Drummers and Dreamers.* Seattle: Pacific Northwest National Parks and Forests Association, 1986.

Richards, Kent D. *Isaac I. Stevens: Young Man in a Hurry.* Provo, Utah: Brigham Young University Press, 1979.

Ruby, Robert H., and John A. Brown. *The Cayuse Indians: Imperial Tribesmen of Old Oregon.* Norman: University of Oklahoma Press, 1972.

Schlick, Mary Dodds. *Columbia River Basketry: Gift of the Ancestors, Gift of the Earth.* Seattle: University of Washington Press, 1994.

Stern, Theodore. "Cayuse, Umatilla, Walla Walla." In *Handbook of North American Indians,* vol. 12, *Plateau,* edited by Deward E. Walker, Jr., and William C. Sturtevant, 395–419. Washington, D.C.: Smithsonian Institution, 1998.

———. *Chiefs and Change in the Oregon Country: Indian Relations at Fort Nez Percés, 1818–1855,* vol. 2. Corvallis: Oregon State University Press, 1996.

———. *Chiefs and Chief Traders: Indian Relations at Fort Nez Percés, 1818–1855,* vol. 1. Corvallis: Oregon State University Press, 1993.

———. "Columbia River Trade Network." In *Handbook of North American Indians,* vol. 12, *Plateau,* edited by Deward E. Walker, Jr., and William C. Sturtevant, 641–52. Washington, D.C.: Smithsonian Institution, 1998.

Thompson, Erwin N. *Shallow Grave at Waiilatpu: The Sagers' West.* Portland: Oregon Historical Society Press, 1969.

Walker, Deward E., Jr. "The Moorhouse Collection: A Window on Umatilla History." In *The First Oregonians: An Illustrated Collection of Essays on Traditional Lifeways, Federal-Indian Relations, and the State's Native People Today,* edited by Carolyn M. Buan and Richard Lewis, 109–14. Portland: Oregon Council for the Humanities, 1991.

INDEX